Practical Course
in **Drawing** and **Painting**

First edition for the United States, it territories
and possessions, and Canada published 2010
by Barron's Educational Series, Inc.

© Copyright 2010 of the English translation by
Barron's Educational Series, Inc.

Original title of the book in Spanish:
Curso Práctico de Dibujo y Pintura
© Copyright 2008 Parramón Ediciones,
S.A.—World Rights
Published by Parramón Ediciones, S.A., Barcelona
Spain.

All inquiries should be addressed to:
Barron's Educational Series, Inc.
250 Wireless Boulevard
Hauppauge, NY 11788
www.barronseduc.com

ISBN-13: 978-0-7641-6307-4
ISBN-10: 0-7641-6307-8

Library of Congress Control Number:
 2009937677

Text: Gabriel Martín Roig
Exercises: Vicenç Ballestar, Mercedes Braunstein,
Marta Bru, Carlant, Marta Duran, Miquel Ferrón,
Mercedes Gaspar, Gabriel Martín, Yvan Mas,
Esther Olivé de Puig, Joan Raset, Esther Rodríguez,
Joan Sabater, Óscar Sanchis, David Sanmiguel,
Esther Serra.
Graphic Design: Toni Inglès
Photography: Estudio Nos & Soto, Parramón files
Layout: Estudi Toni Inglès (Gemma Grau)

Translated from the Spanish by Michael Brunelle
and Beatriz Cortabarria

Printed in China
9 8 7 6 5 4 3 2

Practical Course in **Drawing** and **Painting**

BARRON'S

Drawing

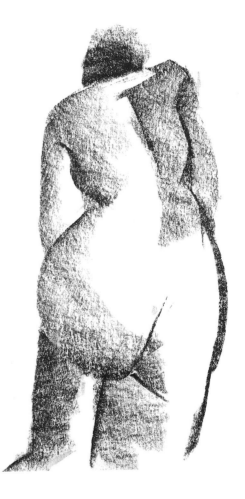

Painting

You can learn to paint and draw

It is widely believed that to be able to paint and draw with some degree of dexterity, ability, grace, and ease, a person has to possess certain innate qualities, artistic genes. Even though it is true that some people have a hereditary predisposition—an artistic sensibility—anyone can learn to paint. All it takes is learning how to observe, practicing the techniques, and understanding how to interpret the subject—that is, how to adapt the scenes that you paint to fit your unique and personal style.

In this book, which is based on practice, beginners will find everything they need to know to learn to draw and paint, explained in an organized fashion. For amateur painters, who may already have some artistic background, this book serves as a glossary of techniques, with new advice and practical solutions that will expand their resources and provide a new world of possibilities, allowing them to improve the quality of their work.

This book introduces you to all the materials you will need and their different applications. It includes the most interesting and important modern approaches, as well as traditional techniques. The apparent difficulty of drawing and painting that intimidates most beginners is tackled with clear, brief explanations that teach you how to use the materials properly. Many examples and basic tips supplement the practical exercises, showing you the immediate application of each process, its characteristics, effects, and creative potential.

This course puts into practice all the major aspects of painting and drawing, using examples by professional artists who apply their knowledge and experience in each detailed graphic demonstration. The result is a truly useful and encouraging book about the practice of drawing and painting.

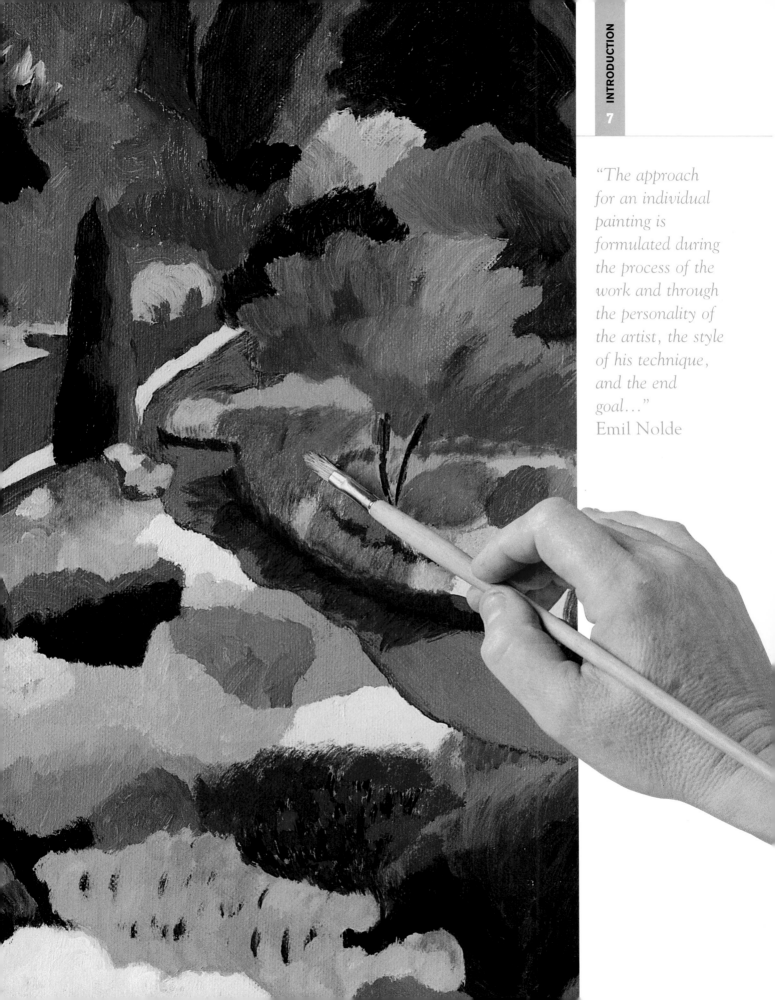

"The approach for an individual painting is formulated during the process of the work and through the personality of the artist, the style of his technique, and the end goal…"
Emil Nolde

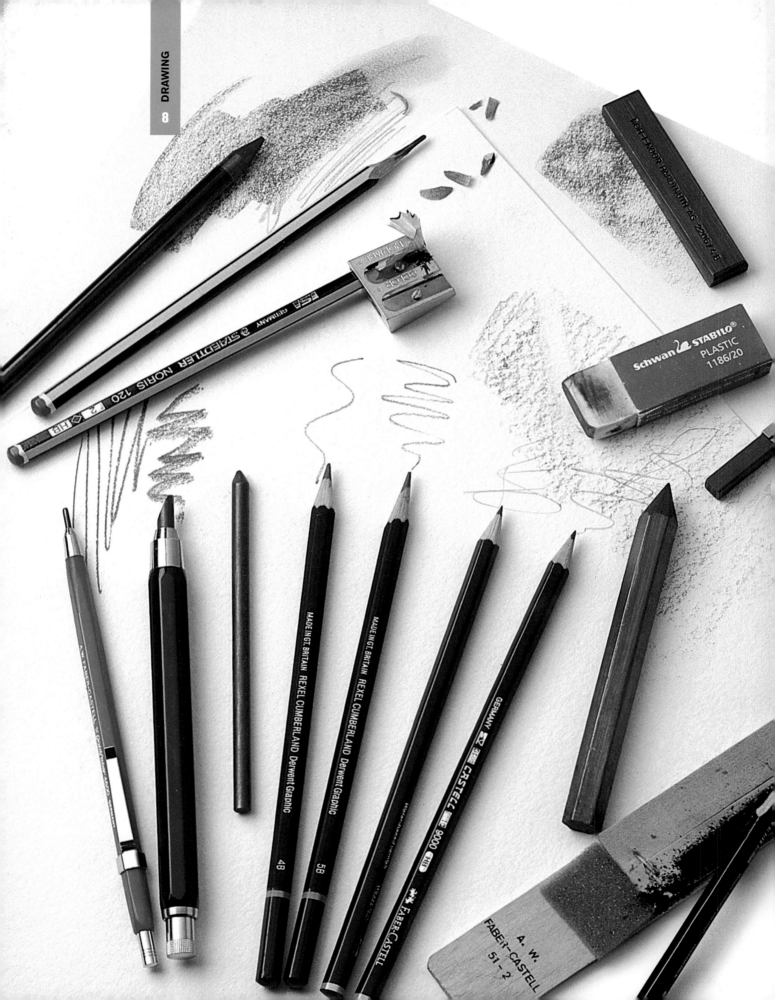

Fundamentals and Synthesis

Drawing is the basic foundation for everything. That is why, to get started in any artistic discipline you must have a basic knowledge of drawing and shading techniques.

Knowing how to sketch is the basis of many art forms. For many artists, the first step in the creation of any work consists of making a light sketch of the composition before beginning to paint, even though those first lines may ultimately be covered by thick layers of paint.

Therefore, in the first section of this book we present a basic selection of drawing media and methods that includes everything you need to start drawing, from how to handle the materials to the most essential techniques. It is important to try everything until you discover what best suits your artistic vision.

IMPORTANT MATERIALS

*T*he first drawings date back to prehistoric times, when humans used any piece of charcoal or pigment that was available to adorn rough, irregular cave walls. Fortunately, through the centuries mediums and supports have improved, and new ones have been discovered that encourage great graphic variety and also different styles and interpretations.

Selecting the material is very important because the look of the work depends on it, whether it is a drawing made with soft, delicate lines that are almost unnoticeable or one with strong, energetic, impulsive lines.

■ Honoré Daumier (1808–1879), *During the Intermission*. A spontaneous, gestural drawing executed with a combination of quick superimposed lines.

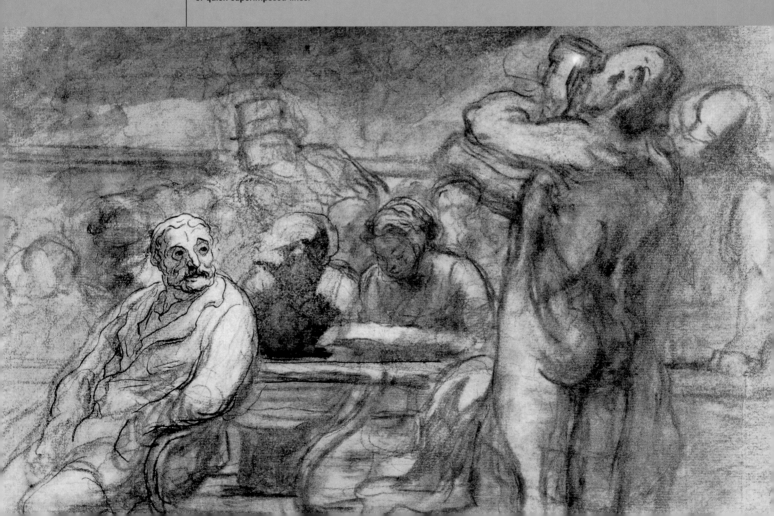

COMPATIBILITY OF MEDIA

If we spontaneously mix lines made with different types of media, we will see that not all of them go well together. Graphite, with its oily consistency, does not mix well with charcoal, chalk, and dry pastels, which do go well together. It can only be combined with colored pencils, markers, ink, and washes. Oil pastels thicken and form clumps when they are mixed with dry pastels, and do not handle washes well at all. It is best to discover for yourself which materials go well together and which do not.

A simple line

Generally speaking, all drawings begin with a simple line produced by lead or a stick of solid pigment that comes into contact with the surface of the paper. This action causes the lead or drawing stick to release particles of pigment that partially or totally adhere to the paper. Each drawing tool generates a different kind of line and each acts differently according to the way it was manufactured. Before beginning any drawing, your concentration should be on mastering the basic elements. Always begin by making simple lines on a piece paper in order to test the hardness, gradation, and blending ability of each material.

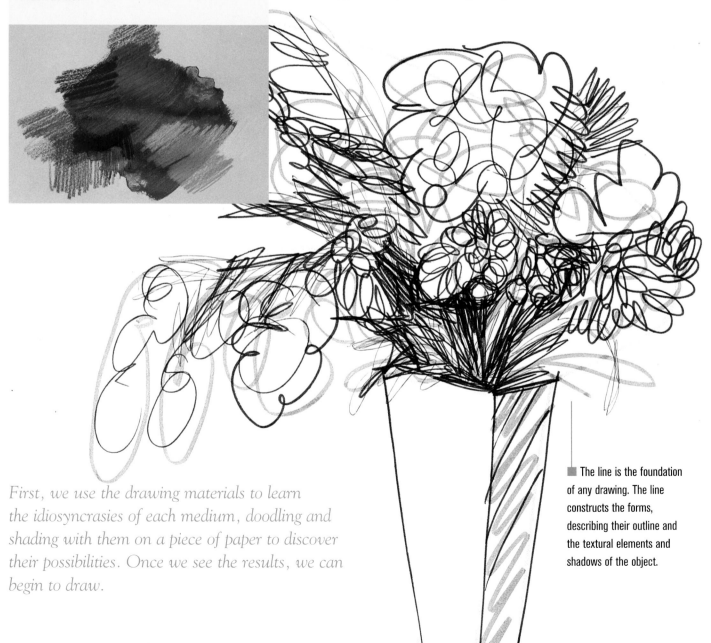

First, we use the drawing materials to learn the idiosyncrasies of each medium, doodling and shading with them on a piece of paper to discover their possibilities. Once we see the results, we can begin to draw.

■ The line is the foundation of any drawing. The line constructs the forms, describing their outline and the textural elements and shadows of the object.

The graphite pencil

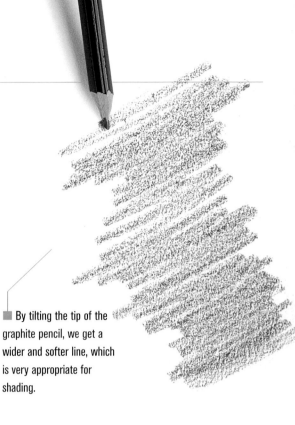

A pencil is the most elemental tool for drawing. It consists of a lead made of natural graphite powder and clay baked at a specific temperature that is then inserted into a wooden tube. One of its most attractive attributes is that it allows the mixing of lines and shading and can be erased with an eraser. It is possible to change the consistency of the lines by controlling the pressure exerted on the paper. If the lead has a rounded tip and we apply light pressure, the line will be soft and light gray in color; on the other hand, if the tip is sharp and the pressure is stronger, the line will be dark and well defined. While we use the tip of the pencil for making lines, for shading it is better to tilt the tip on its side to avoid making lines that are too visible. First, we work the light tones and then we darken them progressively by adding more shading. Graphite is also available in round and square bars, which are very useful for larger drawings.

■ By tilting the tip of the graphite pencil, we get a wider and softer line, which is very appropriate for shading.

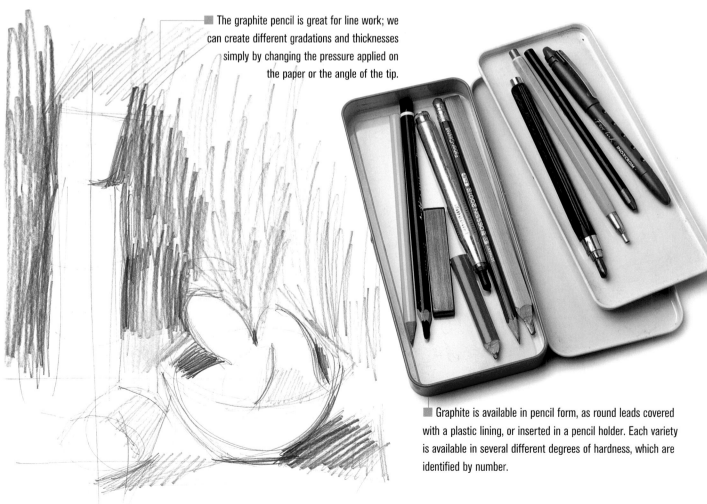

■ The graphite pencil is great for line work; we can create different gradations and thicknesses simply by changing the pressure applied on the paper or the angle of the tip.

■ Graphite is available in pencil form, as round leads covered with a plastic lining, or inserted in a pencil holder. Each variety is available in several different degrees of hardness, which are identified by number.

■ Graphite sticks are
preferred by many artists for
making large shaded areas,
especially for large drawings.

Hard pencils and soft pencils

The different degrees of hardness of graphite
pencils determine the quality of the line. Hard
pencils have a dry, sharp tip and make gray-
toned lines. They are identified with the letter H
for "hard." They are used for very precise
drawings, such as line drawings; the hard leads
make a thin line and do not smear the paper,
providing very clean and well-defined results.

Soft pencils have an oil lead, the tip wears
out easily, and the line is black. They are identified
with the letter B for "bold." Soft leads give the
artist greater freedom of expression and flexibility
in artistic drawings.

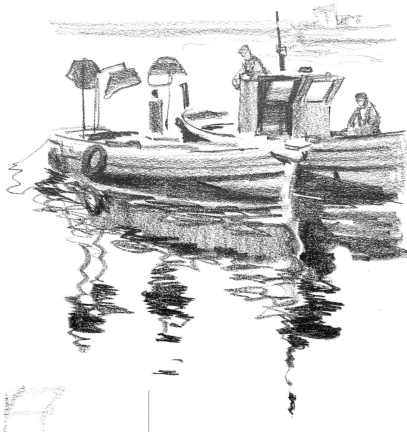

■ As the drawing progresses, we will have to superimpose
thicker lines over the previous ones to darken the shadows and
extend the medium tones or intermediate grays. The white of
the paper will represent the areas of light.

■ A very sharp 6B graphite lead makes a line of great quality.
Because it is a soft lead, we will angle the tip so the first lines
are soft.

Charcoal and its variations

Charcoal is made from a carbonized vine that makes a black line of blendable consistency. It is very popular with beginners because corrections can be made easily. You simply need to softly wipe the line with a rag to remove part of the pigment. Its great flexibility is very useful for making sketches and preliminary studies. Because of its darkness, it can be used in combination with lines, lines with shading, and detailed chiaroscuro studies. The ease with which the pigment adheres to the surface of the paper and can be blended makes it possible to obtain rich shading and gradations with a very expressive quality.

■ Areas shaded with charcoal provide soft, velvety grays that lose their intensity as soon as we touch them with a cotton rag.

■ Charcoal offers many graphic possibilities, from steady, intense lines to shading and high-quality gradations.

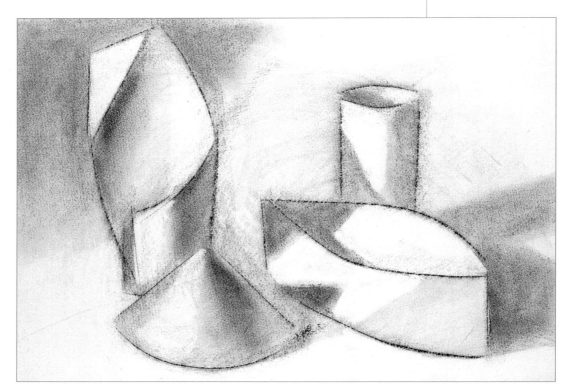

■ Charcoal is very blendable and comes off easily when rubbed with the fingers.

ERASING

A drawing made with charcoal cannot be erased with conventional erasers. To correct any mistakes we will use a white cotton rag or malleable erasers. The latter can also be used to create reflections of light.

Charcoal sticks and how to use them

Charcoal is available in 5- to 6-inch (13–15 cm) long sticks, in diameters that range from $3/16$ to $1/2$ inch (5 mm–1.5 cm). Some brands offer three grades: soft, medium, and hard. By varying the pressure and the angle of the stick, a great range of grays can be obtained, from an intense velvety black to a most subtle light gray. Rubbing the stick on its side on the paper will make shaded surfaces with textures, the intensity of which can be altered and softened by rubbing.

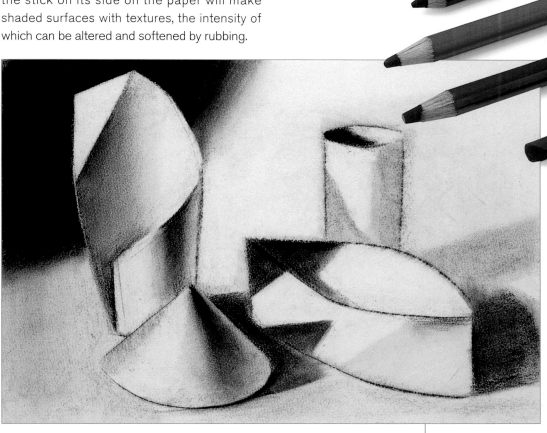

■ Charcoal comes in a range of formats, from carbonized vines to compressed charcoal sticks and pencils that provide deeper blacks.

■ With compressed charcoal sticks, blacks become deeper and the effect of volume is enhanced.

Compressed charcoal pencils and sticks

Compressed charcoal pencils and sticks, also known as charcoal compound, are derived from charcoal. Compressed charcoal consists of a pulverized vegetable charcoal mixed with a binding agent that provides firmness. It makes a darker black line than charcoal and it is less blendable; this means that it adheres to the paper better and that it is harder to erase and blend.

Charcoal and compressed charcoal can be combined in the same drawing to obtain deeper tones.

Sanguine and chalk

Sanguine is a stick of a very characteristic red color that comes from an iron oxide called hematite. Its essential qualities are warmth and its power to imitate flesh tones very closely; this makes it an ideal medium for portrait and nude studies. Sanguine bars come in different tones, which range from orange-red to brownish red.

You do not always have to draw with gray tones; chalks and sanguine add a note of color to drawings and give them greater warmth and natural feeling.

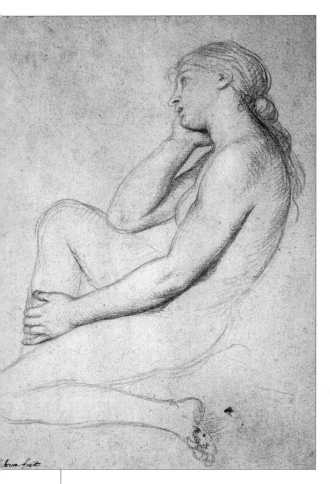

■ Charles Le Brun (1619–1690), *Nude Woman Seated*. Sanguine provides great softness and less contrast than charcoal in the treatment of flesh tones.

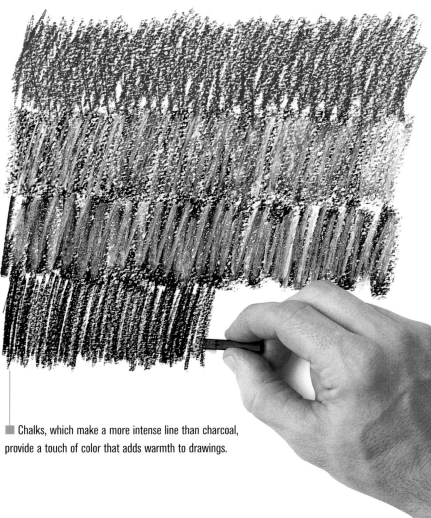

■ Chalks, which make a more intense line than charcoal, provide a touch of color that adds warmth to drawings.

DRAWING WITH THREE COLORS

This technique makes it possible to create a full-color image with only three colors: sanguine, white chalk, and black chalk. By combining the color of the sticks or pencils with the paper, we will obtain different degrees of luminosity.

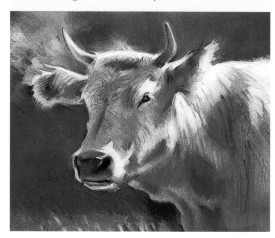

Chalk

Chalks produce an effect similar to charcoal, but their added hardness allows the artist to draw with great precision and to obtain very rich colors. Nowadays, they are available in a wide range of colors; however, professional artists limit their palette to only three or four colors: black, brown, sepia, ochre, and white. To these colors we can add sanguine, which is also considered a chalk, although it has special characteristics. With chalks it is much easier to obtain very precise lines and greater tonal variety than with charcoal; they also provide greater contrast, making them easier to correct.

■ A basic selection of chalks should include a black chalk, a white chalk, and various brown chalks.

■ Sanguine and chalk provide the best results when applied on colored paper.

Pastels: between drawing and painting

Pastels are made of a mixture of powdered pigments, plaster, and glue. Their name derives from the word *paste*, the compound that results from mixing the components to give them the shape of a stick. In the beginning, pastels were used as a dry medium, a quick way to apply color to the drawing without the need for brushes, to reinforce the volumes and chromatic effects. In time, they have become a difficult medium to classify because they are considered halfway between drawing and painting; they draw from both without belonging completely to either of the two categories.

■ Working with pastels is like coloring with pure pigments; they are very intense and have a strong tinting capability.

This medium appeals to many artists because of its intense, luminous color, the result of the large amount of pigment contained in the sticks.

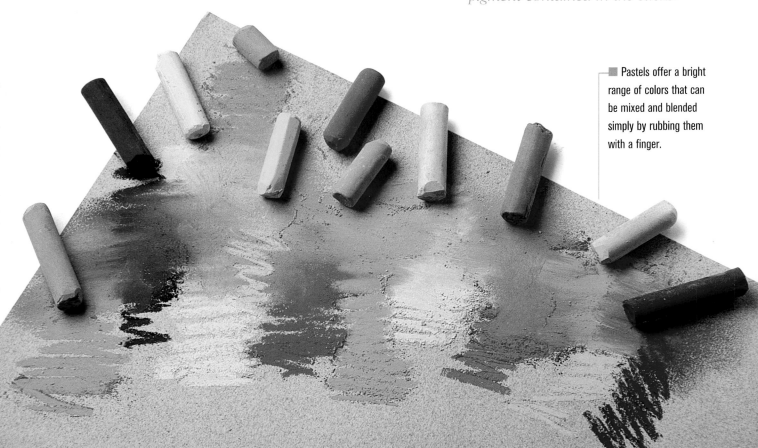

■ Pastels offer a bright range of colors that can be mixed and blended simply by rubbing them with a finger.

Hard and soft pastel sticks

There are hard pastels and soft pastels. The former contain more glue, which makes them more durable and compact; they are most appropriate for drawing lines, although they can also produce high-quality shading. Soft pastels have a minimum amount of binding glue, which results in sticks that are quite brittle and respond to the subtlest changes in pressure. Their tinting capability is very high and the colors are brighter than hard sticks.

Applications

Pastel sticks provide interest and versatility, and they are suited to work with hatching, glazing, and also impastos and saturated colors. The colors mix well when they are superimposed since each application does not cancel out the underlying layer; instead a variety of colors appear little by little. They can also be blended, but rubbing them too much with your finger can cause clumps on the surface of the paper. It's best not to saturate the paper, so that its texture is always visible. Finally, the line or details are applied, usually with pastel pencils because of their greater precision.

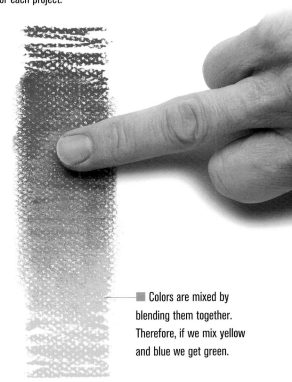

■ The most appropriate supports for painting with pastels are Canson Ingres colored papers. It is a good idea to have an assortment handy and choose the most appropriate color for each project.

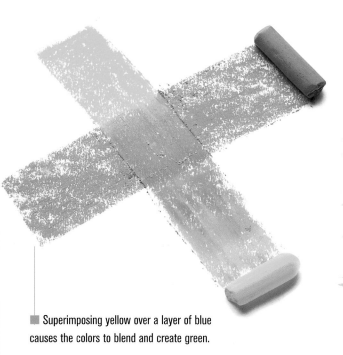

■ Superimposing yellow over a layer of blue causes the colors to blend and create green.

■ Colors are mixed by blending them together. Therefore, if we mix yellow and blue we get green.

Washes: the door to painting

A wash can be defined as drawing with a wet brush and water using a single color, generally black (although all the shades of brown, walnut, bistre, indigo, kaolin green, blue-black, sanguine, and Payne's gray, are suitable for washes). Washes make drawings more realistic and lively, since they complete the linear representation while adding a combination of light and shadow. To work with washes you'll need India ink, sepia ink, or two or three colors of watercolors. But the stars of this technique are the brushes, which create a much softer effect than sticks rubbed on the paper.

CHOOSING BRUSHES

If you are going to work with washes, you should have two or three different-sized brushes that are able to hold a large amount of water. The best approach is to combine a couple of round brushes with a square-tipped flat wash brush.

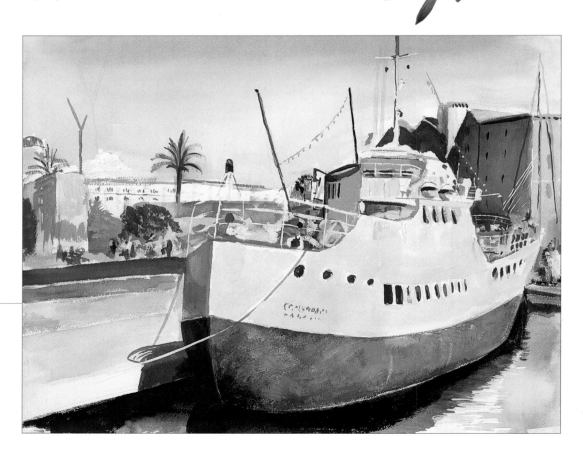

■ To work with washes, it's a good idea to have a variety of quality brushes.

■ The wash technique incorporates many aspects of drawing, like monochromatic treatment, tonal changes, and line details.

The wash is born from the soft movement of the brush, which deposits color on the paper with sinuous, rhythmic movements. With each application, with each turn of the wrist, the bristles bend like the body of a dancer.

Distributing the light

The key to a good wash technique resides in the correct distribution of light in the drawing, which should be established right away with a somewhat diluted wash. It is important to consider first which areas of the white paper will be left exposed, indicating more light; then, the first strokes of soft gray are applied, and as they dry out we continue darkening the shaded areas with new washes.

Cumulative work

The wash is a cumulative technique; it is worked by applying soft, transparent layers, adding one layer over the next until darker tones are achieved. The application of successive layers, gradually darker but always transparent, creates a velvety shading effect. It is important to proceed slowly and to wait until the wash is dry; one layer has to be dry before the next one is applied. Work cautiously, increasing the tonal intensity of an area only after careful consideration.

■ There should be a large amount of water in each color application, allowing for the wash to be applied easily.

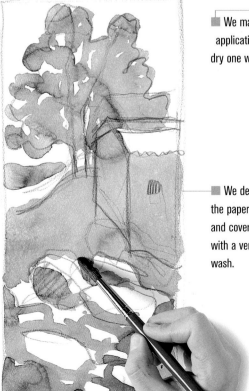

■ We make the second color application over the previous dry one with a new wash that is somewhat darker.

■ We decide which areas of the paper are left exposed and cover the shaded ones with a very diluted sepia wash.

■ The guide for the wash is a line drawing made with a graphite pencil.

PLANNING, SKETCHING, AND SHADING

*B*efore you begin to draw, it is a good idea to plan the theme—that is, to lay out the main forms on paper so they can help you define the areas, the masses, and the volumes. You can use small tentative diagrams or sketched lines. These diagrams are usually simple geometric shapes that match the forms represented in the model. This first phase is done exclusively with lines or shading. The medium used is not important as long as the model is reduced to basic, elementary lines. With a good layout it is much easier to draw definite lines.

■ Théodore Gericault (1791–1824), Louis XVIII *Inspecting the Troops in the Field of Mars.* Just a few lines are all that is needed to lay out the composition; the shaded areas are an excellent complement to the lines because they define the volume and the direction of the light.

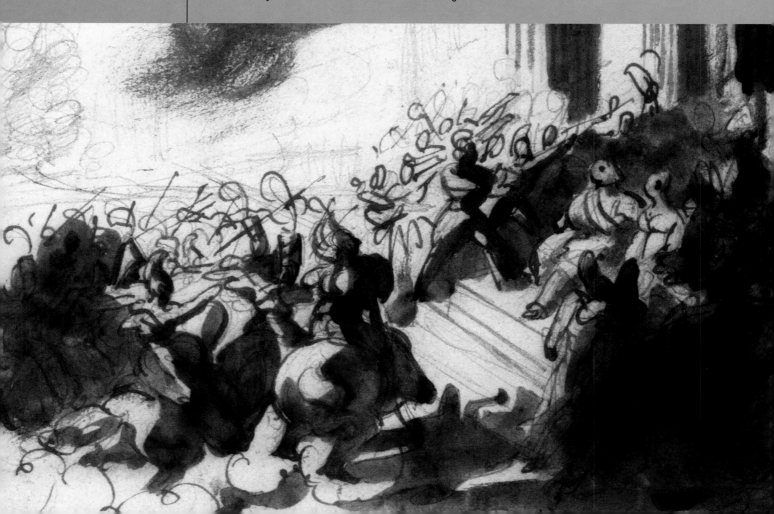

LAYING OUT WITH SIMPLE SHAPES

Sketching with just a few lines, using simple geometric shapes, is the first step in any drawing. When reduced to basic shapes, any structure is easy to understand, no matter how complex it may seem.

Understanding shading

Once the line drawing has been laid out on the paper the next step is to add the shading. It is not easy to understand shading without practice. Everything has color, and it is not easy to translate colors into gray tones. A very useful method is to look at the shaded object while squinting your eyes. This way, the shaded areas are more clearly defined because the details are eliminated; the eye sees only the stronger contrasts.

■ By changing the pressure applied to the charcoal stick, you can create different tones of gray.

Colors are not just for filling

Adding color is an active part of the drawing process. It allows you to give form to the linear drawing, it transforms a group of lines into volumes, and it helps define the planes and depth. If you look around, you will see that there are no lines that separate objects from the background. What you see are areas of color that your brain simplifies as an edge.

■ Beginners should learn to sketch models with just a few lines.

■ Defining the areas of color is the first step in shading; the colors are only suggested by shading to give the objects volume.

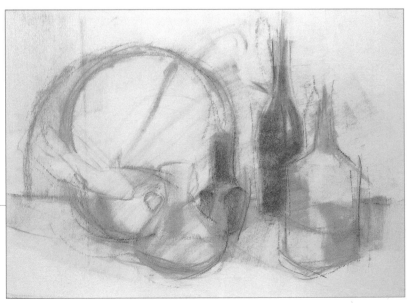

Fundamentals of sketching

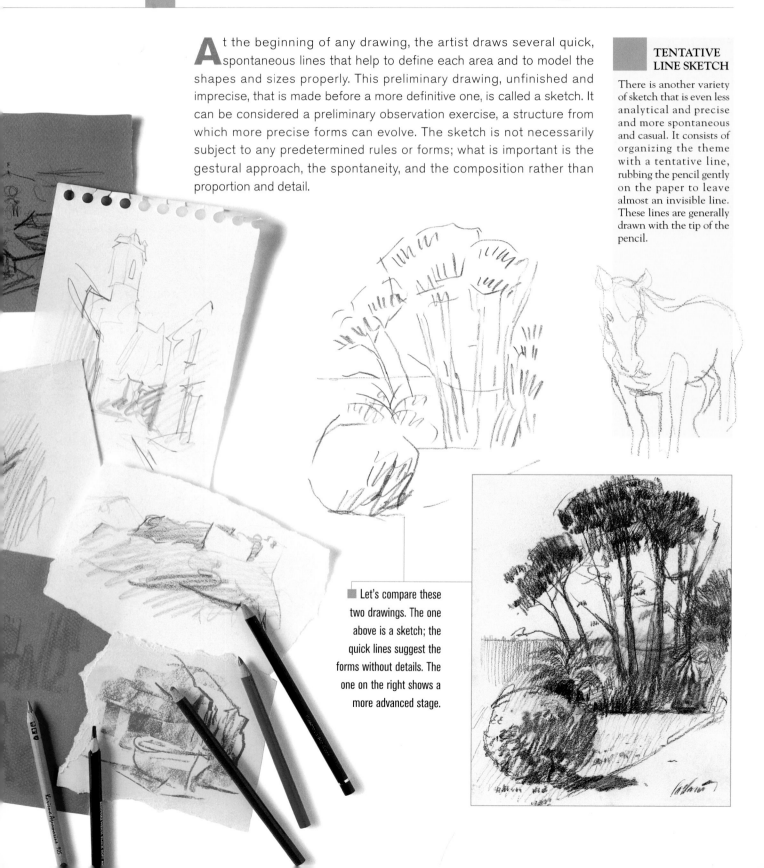

At the beginning of any drawing, the artist draws several quick, spontaneous lines that help to define each area and to model the shapes and sizes properly. This preliminary drawing, unfinished and imprecise, that is made before a more definitive one, is called a sketch. It can be considered a preliminary observation exercise, a structure from which more precise forms can evolve. The sketch is not necessarily subject to any predetermined rules or forms; what is important is the gestural approach, the spontaneity, and the composition rather than proportion and detail.

TENTATIVE LINE SKETCH

There is another variety of sketch that is even less analytical and precise and more spontaneous and casual. It consists of organizing the theme with a tentative line, rubbing the pencil gently on the paper to leave almost an invisible line. These lines are generally drawn with the tip of the pencil.

■ Let's compare these two drawings. The one above is a sketch; the quick lines suggest the forms without details. The one on the right shows a more advanced stage.

Freehand

The sketch is usually done freehand—that is, with quick and spontaneous movements of the hand, drawing very fast and barely applying any pressure on the paper. These drawings are not very exact; they look more like doodles made with three or four imprecise lines. Almost abstract, they sometimes are only understood by the artist. The sketch should not take more than a few seconds.

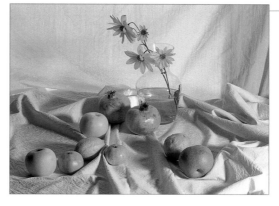

■ You can begin by making sketches of a simple still life.

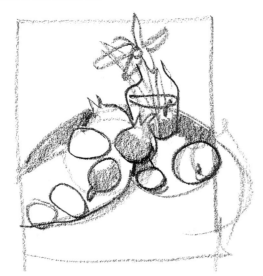

Anticipating the theme

The preliminary sketch is a way of getting acquainted with the forms, of addressing the blank paper, of anticipating the theme. The sketch will help you gauge the representational possibilities of the model, gather information, and try out your interpretational abilities to prevent the sketch from looking too mechanical. It is a good idea to make numerous preliminary sketches to experiment with the formal layout of the model, select the most interesting aspects, and relate all the parts of the drawing to each other.

■ Making a series of preliminary sketches allows you to modify the composition and the sizes of the elements to get the most out of the model.

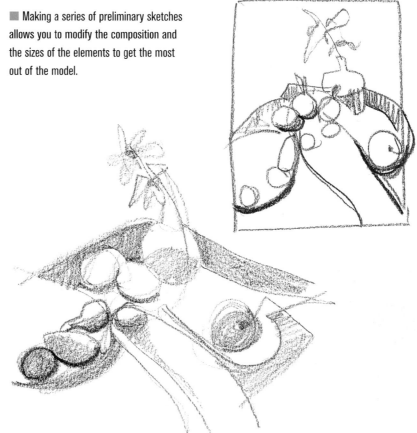

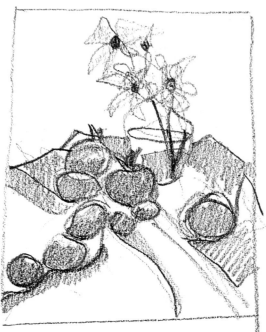

Kinds of lines and hatching

The low-tech pencil is a useful tool for making line studies and hatching. You can make a wide range of lines with it, soft gray, intense black, and textured, and layer different types of lines. Any tonal drawing can be created with a series of lines drawn in multiple configurations: lines of various densities, groups of parallel lines, groups of short and rounded lines, series of spirals, and so on. These are examples of very common hatched lines that add tonal value to a drawing without completely abandoning the line treatment.

■ Any object can be shaded with hatched lines. With a pencil it is easy to draw shading with visible lines.

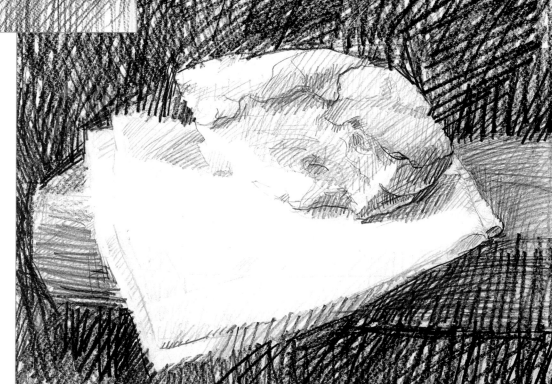

■ We adjust the tones and define the shading by crosshatching the lines of the previous step. The hatched lines are closer together and thicker in the background, while the hunk of bread is resolved with soft, grayish hatched lines.

■ The direction of the hatched lines helps to contrast the planes and to set them apart. By changing the direction of each set of hatched lines, the contour of the model will emerge through contrast, without the need to draw an outline.

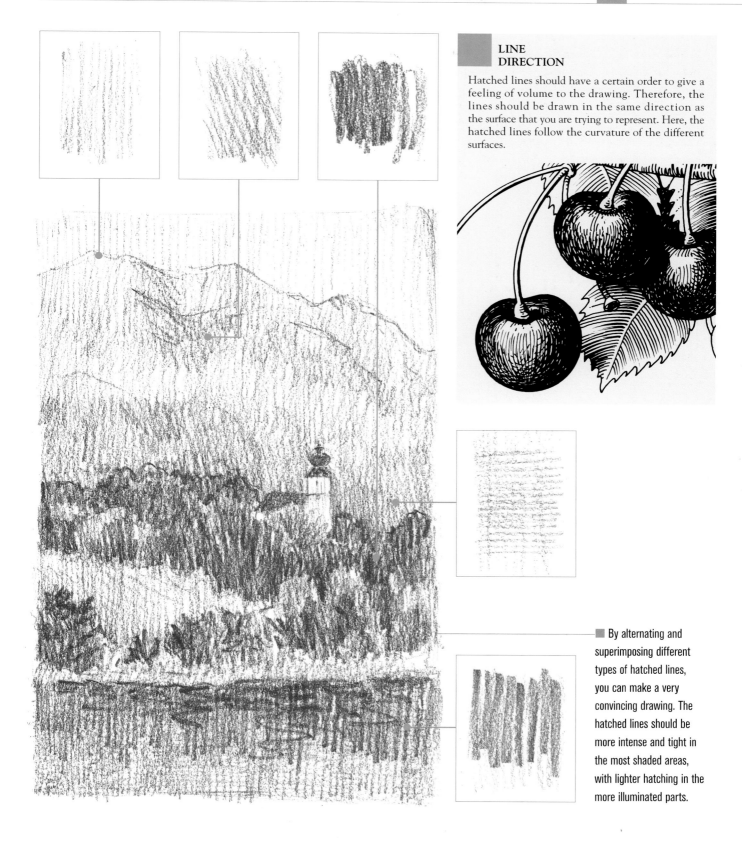

LINE DIRECTION

Hatched lines should have a certain order to give a feeling of volume to the drawing. Therefore, the lines should be drawn in the same direction as the surface that you are trying to represent. Here, the hatched lines follow the curvature of the different surfaces.

■ By alternating and superimposing different types of hatched lines, you can make a very convincing drawing. The hatched lines should be more intense and tight in the most shaded areas, with lighter hatching in the more illuminated parts.

Shading with charcoal

Drawing with a charcoal stick produces realistic volumes. You can use the entire length of the stick, held diagonally, which allows very fast work. Then, with the tips of your fingers or with a blending stick, you can blend or change the tones as you please. Finally, you can define some of the forms with the tip of the charcoal stick or with chalk, or erase with a kneaded eraser.

THE MODEL

■ A simple still life with a deep chiaroscuro effect—that is, with well-defined areas of light and shadow.

PHASE 1:

**DRAWING AND
SHADING**

1

1. The initial drawing is very basic, done with the tip of the charcoal stick.

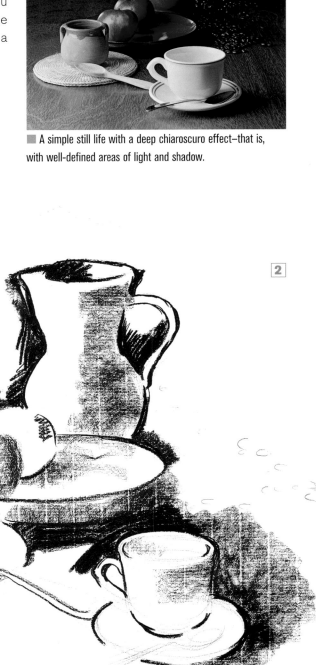

2

2. With a piece of the charcoal stick about 1¹/₄ inch (3 cm) long, we shade the areas that have a darker shadow. We rub with the stick lengthwise, applying pressure to create deep blacks.

As you add new shading to the drawing with the charcoal stick, remember to blend it with your fingers to model the shapes of the objects and to prevent the material from forming clumps.

PHASE 2:
BLENDING AND SHADING

3. We represent the shaded areas by blending with the hand and erasing with a cotton rag. The black lines look less intense. The shadows inside of the objects become softer and less contrasted.

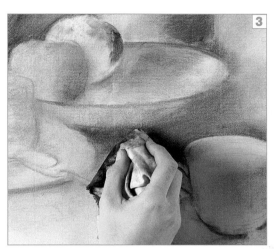

4. When the drawing looks very black from the effect of the charcoal, we turn to the kneaded eraser, which will let us erase certain parts to make very bright white areas.

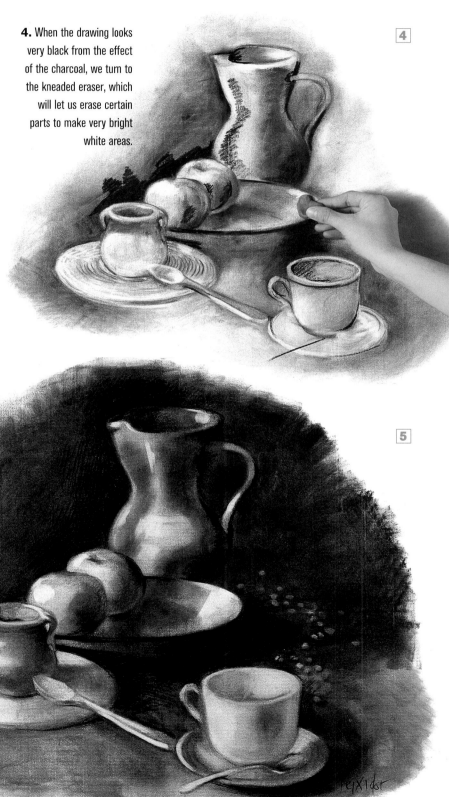

5. We darken the tones of the background and define the contours of the objects with the tip of the charcoal, blending the lines again with the tip of the fingers. The final drawing has a chiaroscuro effect.

Appreciating light

The representation of the effects of light with shading is the artist's main resource for re-creating volume and space. Shading gives coherence to all the objects of the model. A shaded drawing has different values, each representing a degree of light or shadow. It is a good idea to learn to distinguish them, but don't overdo it; avoid working with eight or ten values. It is best to familiarize yourself with just four: the white of the paper, black, and two intermediate grays.

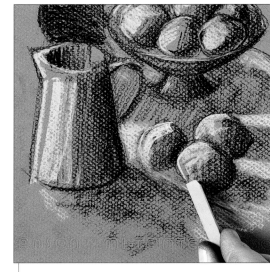

■ White chalk on colored paper is the best way to highlight the effect of light.

■ To reproduce the effect of light on an apple, we need to think of it as if it were a sphere, shading with the side of the stick.

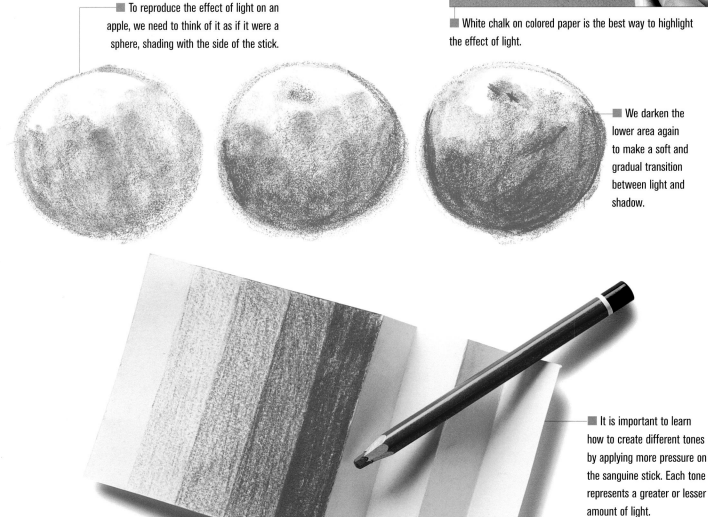

■ We darken the lower area again to make a soft and gradual transition between light and shadow.

■ It is important to learn how to create different tones by applying more pressure on the sanguine stick. Each tone represents a greater or lesser amount of light.

The artist should think of shading as if it were building blocks, like masses that are used to create a convincing illusion of light.

DRAWING

FUNDAMENTALS AND SYNTHESIS
PLANNING, SKETCHING, AND SHADING

31

THE MODEL

This is a close-up of an interior with the direct impact of an artificial light source.

Shadows express the light

Graphite lead creates tonal areas very easily. The softer ones (4B, 6B, and 8B) are ideal for working the light in a drawing, because they can produce a great variety of tones. On white paper, light can only be represented through contrast with areas of shadow. We reserve the white of the paper for the lighter areas of the model, and we extend a simple gradation over the areas in the shadow. Light cannot be expressed without shadows.

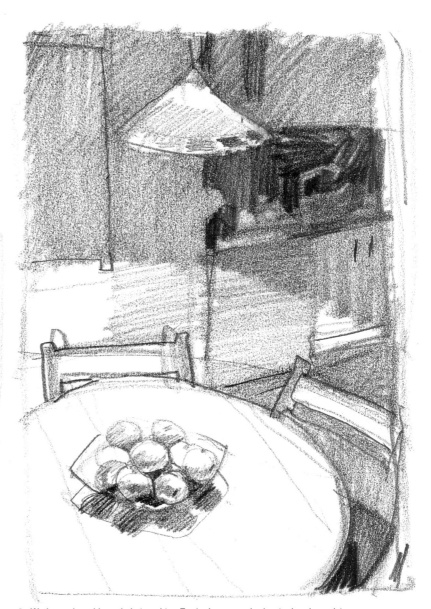

1. The first drawing is linear. The distant planes have hardly any definition. The objects in the foreground are given more importance.

2. We leave the table and chairs white. To shade, we angle the tip, barely applying pressure. The background appears much darker. We use only three tones.

Using gradation to show volume

Learning how to make gradations may be perhaps the most important step in giving objects volume. Gradation is the smooth transition, without sudden changes, from a light tone to a dark one or vice versa. We begin with a very light tone that is gradually extended and intensified with every stroke, and the pressure applied is increased or reduced until a series of different tones of gray is achieved. Generally, gradation is finished with light shading that softens it even more.

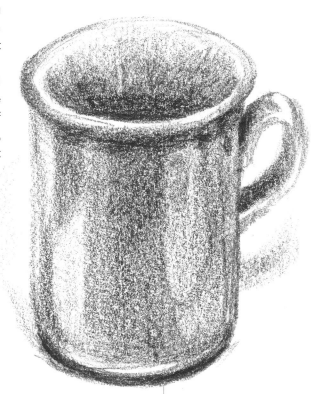

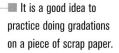

■ It is a good idea to practice doing gradations on a piece of scrap paper.

■ It's best not to apply too much pressure on the chalk; this way, the texture of the paper becomes an asset and reinforces the three-dimensional effect of the cup.

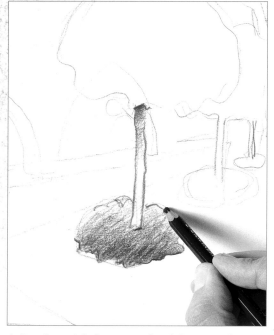

1. To understand the importance of gradations, try applying them to your drawings, even if it looks forced.

2. The final result is a study with a highly emphasized volumetric effect, even if the lighting is somewhat ambiguous and unreal.

THE CHIAROSCURO EFFECT

Very abrupt changes in gradation, with strong contrasts between light and shadow, are known as the chiaroscuro effect.

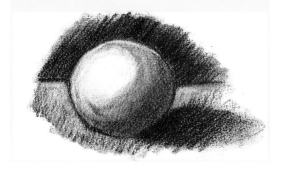

Shading rounded surfaces

Although the best way to shade a flat surface is by using a uniform tone, we use gradations to represent the irregular distribution of light on a rounded surface. Curved and rounded surfaces express shadows in a decreasing manner, which creates the feeling of roundness. Whether the gradation is very diffused or textured, the strokes should not be visible.

■ Gradations applied to represent volume highlight the cylindrical nature of a tree trunk or the voluptuous aspect of smoke coming out of a chimney.

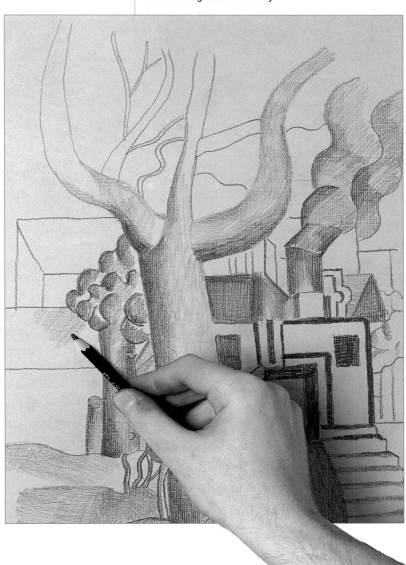

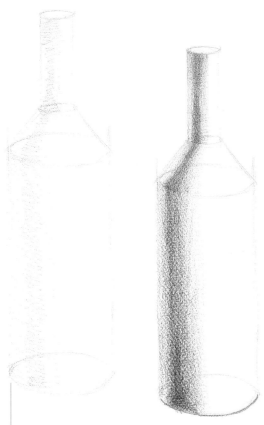

■ Cylindrical objects are the best models for experimenting with gradation. After a light gradation is created with the graphite pencil, it is blended to achieve a soft tonal transition that explains the roundness of the object.

LOOSENING UP
WHILE DRAWING

At first, making a quick sketch may seem complicated, and the results can be discouraging because rushing to finish can diminish precision. But if you want to become comfortable you need to take a bold approach, allowing yourself to draw and make many mistakes, because technical ability increases with experience. The speed of the work makes it impossible to control the proportions of the model, and some sketches may even appear distorted, but you will gain experience and expressivity in the process. Since the goal is to loosen up, don't worry about correcting a drawing that you think has not come out right.

■ You loosen up by adding character to lines and shading,
working fast and without fear of failure.

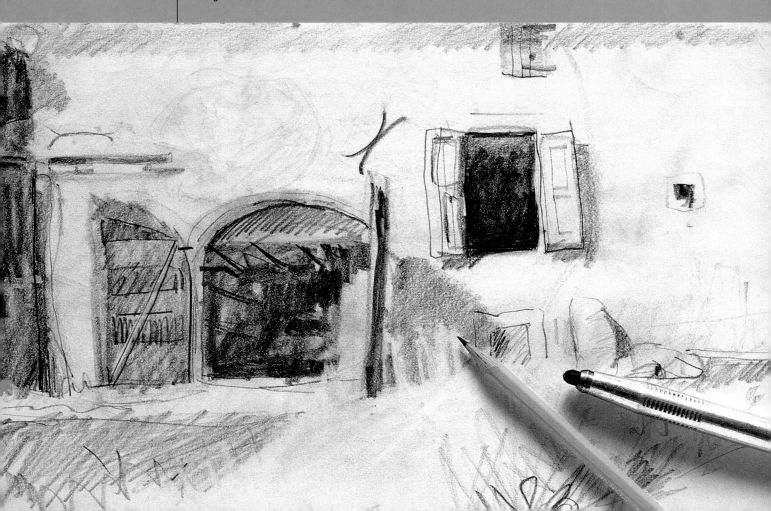

QUICK
SKETCHES

It is important to keep sketch pads or pieces of scrap paper handy at all times to make quick sketches, which can consist of just a few loose inconsequential lines. This will help you practice the use of quick gestural movements.

How to work fast
Before you begin to draw, limit the time you allow yourself to make a sketch—give yourself one or two minutes at the most. First, draw the main lines, the ones that best define the contours or the form of the model. Then, sketch a few interior lines that complement the form or that provide relevant information about the object. Finally, do the shading in a relaxed way, without precision, using quick lines whose only purpose is to cover the darker areas.

Trying out different media
When you do quick sketches it is important to experiment with different tools often, because the nature of each medium triggers new color and line ideas. The sooner you learn and adapt to all the possibilities offered by the drawing materials, the better your output will be.

■ Lines should be quick and gestural, with little definition or precision. It is a good idea to change the angle of the tip and the amount of pressure applied.

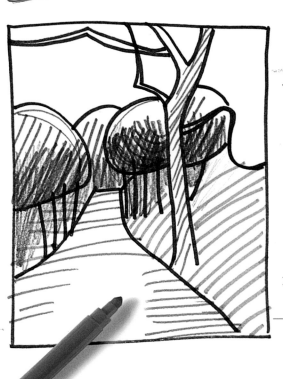

■ Try to draw the same subject using different techniques, because each one offers a new opportunity for experimentation.

Intuition and automatic drawing

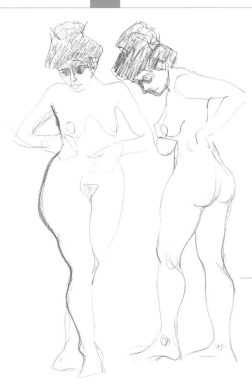

One of the most enjoyable and fascinating aspects of intuitive drawing is suggesting the forms without drawing them completely, letting viewers guess and complete them with their imagination. This is also an important way to stimulate your creativity and allow yourself to loosen up and be more spontaneous with the line. Though sketches may consist of just a few loose, easy lines, they can be of great use. Many times these lines, drawn spontaneously and without stopping, trigger unusual possibilities for the artist. One way of working fast and spontaneously is to attempt to resolve the model with a single line, without lifting the lead off the paper. This approach will help you to conquer your fear of drawing, avoid broken lines, and make more confident lines overall.

■ These two female figures were drawn with a single, quick line. The lack of proportion of some of the parts should not be of concern; the role of the sketch is simply to capture a pose, a gesture.

■ We use a pen to ensure the regularity and continuity of the line. We begin by drawing hatch lines for the floor and continue upwards with the outline of the architectural features.

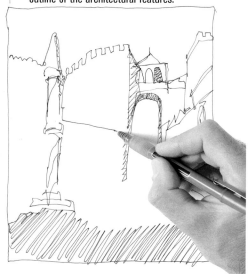

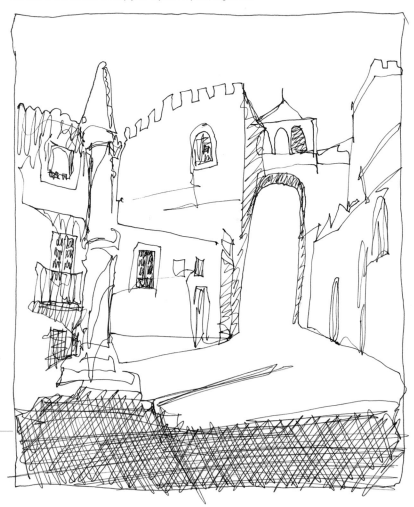

■ If it is necessary, to draw the windows that are separated we could draw a line to link them together as if we were drawing them with a thin continuous wire.

*To practice automatic drawing means to let yourself
be guided by the movements of the hand, carried out in
an intuitive, quick way and without thinking about it.*

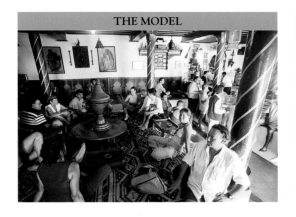

THE MODEL

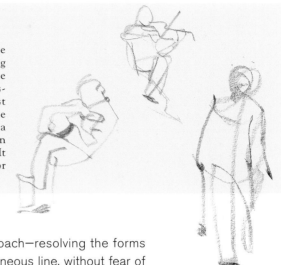

SKETCHING FIGURES

When faced with the challenge of drawing figures that are prone to movement or posture change, the best approach is to make quick sketches with a few lines that explain their forms and poses. It is a way to imprint or freeze the pose.

A quick sketch

The automatic approach—resolving the forms with a single, spontaneous line, without fear of errors—is rewarded with a quick, dynamic sketch like the one shown here. Generally, in interiors where many figures are involved, there is continuous movement, which requires working with quick, confident lines and without hesitation; the objective is to capture that movement and to resolve the scene in a few minutes, because there is a good chance that the figures will move, or change places or positions.

1. We practice making lines with a sepia-colored chalk. First, we indicate the location of the columns and establish the position of some of the figures with lighter lines.

3. Keep in mind: The farther away a figure is, the lighter and less defined its outline will be.

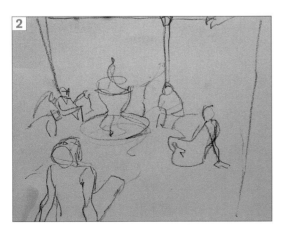

2. The central table with the vase and each of the figures are resolved with a single intertwined line, barely lifting the lead off the paper.

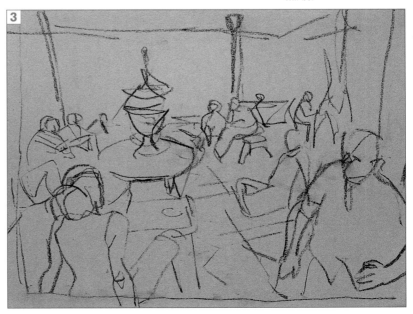

Continuous line with charcoal, chalk, or pastel

In the same way we make gestural drawings with lines, we can use a charcoal stick, chalk, or pastel. For this type of shading, it is not a good idea to use the entire stick. Rather, you should break it off to make thinner lines of a width that feels more comfortable to your hand, allowing it to move more freely. Then, try a few lines on white paper to see how changing the angle of the stick changes the width of the line.

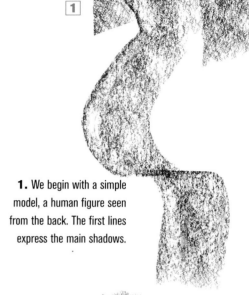

1

1. We begin with a simple model, a human figure seen from the back. The first lines express the main shadows.

■ As we rotate the stick to a more upright position, the line gets thinner.

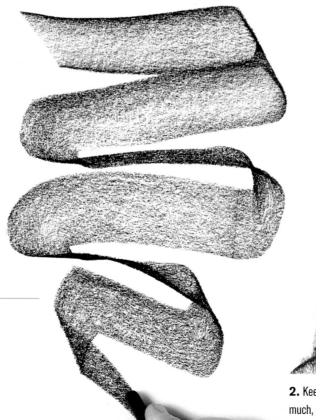

2

■ Next, we will attempt a line that is as long as possible by changing the position of the stick and varying the pressure. When we rotate the stick we change the width of the line.

2. Keeping the stick flat on the paper without lifting it much, and alternating the angles, we finish drawing the head and the profile.

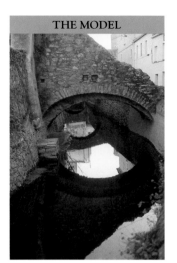

THE MODEL

◼ The greater the pressure, the more intense the line will be.

◼ Light reflects on the water of a canal, while the bridges above offer a shadowy contrast.

Shading is also drawing

Greater control of the charcoal, chalk, or pastel stick will help you achieve much more effective shading. Shading is not just a coloring effect; it can contribute to the modeling of the form as well, outlining the subject by using marked contrast. Individual lines or strokes may even be unnecessary. In this exercise, you should focus on the direction of the shading, as well as the pressure applied on the stick, to intensify the shading in some areas of the drawing.

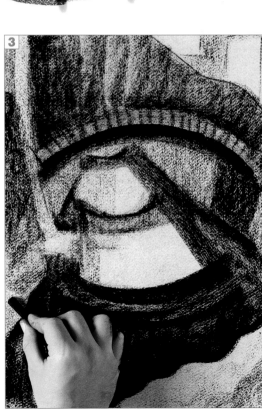

◼ Make sure to watch the direction of the line at every step, to define the surface of the object accurately.

1

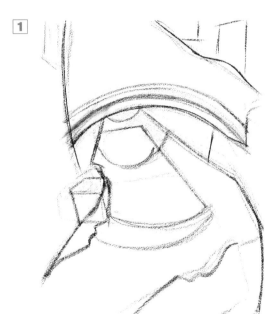

1. With the tip of the charcoal stick, we define the main forms without paying attention to any of the details.

2. The first shading is very homogenous. If the paper has a little bit of texture, the result is even more attractive.

3. The intensity of the shading depends on how much pressure is applied on the paper.

2

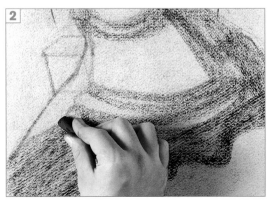

3

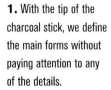

Creative composition

Composition is the arrangement of objects in a painting or drawing. It is a simple scheme showing where different masses and visual forces meet. Composition requires a certain skill on the part of the artist, who must learn to lay out the different elements on the paper or canvas in an appropriate and creative manner, optimizing the dynamic relationship between them, so that the final result is harmonious and pleasing to the eye.

Compositional skills

Composition is a skill that is based largely on intuition, but it can be developed with practice and experimentation. Working with preliminary sketches, artists select and organize the forms, evaluating all the visual possibilities to find the most appealing and effective. It is very important to practice this approach, because a good composition is a key factor to the success of the painting or drawing.

■ You can practice creating dynamic compositions with a few cardboard cutouts lightly covered with color. Keep moving the objects on the surface of the paper until you find the most convincing layout.

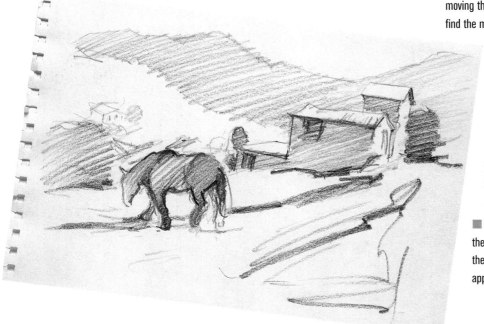

■ A simple diagram will help us evaluate the layout of the main elements. The masses are balanced because they have different intensities, which is why the horse appears to be a darker gray.

Symmetry, asymmetry, and originality

Which compositions draw people's attention the most? It's proven that, to be able to surprise, the artist must avoid the principles of symmetry, refraining from excessive order and regularity. Asymmetry offers greater compositional freedom; it is much more intuitive because it is our natural way of seeing the world. To explore this idea, let's look at several examples.

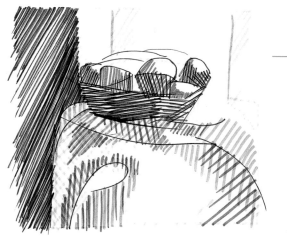

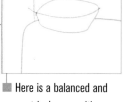

■ Here is a balanced and symmetrical composition. Everything looks too centered and static. We try to break the excessive symmetry with the dark band on the side.

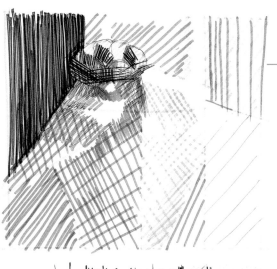

■ We create a compositional pyramid with the table and the tablecloth, and we place the basket at its tip. This way, we create a composition in which the diagonal lines direct our attention to the top.

■ This is an asymmetric composition. This time, the fruit bowl has been moved to the right. Despite the apparent disarray, everything maintains perfect balance.

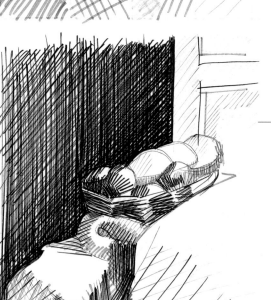

■ This is centered and unified composition. However, to give it more interest, we have angled the basket, forming a diagonal and making one half darker and the other lighter.

Drawing with a blending stick

THE MODEL

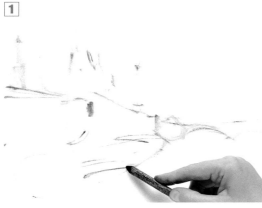

■ We will transform an architectural model, complex in appearance, into a simple drawing by creating areas of shaded tones with a blending stick.

The blending stick is a drawing tool that is used to go over the marks made with charcoal, chalk, or pastels, as a way to blend or reduce their tone. However, blending sticks can also be used for drawing. The result is a drawing characterized by medium tones, with no sudden tonal changes, very pictorial in nature and free of unnecessary details. To draw with a blending stick, cover the tip thoroughly with pigment powder and shade by simply rubbing it on the surface of the paper.

1

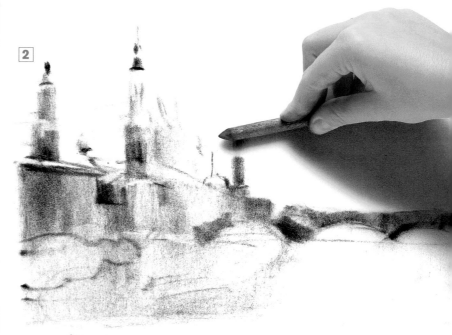

2

1. We draw the main lines with the blending stick charged with pigment. The lines are soft and tentative and reveal the shape of the building.

2. Again, with the tip charged with charcoal, we add the first layer of tones. We angle the tip and rotate the stick to make sure that all the pigment is transferred onto the paper.

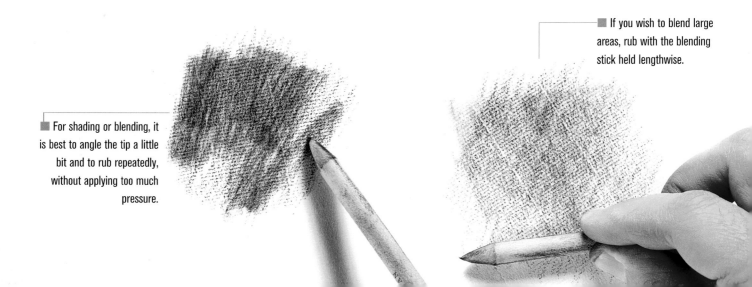

■ For shading or blending, it is best to angle the tip a little bit and to rub repeatedly, without applying too much pressure.

■ If you wish to blend large areas, rub with the blending stick held lengthwise.

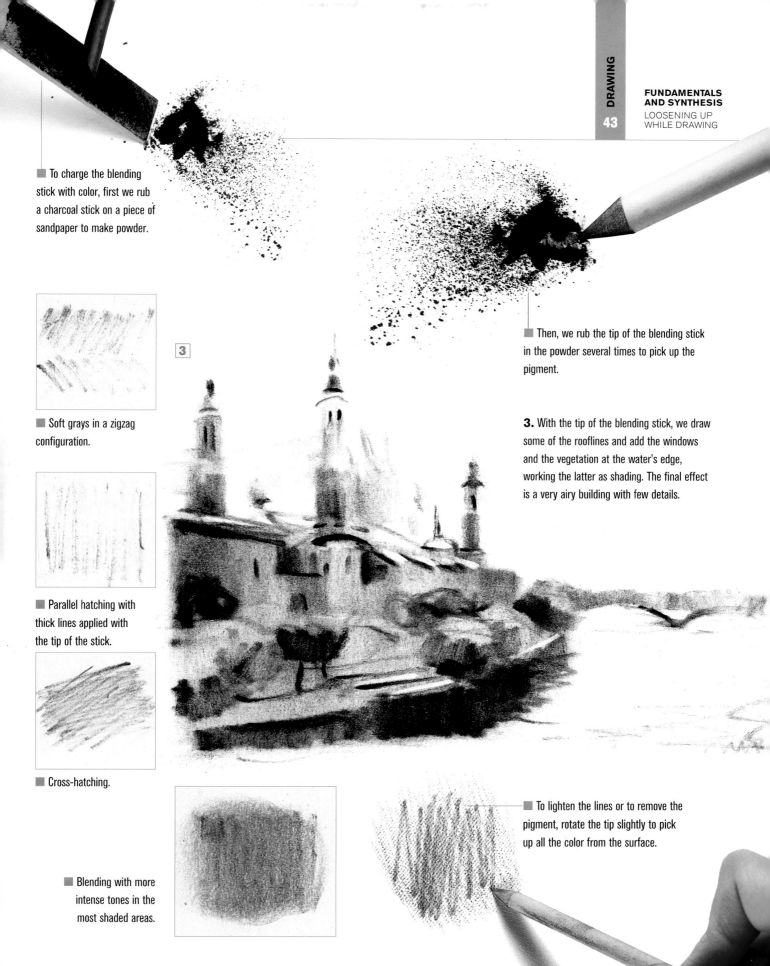

■ To charge the blending stick with color, first we rub a charcoal stick on a piece of sandpaper to make powder.

③

■ Soft grays in a zigzag configuration.

■ Parallel hatching with thick lines applied with the tip of the stick.

■ Cross-hatching.

■ Blending with more intense tones in the most shaded areas.

■ Then, we rub the tip of the blending stick in the powder several times to pick up the pigment.

3. With the tip of the blending stick, we draw some of the rooflines and add the windows and the vegetation at the water's edge, working the latter as shading. The final effect is a very airy building with few details.

■ To lighten the lines or to remove the pigment, rotate the tip slightly to pick up all the color from the surface.

INCORPORATING WASHES

*J*ust *as graphite pencils are used to make thin lines, washes applied with a brush are used to add shadows, to define the model, and to create contrast. Therefore, washes complement many line drawing techniques. Including them in a drawing makes it more realistic by adding light and shadow, and better representing the model. Washes also give the drawing new light and chromatic qualities.*

Once you learn and experiment with the possibilities afforded by this wet medium, it is much easier to transition to complex techniques involving paint and color.

■ Théodore Caruelle d'Aligny (1798–1871), *View of a River's Edge.* Washes establish light and shadows and contrast the different planes of a drawing made with a reed pen.

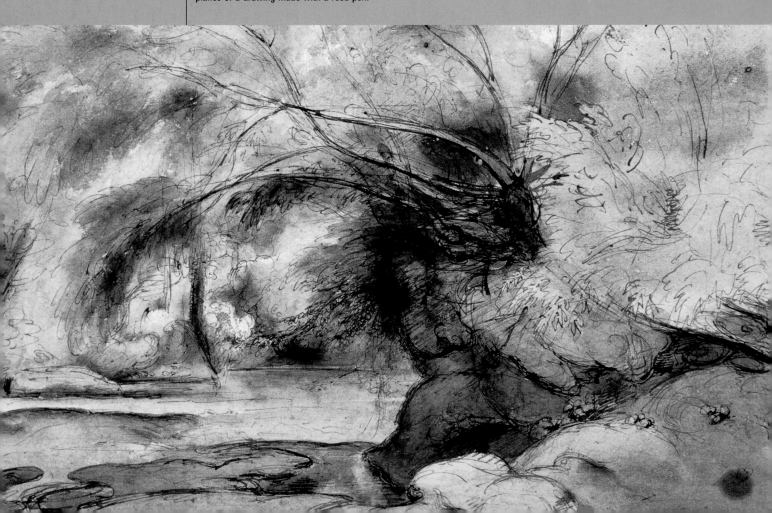

White paper is used for drawing with washes, and values are added gradually, beginning with the lighter shading and ending with the darkest contrasts.

The key to washes

The key to a good wash technique resides in proper planning of the distribution of light in the drawing. It is important to decide which areas of the paper will be left exposed and the number of tones that will be used; the success of the wash depends on meticulous attention to shading, so the drawing shows appropriate lighting with enough contrasts. Luckily, waiting for an application to dry before a new layer is applied forces the artist to work cautiously and slowly, increasing the tonal intensity of each area only after careful consideration.

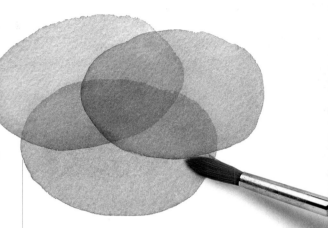

■ The brightest areas in a piece, which are represented by the white of the paper, should be designated from the beginning.

■ Different tones are achieved by accumulation, by superimposing one wash over the other after each layer has dried.

Layering

The wash technique is based on layering translucent applications of color. First, the lightest and most transparent layers are applied, adding one over the other until the darkest tones are achieved. It is important to work slowly and test each color beforehand on a piece of scrap paper. It is difficult to reduce the intensity of a color once it has been applied on the drawing, so avoid excess pigment at all times. Applying cumulative color glazes, gradually darker but always transparent, gives the shadows a velvety effect.

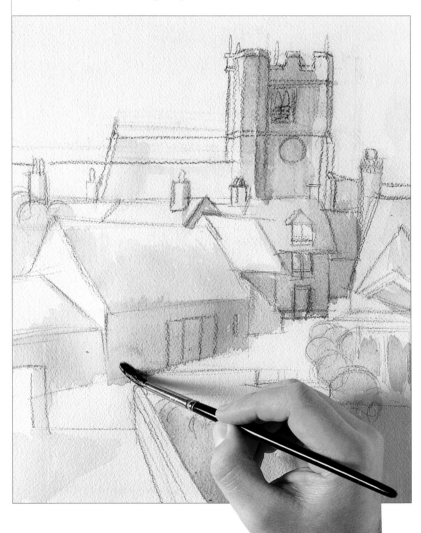

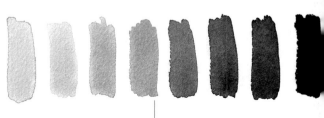

■ The more water you add to a color, the softer and more transparent the wash will be.

Let the water flow

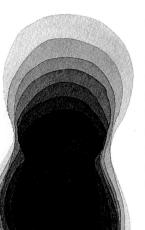

Working with only one or two colors is the best approach for understanding how to mix color with water, and the different degrees of intensity that can be created. White paint does not exist in washes; instead the paper is left exposed in certain areas. Lighter colors are obtained by diluting the paint with plenty of water, making it almost transparent; this way, the white of the paper shows through, giving the wash a bright effect. It is not a good idea to begin painting a wash with dark tones, especially if you have no experience. Since the white color in washes is the paper itself, the way to balance it and to create contrasts is by gradually darkening the colors around it.

■ With washes, dripping should not be viewed as a mistake but rather as an expressive resource.

■ Practice with washes by doing an exercise like this, which shows a scale of grays made by laying one wash over the other until the dark black in the center is achieved.

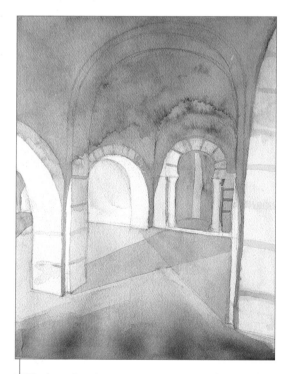

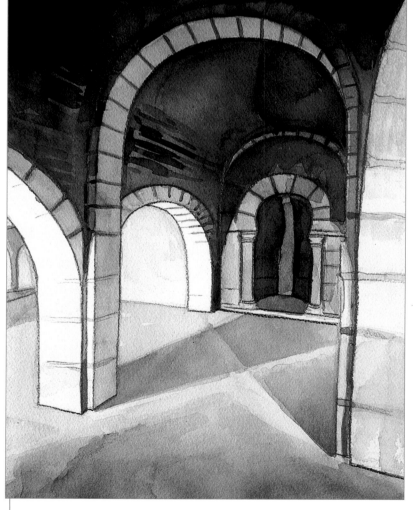

■ The first color values should be very light. The white of the paper can be seen through the transparent washes.

■ After the previously applied washes have dried, we lay over new washes, creating a clear contrast with the lighter areas.

Spreading the wash

A very common practice with washes is to apply a dark color, then—after washing the brush, recharging it with clean water, and ridding the tip of excess water—extending the color by passing the brush over it to obtain a gradation, letting the water flow. The more the color is spread, the lighter the gradation will become and the smoother the transition from darks to lights will be.

Playing with colors

Now that we've reviewed the basic principles of washes, we will attempt to make a drawing exclusively with color washes. We won't worry if there is some splashing or if the colors mix spontaneously on the wet paper; these effects are outside of our control, and they often add interest to the drawing.

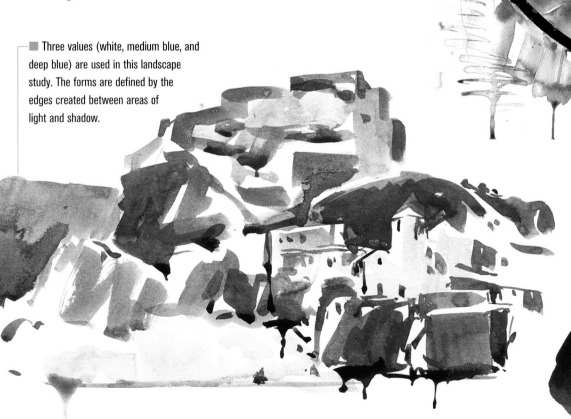

■ Three values (white, medium blue, and deep blue) are used in this landscape study. The forms are defined by the edges created between areas of light and shadow.

■ You can alter the effect by tipping the support to let the wash run, forming droplets that add character to the piece.

■ To create strong tonal contrasts, we recommend using colored inks because they produce more intense colors than watercolors.

Drawing with brushes

Brushes can also help create interesting line drawings that have a strong gestural and expressive quality. With the brush charged with paint and plenty of water, we sketch the model quickly, barely lifting the tip from the paper; we let the brush discharge all the color on it, describing the model with an exaggerated stroke that lacks precision but is full of emotion. Our job is not to explain the model in detail, but rather to convey its essence or a specific state of mind with passion, using ample gestural brushstrokes.

Modulated lines

Modulated lines show subtle changes in the width and intensity of the stroke; the goal is to convey the fragility or precision of the forms that we are drawing.

■ The variety of shapes you can create with ink applied with a brush make this an ideal medium for gestural drawings.

■ Drawing with a brush allows us to study the form and contours of the model and to emphasize the rhythmic aspect of the line.

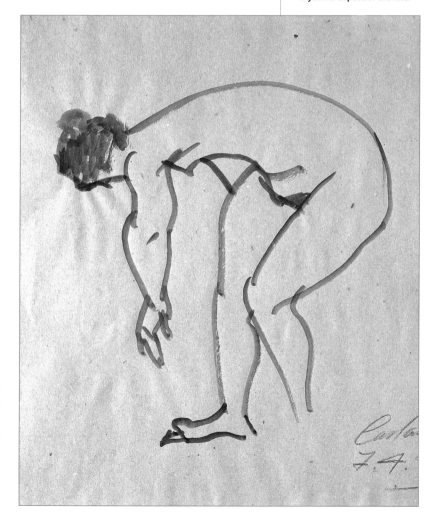

Drawings done with a brush feature wide, whimsical lines that are the result of quick movements of the artist's forearm; the objective is to express the subject with rhythmic, dynamic lines.

DRAWING WITH INK

The most common medium for line drawing with a brush is India ink or sepia. The former is made from soot dissolved in oil, gum Arabic, and agglutinant; the latter with an ink from the substance contained in the gland of the cuttlefish of the same name.

Gestural drawings

To create a gestural drawing, you must know how to make quick doodles to describe the contours of a form. The line produced with a round brush (the most appropriate for this kind of drawing) should be neither rigid nor uniform, but rather the opposite. The tip of the brush must respond to the movements of the hand: It should bend and angle when you want to make wider lines and caress the paper when you want to make thin, subtle lines.

■ In gestural drawings, the line should vary in width constantly to differentiate the light areas from the shaded ones.

■ The brush should glide smoothly. To achieve this, the hair of the brush should be lifted off the paper as little as possible.

■ To lend character to a wash, we will construct the drawing with small brushstrokes that give each area of color a broken, choppy aspect.

Wetting the lines

Sometimes, when the medium allows it, it is possible to add interest to a drawing by going over certain areas repeatedly with a wet brush and allowing the water to dislodge part of the pigment and spread it, forming a light wash. There are different drawing media (wax, pencils, pens, pastels, and markers) that are soluble in water and that can be used with watercolor techniques. Usually, the foundation of the drawing is done with traditional line techniques, using grisaille or hatching. Then, when the brush is passed over the lines, the wash blends the colors and softens the lines, toning down a multicolor piece.

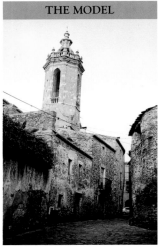

THE MODEL

A small rural street with shaded façades.

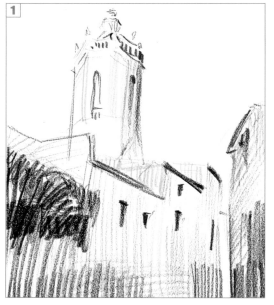

1. With just two watercolor pencils (yellow and black), we do a simple sketch shaded with hatch lines.

2. With the brush soaked in water, we dilute the lines to intensify and blend the areas of color.

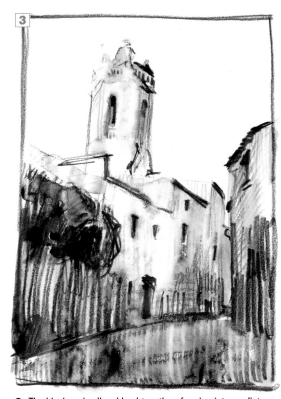

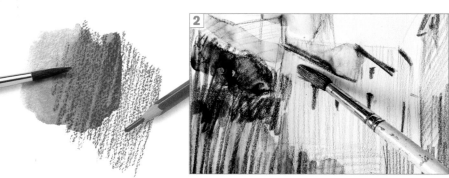

3. The black and yellow blend together, forming intermediate colors and creating transition areas between the two colors.

When lines have been drawn with soluble media, washes make it possible to blend them together and unify the color in each area.

DON'T OVER BLEND

It is not a good idea to blend the colors too much with a wet brush, to the point of losing the definition of the lines, as this will obscure the drawing technique.

Pens and markers

As with pencils or watercolor sticks, soluble ink markers and pens provide interesting washes when we use a brush charged with water. Once the drawing is finished, it is a good idea to work one area at a time, avoiding very heavy washes. It is best not to apply excess water when trying to extend the color. Using this approach, you prevent the line from looking too stiff and can take advantage of the ink that bleeds from the lines to apply color very quickly.

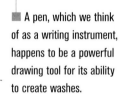

A pen, which we think of as a writing instrument, happens to be a powerful drawing tool for its ability to create washes.

THE MODEL

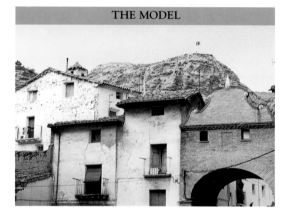

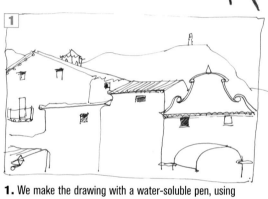

1. We make the drawing with a water-soluble pen, using simple, direct lines, without shading or hatching.

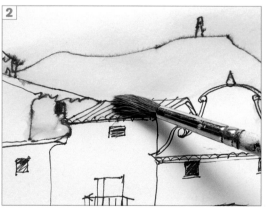

2. With a medium round brush charged with water, we go over the previous lines, creating soft washes for the shaded areas of the roofs.

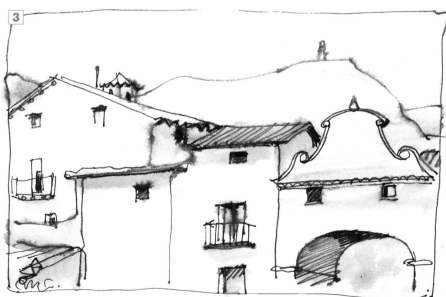

3. We have blended the lines on the mountains and on some of the shaded roofs; the other lines can be left untouched to create greater graphic diversity.

A few washes are enough

The subtlety of the wash makes it a very appropriate technique for atmospheric effects, where the line almost disappears and the scene is represented with various areas of color. Working with ink and watercolors, either in black or color, you can create subtle drawings and produce a wide range of shades. The wash is a very expressive medium that can contribute to an evocative drawing if we control the gradations and the amount of water in each wash.

Painting on wet paper

When we work on wet paper, the colors expand out of control and give the drawing a blurry look. The amount of water in the paper determines the appearance of the brushstrokes; the more water, the greater the color expansion will be. This technique produces a foggy, atmospheric effect, with lines and forms disappearing completely and colors blending together softly.

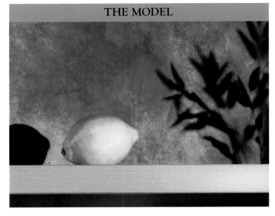

THE MODEL

■ A lemon on a shelf. The harmony is broken only by the presence of the shadows.

1. We make the initial drawing with a pencil. It is not difficult, given that the model is extremely simple.

2. We begin painting the lemon with areas of medium gray color applied around the edges. Then, we extend them across the wet paper.

■ If we paint a color on wet paper at different time intervals, waiting one minute each time, we will have better control of the bleeding effect.

■ Each wash should be applied with a single stroke, without stopping or waiting. If we apply it in several steps, it will appear broken and will have tonal changes.

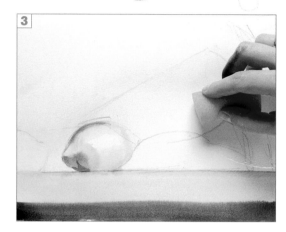

3. We paint the shelf with two parallel brushstrokes, one in soft gray and the other one darker. To make it easier to spread the water on the support, we wet the paper beforehand with a sponge.

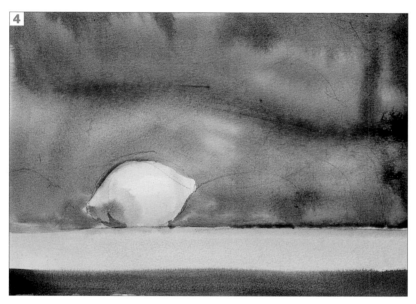

4. Since the background is wet, the gray wash does not look even but rather airy, full of different shades.

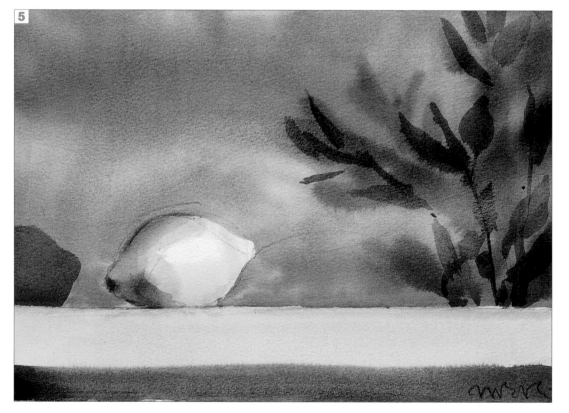

5. We use two washes for the shadows of the leaves. The first one is applied when the background is still wet, giving us a very diffused and ghostly-looking shadow. After letting it dry, we draw a second shadow above with more defined contours.

Landscape with blue washes

A wash can also be applied with watercolors. Here, we will paint a simple mountain landscape with ultramarine blue washes, since this is the most dominant color. It is not exactly a monochromatic exercise because, in addition to blue, we will incorporate two other colors (carmine and lemon yellow) that will help us get different shades of blue. Watercolors are subtler than ink, and with them you can create a much wider tonal range, making them a very suitable medium for monochromatic washes.

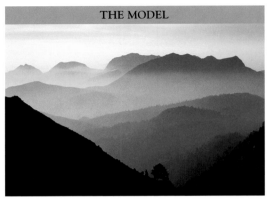

THE MODEL

■ The colors of the landscape and the light require a monochromatic approach, using washes and soft transitions between tones.

1. We make a drawing in pencil, which is extremely simple. With a touch of very diluted carmine and yellow, we apply a large wash that will cover the distant areas.

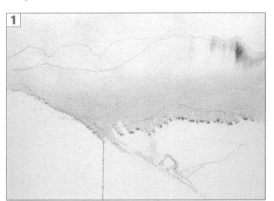

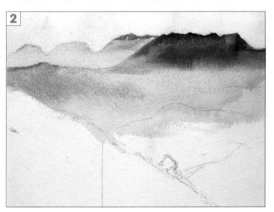

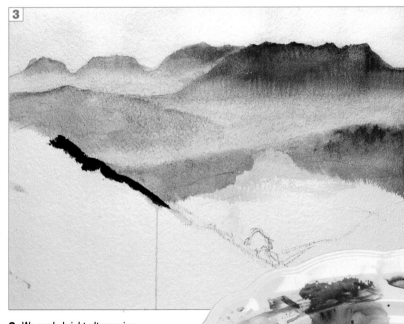

3. We apply bright ultramarine blue to the tops of the mountains. As we go down, we dilute it with a small amount of water until we reach the fog, where we add a very soft, almost imperceptible, touch of yellow.

2. With the paper still a little bit wet, we paint the outlines of the mountains in the distance with ultramarine blue diluted in water.

4. With the ultramarine blue and a touch of carmine, we apply a violet wash to represent the mountaintop that rises above the fog. On its base, we apply a small amount of yellow to the blue wash.

■ Blue is a recurring color in monochromatic washes.

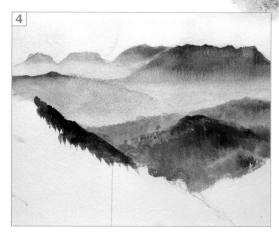

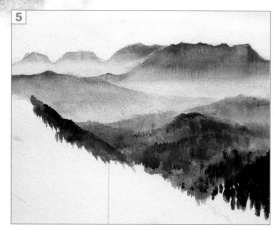

5. As we approach the vegetation that covers the nearby mountains, we gradually increase the carmine in the blue mixture. The paper is completely dry; therefore, the colors and forms are very well defined.

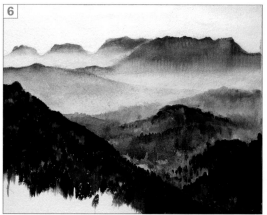

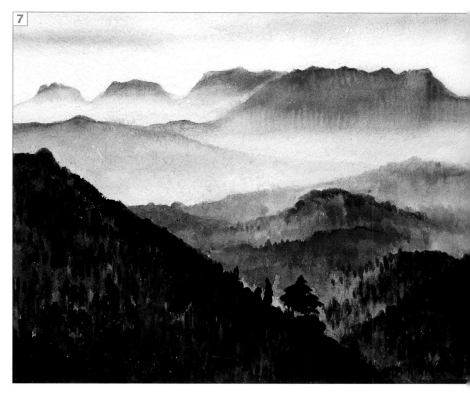

6. To represent the forest in the foreground, we apply brushstrokes with a vertical motion. The intensity of the brushstrokes, some blue and others purple, should vary.

■ A plate used by the artist as a palette to mix the colors.

7. In the finished exercise, the intensity of the washes increases as the mountains get closer. The mountains far in the distance are soft and have blurry contours.

Incorporating color

The hallmarks of drawing are line, shading, and a monochromatic look; however, we have seen that color can work quite well in drawings.

The colors in a drawing are not mixed on a palette but directly on the paper, which is why it is important to have an assortment of colors (to avoid excessive layering or muddy blends). Mixing and blending give good results only when just a few colors are included and when they are applied in very thin layers, without superimposing too many colors.

The beauty of a color drawing resides in the purity of the colors and their direct presence on the paper. In the following pages, we will study the most common coloring techniques and their application to drawing.

BETWEEN DRAWING AND PAINTING

*D*rawings that have many colors are commonly placed in a category between painting and drawing. Despite the fact that many of them are applied with rubbing techniques (like charcoal, chalk, colored pencils, or oil pastels), it is true that—because of the richness of color, blending effects, gradations, and color combinations—some drawings look more like paintings. In this chapter, we will explore that thin divide, looking at the chromatic and creative possibilities provided by color drawings, and what we can learn from them, before we tackle painting.

■ Óscar Sanchís, *Bouquet of Flowers*. Certain works done with pastels have a finish that resembles a painting.

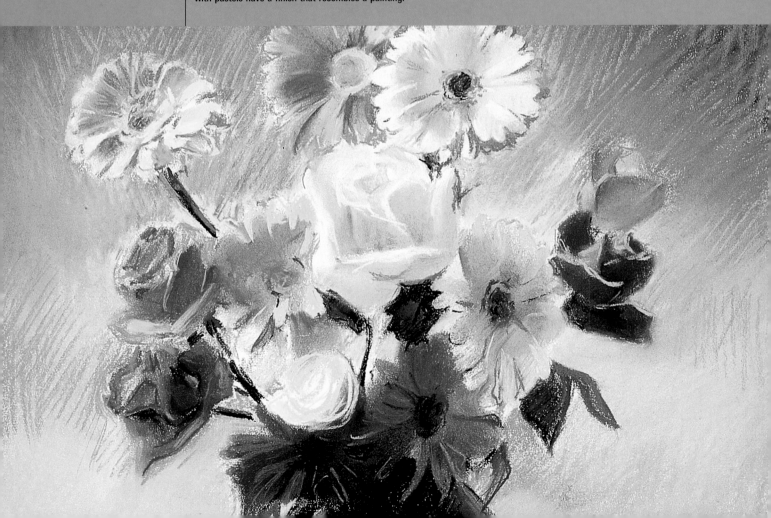

Our main goal is to experiment with the media, without worrying about whether the resulting piece should be considered a drawing or a painting.

Diluting colors

Using a wide range of colors makes a drawing look more like a painting, and dissolving the colors with any medium (water, alcohol, oil, or mineral spirits) intensifies the effect. Mixing dry techniques with wet techniques is not unusual in drawing; however, this takes on a different dimension when working with a large chromatic range. When colors are mixed with organic solvents like mineral spirits, they turn into a creamy substance that is easy to manipulate with a brush, which is reminiscent of painting.

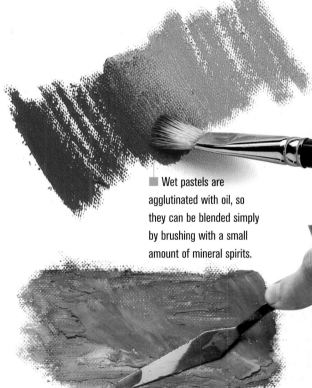

■ Wet pastels are agglutinated with oil, so they can be blended simply by brushing with a small amount of mineral spirits.

■ Oil pastels can be mixed with color washes. Since they repel water, the lines do not disappear; instead they look bright and expressive.

■ The creaminess that oil pastels acquire when they are warmed up makes them easier to apply with a spatula.

First, experiment

While it's useful to consider the thin line between drawing and painting and think about their limits, that should not condition our work. We should not avoid incorporating a specific effect into a drawing for fear that it may look like a painting. The main goal is to enjoy the process, adding color to the drawing by mixing and diluting if needed. What is important is to experiment and evaluate the results; we will decide later in which category the work falls.

Pastels: almost paint

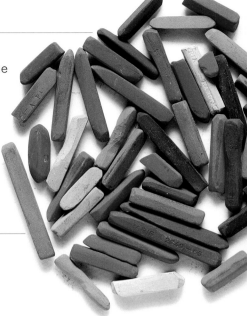

With dry pastels it is possible to draw and to paint at the same time, working the outline of the objects with firm, decisive lines and covering large areas with dense and opaque colors. Pastels are very malleable, and they can be manipulated and blended with great precision. The impact of the colored areas can be modified by adding layers or by blending them with your fingers to make subtle, painterly gradations.

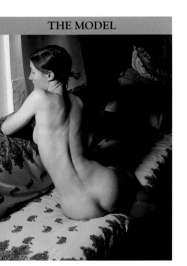

THE MODEL

■ A back view of a nude figure with a strong contrast between light and shadow.

■ It is a good idea to have an assortment of pastels; this way, you will avoid unnecessary blending and layering, which can affect the intensity of the colors.

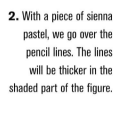

2. With a piece of sienna pastel, we go over the pencil lines. The lines will be thicker in the shaded part of the figure.

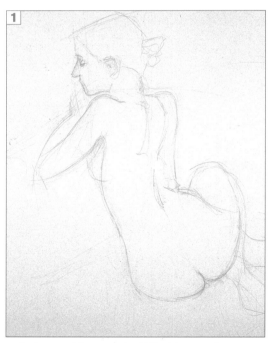

1. Back views of figures are less difficult because the limbs are mostly out of sight. We make a simple pencil drawing to give us a base.

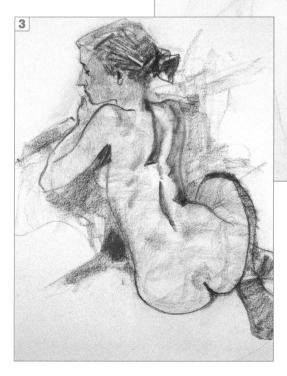

3. Once the contours are complete, we shade the skin with pink tones. With a small amount of yellow, we add warmth to the upper back.

Drawing with pastels

The best way to work with pastels is the same as with charcoal or chalk: by alternating the point and the side of the bar to apply shading. Because the color applied with each stroke covers more than the other two media, however, the line does not need to show intention. In other words, it is not important to show direction when we drag the pastel bar; it is sufficient to cover an area with color. We do this by passing the bar repeatedly over the same area with a circular or up-and-down motion.

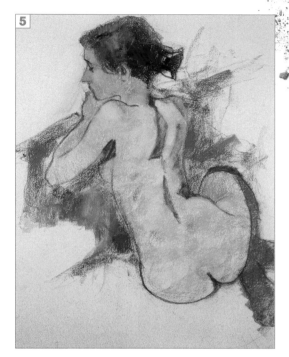

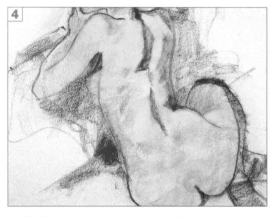

4. We fill in the skin of the model mainly by superimposing pink and orange shades. With a yellow-orange, we apply more pressure to the areas that catch more light.

■ If we rub the pastel bar vigorously over an area that has already been colored, the color beneath will be covered almost completely.

■ If we rub the pastel repeatedly, the color thickens and covers the grain of the paper completely.

5. We resolve the hair by layering browns and blending them slightly with our fingertips. To make the body stand out, we darken the sofa with a range of blues and violets.

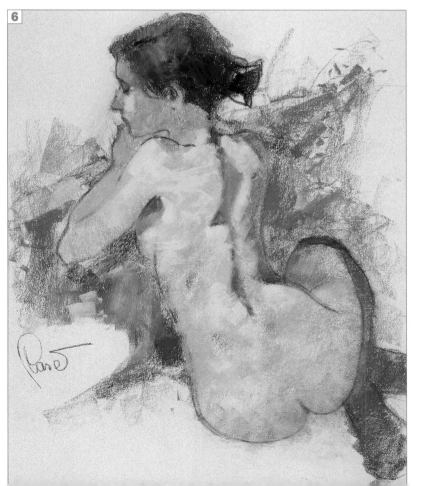

6. In the final stage the colors look a little more blended, but the non-blended layers and the initial sienna that outlines the figure are still apparent.

Oil pastels: washes and sgraffito

THE MODEL

■ Houses and roofs viewed from above offer many possibilities if we understand that we should begin by synthesizing the scene.

PHASE 1:
A COLOR PUZZLE

2. We lay out geometric shapes of pink, brown, and ochre that represent the façades and the roofs. It is not necessary to be precise; there's room for imprecision and spontaneity.

Here is an exercise with oil pastels, a clear example where drawing crosses over to painting. This medium is not as opaque as dry pastels and cannot be blended with the fingers; to blend oil pastels you need to use essence of turpentine or mineral spirits. The lines made with oil pastels are waxy, and if diluted with a brush, the drawings will look more like oil paintings than drawings done with dry pastels.

1. Working on black cardboard, we prepare the background with a heavy layer of white pastel. As you can see, the color does not cover the paper completely.

3. Little by little, the colors cover the initial background, filling up the empty spaces as in a puzzle. Be sure to press on the stick with force for the color to adhere properly.

Oil pastels can be worked dry; however, to take full advantage of their possibilities, use them in combination with wet techniques involving mineral spirits.

PHASE 2:
BLENDING, SGRAFFITO, AND DILUTING

4. Once the roofs and the façades have been resolved using synthesis, we blend some areas with our fingers to create gradations. It is a good idea to press hard because wax is not easy to blend.

5. Now we try to recover the line by scratching the surface covered with oil pastel with a wood stick. These sgraffito, or incisions, will define the profiles of the closest buildings, as well as their most prominent architectural features: doors, windows, and galleries.

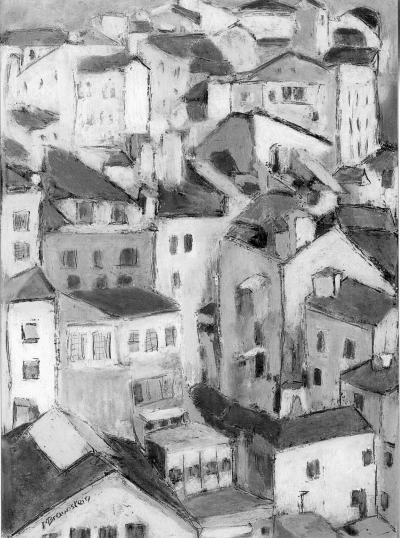

6. We will modify a few colors as well as any sgraffito mistakes using a brush charged with mineral spirits. After passing the brush over the oil pastel, it blends like oil paint.

7. We leave for the end any sgraffito details or color touch-ups with pastels on some of the roofs. The finished drawing is reminiscent of an oil painting.

Collage: Color in pieces

Drawing with any dry or wet technique on a collage base—that is, a support where different colored papers have been pasted—produces very good results. Collage makes it possible to incorporate color with media that are commonly used for monochromatic drawing (charcoal, inks, chalk, and markers). In addition, it is a good abstraction and synthesis exercise for any beginner, since the glued colored papers define the planes and indicate the main forms.

Composing with collage

Cutting and gluing colored papers on a support is a challenging exercise; you must learn how to synthesize the elements of a model into a few paper cutouts. This exercise requires thinking carefully, interpreting the way in which we perceive the figure. Composition takes place during this phase, as we move and paste all the papers in the places that we consider most appropriate. Then, we simply draw over them.

■ The drawing is developed on a color background that complements the lines and enhances the graphic interest of the drawing.

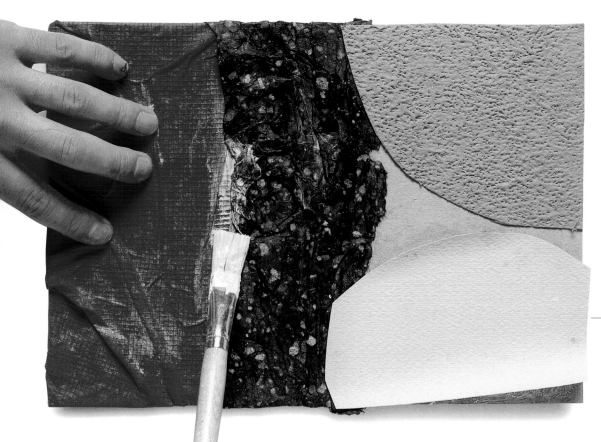

Collage is a good way to add color to your drawings and to stimulate your creativity.

■ Before you draw, glue the colored papers to the support. Once the glue is dry, you can begin to work.

A modern technique

Working over a base of collage enhances the expressive possibilities of drawing, and the contrast between the line and the background gives the work a very interesting finish. From its origins at the beginning of the twentieth century, collage has been a favorite of contemporary artists for the endless color combinations that it provides, its simplicity, and its expressive possibilities. It is a good format for drawing in an uninhibited way, without set rules.

■ It is a good idea to have colored papers handy because they are very useful for drawing and making cutouts for collage.

■ After laying down the first color impressions with collage, we finish the drawing with a few lines in India ink.

THE MODEL

■ Colorist still lifes are very appropriate for collage.

1. A view of the support before we begin to draw. We have laid out the main areas of the model by gluing down colored papers.

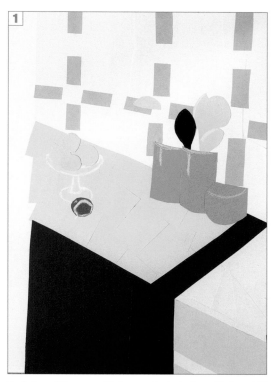

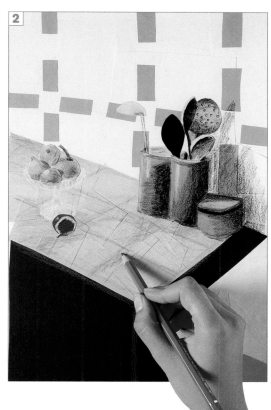

2. Using a pencil, we will turn the pieces of paper into objects, shaping them, giving them volume, and shading them until they have a convincing appearance.

Originality in drawing

When beginners learn to draw, they try to stay as close to reality as possible; this is understandable, because their main goal is to learn the technique. They mimic reality because they have not yet developed a sense of interpretation. In time, as they acquire more experience and their technique improves, they cease to be beginners, and the need to personalize their drawings—to instil in them part of their personality, their character—emerges. At this point, artists wish to make their approach recognizable and to be known through their work. This instinct to personalize their work distances them from academic representations, prompting them to discover approaches and languages of their own. Down the line, the goal of every artist is precisely that—to create a particular, personal, and unique style.

INTERPRETING
IS PERSONALIZING

Interpretation is the personal way in which every artist develops his or her own artistic intention. It is related to the style and imagination of the artist, and it is essential to give the work authentic interest and to awaken the viewer's curiosity.

■ Experienced artists learn to apply greater sensuality to the line, to play in a subtle and imaginative way, as in this floral representation.

■ Once we have technical mastery of the stroke, we can play more with the sinuosity and curvature of the line.

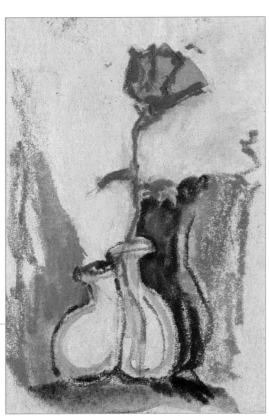

■ We instill character in the line to create a more personal interpretation of the object.

A piece of work is original when it has internal vitality,
when the representation is as convincing as a real object
but is not reduced to a cold copy of reality.

The keys to creativity

Let's look at the basic keys to producing an original and creative drawing. One of them is mastery of the line. In addition to defining contours, it establishes a sense of direction and vital impulse; it creates tension and reactions, a certain special rhythmic cadence in the model. Another is the free interpretation of form and color. We can transform or modify the representation of a real model by altering shapes or colors to achieve an interpretation that is more original and that has greater impact. This free approach must be based on stylistic motives and have visual value; it should enhance the interest of the drawing and be taken as an expressive resource, not as a result of the artist's clumsiness.

■ This drawing encompasses many of the keys to creativity. It shows a particular use of color, a rhythmic and confident line, and a certain degree of distortion.

■ Originality has to do with a very personalized selection of colors, which should not resemble those of the real model.

■ The best way to find your own personal style is to experiment with different interpretations of simple objects until you discover the one that moves you the most.

FULL COLOR

Color, more than any other aspect of artistic endeavor, is not usually subject to rules and laws. Frequently, the inspiration of the moment gives us an unsuspected solution, one that was not foreseen and that improves the work. The generous use of color in a drawing makes a powerful design statement and contributes to the viewer's understanding of the drawing's structure and form. Therefore, the effective application of color is fundamental to finding the path to interpretation. Appropriate use of color provides a distinctive character and background to any theme. In the following pages, we will learn how to harmonize colors, how to dilute them by mixing them with water, and how to achieve the most vivid contrasts.

■ Odilon Redon (1840–1916), *Profile of a Woman with a Pink Veil.*
The drawn lines of this pastel are almost imperceptible; color
contrasts are what make it possible to distinguish the forms
and the profile of the figure.

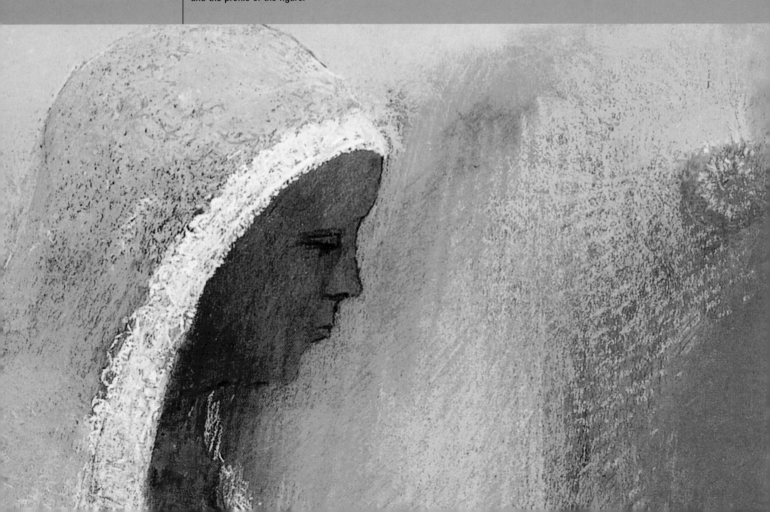

*Color can be used to suggest and highlight the character
of a drawing or painting, as well as to create an emotional
response in the mind of the viewer.*

COLOR IS COMPOSITION

The application of color in a drawing is not merely
decorative. Colors play an important role in the
composition. The contrast provided by different
chromatic ranges and the degree of color saturation
establish the drawing's focal point and its spatial
limits.

Playing with colors

Looking at the multitude of color possibilities,
it is obvious that there are many ways of
achieving chromatic effects. While it's important
to be familiar with the most common color
combinations, it has been proven that contrasts
between bright, brilliant, saturated colors are
what catches the viewer's attention most.

Bright color treatments allow us to distance
ourselves from the standard representation of
the model to concentrate on an emotional and
compelling vision. The brightest results are
achieved by contrasting complementary
colors—that is, the colors that are most distant
from each other on the color wheel: orange and
blue, violet and yellow, green and magenta. With
a simple circular display of all the colors, we can
best see their contrasts and affinities.

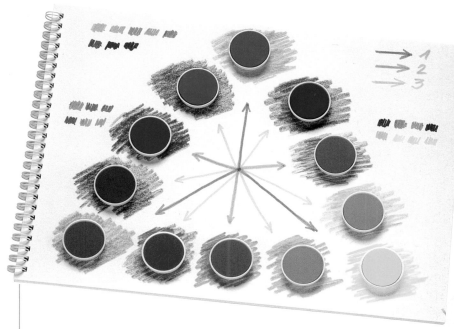

■ Make a color wheel, laying out all the colors of the spectrum in an organized fashion to study
their affinities and contrasts.

■ Markers make it possible
to combine in a single
drawing bright, saturated
colors and dynamic,
expressive lines.

■ Maurice Chapas (1862–1947), *Toward the Light.* The colors in
this work were applied with quick washes. The lines of India ink
outline the masses of color and give them meaning and form.

Broken color: colored pencils

To create a successful original piece, we must learn to apply and mix the colors on the drawing using different methods and techniques. For example, instead of covering large areas of the drawing with a single color, we use small, juxtaposed touches of various colors to achieve a great richness of shades and an interesting atmospheric effect. This technique is very appropriate if we want to color a pencil line drawing to obtain soft transitions between light and shadow, without big contrasts.

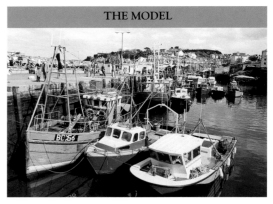

THE MODEL

■ This seascape with anchored boats is a model rich in colors and shading, very appropriate for working with colored pencils.

PHASE 1:
DEFINING THE FORMS

1. We begin the line drawing with a brown pencil. We outline the main forms of the boats as a guideline to follow.

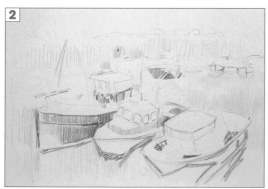

2. Though the first drawing is light, with the application of red and blue lines the boats begin to emerge.

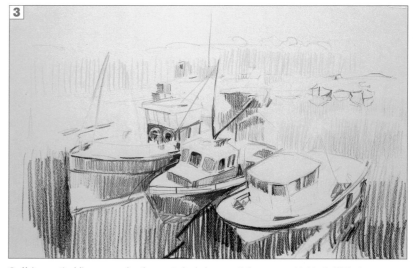

3. Using vertical lines, we color the most shaded areas of the water with black. With the same black pencil and a blue one, we continue drawing the boats.

This technique, also known as hatching, was done in the past with a reed pen. The Impressionist painter Edgar Degas used it regularly in his pastel drawings.

CREATING UNITY WITH LINES

To create unity and avoid sudden changes between colors, we must draw an orderly succession of more or less similar lines, in a vertical or diagonal direction.

Optical mixtures

If we apply colors with short, juxtaposed lines, the eye will mix them. The basic principle is that any color has an influence on its adjacent colors, creating a visual effect where the eye blends them together. Therefore, an area that has a mixture of blue and yellow lines is perceived as green. Optical mixtures produce better results than blending and mixing colors with the fingers, because the pigments do not cover each other and the purity of the colors is not lost.

PHASE 2:
JUXTAPOSING COLORS

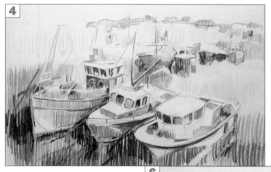

4. Now, yellow and orange come into play, which we superimpose on the black of the water with vertical lines. We distribute them over the entire surface of the paper, because these colors provide unity and continuity to the scene.

5. We apply each new color with vertical lines, except for the water in the background; there, the vertical lines are combined with horizontal blue lines. This change in direction allows us to show the reflections on the surface of the water.

6. With this technique, the surface of the drawing takes on a very distinctive look. The accumulation of lines modifies the perception of the colors, creating subtle optical mixtures that resemble those of Impressionist paintings.

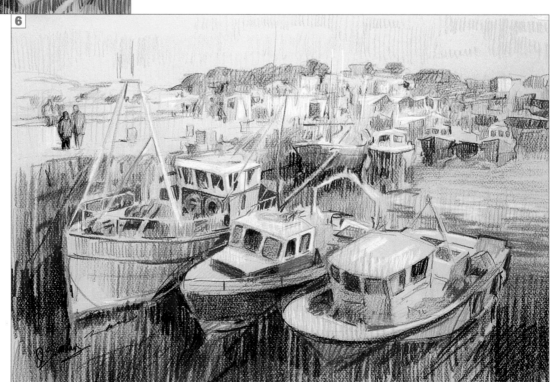

Color washes: watercolor pencils

Watercolor pencils provide many more possibilities than traditional ones because you can draw lines with them as well as mix them with water to obtain a more fluid, painterly finish. If we brush over them with a generous amount of water, the colors will not blend completely; instead, they will create a wash while the pencil lines will remain visible, providing an interesting texture of line and color.

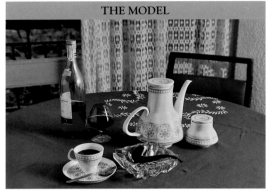

THE MODEL

■ The still life, a basic model for many artists, will be the subject of our work with colored pencils.

PHASE 1:
COLOR
SHADOWS

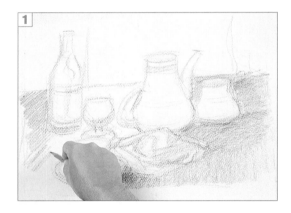

1. With a blue pencil we make a drawing of the still life, without paying too much attention to the details. Immediately after, we color the tablecloth with a green pencil.

■ When we add water to the pencil lines, they turn into watercolors, which can then be mixed with adjacent colors.

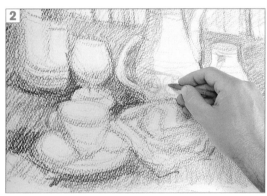

2. We shade the darkest areas with a bright blue. It is a good idea to work with the tip of the pencil held at an angle to avoid lines that are too prominent. Using a brown pencil we draw the decorative patterns on the coffeepot.

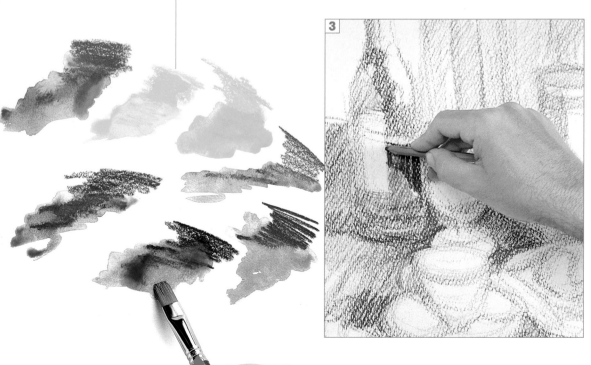

3. We complete the volumes of the objects by alternating brown and gray, beginning with the bottle. The colors begin to blend together with the effect of the overlaid grays.

■ The pencils that we are using are water soluble, so their lines can be easily diluted with the brush.

PHASE 2:

INTENSIFYING AND WATERCOLORING

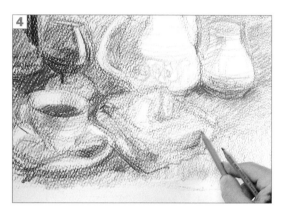

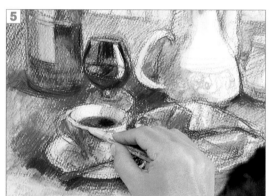

5. When we've finished coloring with pencils, we go over it with a brush soaked in water. The objects should be brushed only once, but the tablecloth can be worked in more detail. Once dry, we can recover some white areas with white wax.

4. We return to green to intensify the color of the tablecloth and to complete the forms of the objects. It is important not to hurry; the volumes of the elements should emerge slowly, without great contrasts.

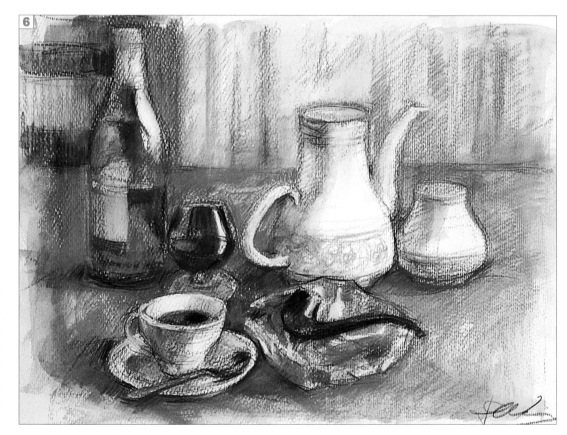

6. When we watercolor the pencil lines, the colors intensify. Despite the washes, the line always remains visible underneath; this makes the drawing very appealing and gives it an interesting three-dimensional effect.

Drawing with three colors of chalk

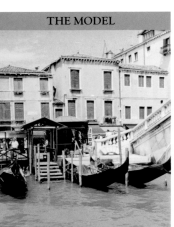

Today there is a wide range of chalks, but traditionally only three colors are used: black or sepia brown for creating shadows, sanguine for intermediate tones and for adding warmth, and white for adding light. These three colors harmonize and combine very well with each other. This technique, known as "three colors," combines the three different colors of chalk and accurately depicts the dark and medium tones and highlights. Colored paper should be used with this technique to create a more striking effect.

■ Sanguine, sepia, black, and white chalk provide great tonal range.

■ This scene is dominated by brown colors, very appropriate for working in three colors with chalk.

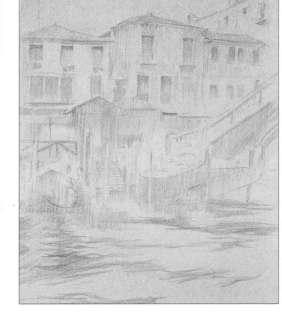

1. We begin drawing in three colors with a study of the intermediate tones in sanguine. We simply apply soft shading, reserving the color of the paper for the lightest areas.

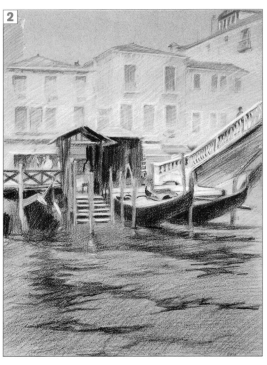

2. We complete the drawing by superimposing the most intense shading with sepia chalk and drawing highlights with white chalk. This way, the tonal range increases as we add contrast to the forms.

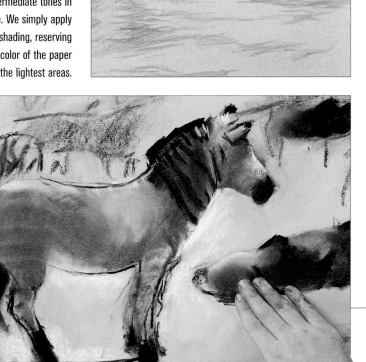

■ Artists normally use their fingers to shade with white chalk. However, a blending stick can be used if you feel that some details are hard to do with your fingers.

Drawings done with the "three color" chalk technique look very convincing in terms of volume effect and color and can easily stand against any work created with a more extensive color palette.

Grouping tones together

Working with three colors does not mean that you need to use an extensive range of tones to represent a subject. Although the model may have different color nuances, they should be grouped according to their similarities into three categories: light, intermediate, and dark. Once this is established, each tone will be assigned a color equivalent (sepia for darks, sanguine for the medium tones, and the color of the paper for the lightest). As we blend colors with our fingers and add highlights with white chalk, we will obtain a greater tonal variety than we had at the beginning of the exercise.

WHITE HIGHLIGHTS

White chalk is an interesting resource for adding highlights to a drawing executed with dark chalk on colored paper. The white is used wherever the most light is found. The highlights make the intensity of the shadows stand out by contrast.

1. It is a good idea to work with only a few tones at the beginning. Chalks mix very well and can provide very soft blends and gradations.

■ Black, sepia, white, and sanguine chalks have similar tones and harmonize well.

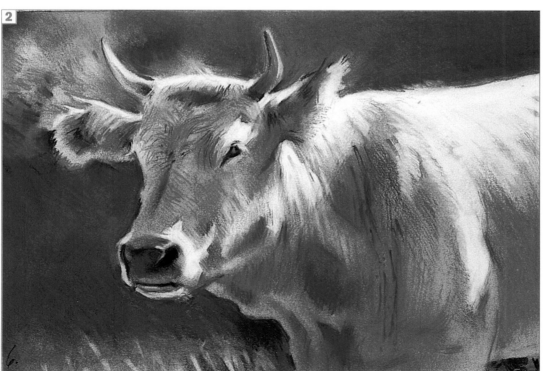

2. Although the range of colors is limited, we have blended sepia chalk with sanguine, resulting in a rich variety of intermediate tones. We have left the highlights until the end so that they will give a greater texturural effect to the hair.

Distorted drawing with oil pastels

Oil pastels are not as opaque as dry pastels. You should plan your drawing in such a way that the lines blend together with the pressure applied to the stick and not with the tips of the fingers; the colors will be overlaid on top of each other like a thick paste. The downside is that light colors cannot be applied over dark colors. Each oil pastel color provides different degrees of transparency. It is worth checking beforehand which colors are more transparent and which are more opaque.

You can draw a wide variety of lines with oil pastels. The richest and heaviest textures are obtained by vigorously rubbing the small stick on the surface of the paper, covering the color of the support almost completely.

Limitations of wax

Wax media have certain intrinsic limitations. Even though they are suitable for working with tight, opaque lines, they present some difficulty with blending and gradations. Another considerable drawback is their limited adhesiveness to certain papers and to other layers of color. The first problem can be solved by avoiding shiny papers or ones that have too much texture, the most appropriate being medium-grain papers; the second by applying a fixative spray to the layer of color so it can withstand a new layer of color applied over it.

■ Oil pastel sticks are softer, stronger, and less brittle than dry pastels because they have an oily agglutinant.

■ Drawing on a heavily textured paper has its own appeal if we work the wax like an impasto; to do this it is important to press hard on the crayon.

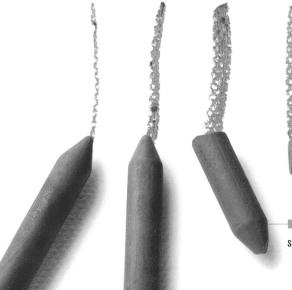

■ The position and angle of the stick with respect to the support determine the nature of the line.

Emphasizing the curves

We are going to draw an urban scene that is somewhat distorted; this requires careful consideration of the real model before altering the appearance of the buildings and their proportions, exaggerating the curvature of the lines to create tension and a greater dynamic effect. We will achieve all of this with a selection of saturated colors that do not resemble the colors of the real subject. The medium we will use is oil pastels and wax, which have great chromatic potential and produce a thick line that lends great dynamism to the drawing.

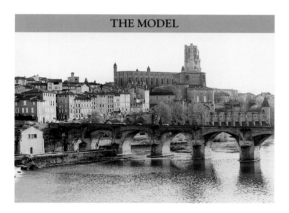

THE MODEL

■ A view of the old section of a city, with a river and a bridge over it in the foreground.

PHASE 1:
A DISTORTED DRAWING

■ Interesting gradations can be created between two colors if we rub the surface repeatedly with the crayons until the colors blend and thicken.

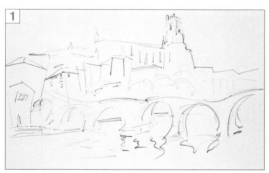

1. We do the initial drawing with graphite lead; this way, mistakes can be corrected with an eraser. We have exaggerated the arches of the bridge, and the buildings were constructed with overly angled lines, which gives them an unstable appearance.

2. Alternating red and violet, the first areas of color are applied on the cathedral, and we begin to color the arches of the bridge. The colors are applied thickly, which requires pressing hard on the bar.

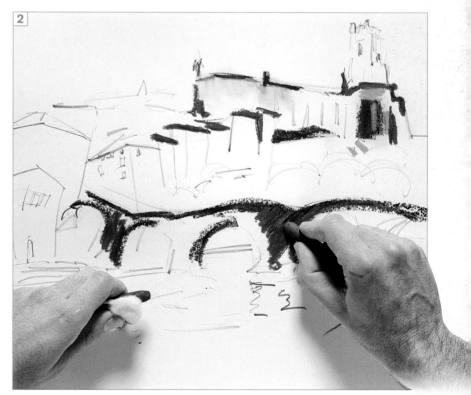

LIGHTENING THE COLORS

White oil pastels cannot be used to make highlights because they are not opaque; however, they can be used occasionally to lighten a color. Compare these two gradations: The bottom one has been lightened with white wax.

PHASE 2:

PHASE 2:
CONTRAST BETWEEN COMPLEMENTARY COLORS

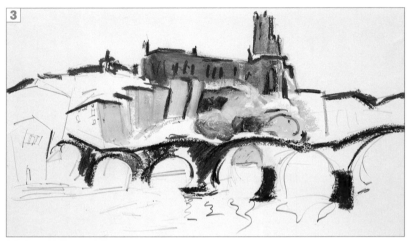

3. In the shaded and darker areas, violet tones are predominant, but on the lighted façades, yellow is the dominant color. Here we take advantage of the contrast between two complementary colors.

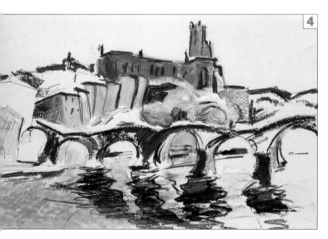

4. We alternate orange and yellow on the façades as well as on the arches of the bridge. With a sky-blue crayon placed at an angle, we color the surface of the river. Over that surface we draw zigzag lines with red and blue.

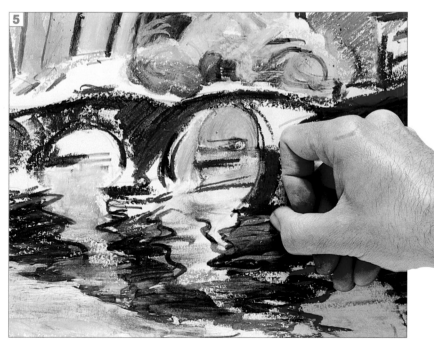

5. With a stick of carmine, we re-cover the lines that may have been obscured. After covering the sky with soft yellow, we use white to lighten the lines that represent the reflections on the water.

PHASE 3:
MAKING VIBRANT COLORS

6. To create the reddish hue of the sky, first we draw the contour with a blue marker and then we draw a regular line with a red one. Be sure to draw on the white part of the paper, as the marker may slip on the layer of oil pastels.

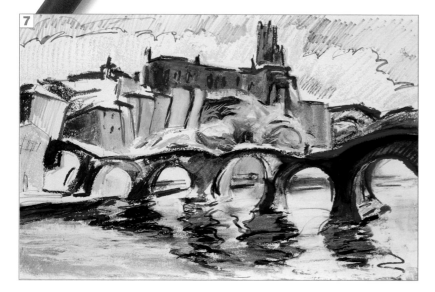

7. We apply new areas of bright red on the bridge and the water to create more color variety. The façades are finished by alternating orange and violet tones. Notice how some of the buildings twist and flex.

8. Once the façades are finished, we apply a green patina over the river and the surrounding vegetation. The colors are very bright and surreal, the buildings appear to sway, and the bridge looks like it is about to collapse. The colors are incredibly vibrant and everything conveys a dynamic feeling that is very striking.

Drawing with markers: lines and washes

Working with markers is similar to working with colored pencils, but the results are different: Markers are cleaner, more precise, and provide clear outlines. There are some special considerations; for example, the contours of certain elements must be drawn with the appropriate color for each object. If you use a black marker to draw all the forms, the color can distort the results. It is also a good idea to follow a coloring order: first the light colors and then the dark ones. The reason for this is that the light tones are very transparent and do not cover the dark ones.

■ The most common way to work with markers is to draw hatch lines; the amount of space between the lines makes them look lighter or darker.

Combinations

Color combinations are achieved by superimposing hatch lines of different colors: Since the ink is semitransparent, optical mixing of light and medium tones is obtained with glazes, which is why we recommend working on white paper at all times. With water-based markers, once the line is dry the ink is indelible, which means that you can draw over it with another color without causing bleeding or muddying the colors. However, some colors do alter others when they are superimposed, as markers cannot be layered excessively.

■ All the hatch lines are drawn in the same direction. Different values are obtained by superimposing one color over the other. There is no white marker; the lightest areas are represented by the white of the paper.

■ Markers can be used to create drawings with vibrant and very luminous colors.

■ Professional markers come in a wide variety of colors, including different shades of the same color.

Water-based markers

The lines made with water-based markers take a long time to dry, but they have an advantage over oil-based ones: They can be dissolved with a wet brush. The approach consists of drawing and coloring with the marker and then brushing the lines softly with a wet brush so the ink loosens up and forms washes. With markers, you can let the line develop freely, leaving spaces in between that will later be resolved with washes.

GRADATIONS WITH MARKERS

Colors of the same hue or that are very close to each other on the color wheel can be mixed until they form gradations, providing soft transitions from color to color.

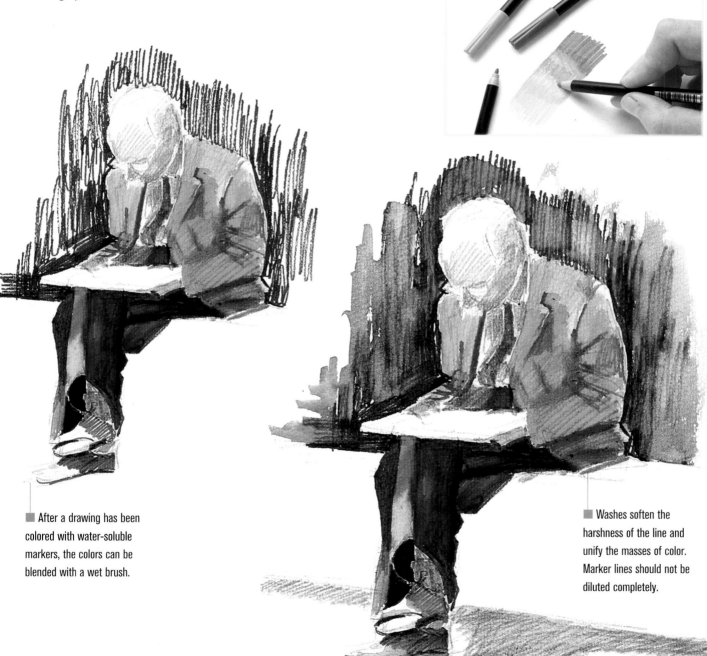

■ After a drawing has been colored with water-soluble markers, the colors can be blended with a wet brush.

■ Washes soften the harshness of the line and unify the masses of color. Marker lines should not be diluted completely.

Rural scene with colored chalk

The approach for drawing with chalk is shading in combination with a few defining lines. Therefore, it is best to begin working with the side of the chalk and to finish with the tip. Chalk drawings look grainier and less vibrant than drawings with pastels because they do not have the same pigment charge. On the other hand, this can be an advantage because it gives the drawing great luminosity and better color harmony. Plus, if you make mistakes you can correct them very easily, because lighter lines can be eliminated simply by rubbing with an eraser.

PHASE 1:
LIGHT AND SHADOW

THE MODEL

■ A rural scene presenting strong contrasts between the illuminated façade of the house and the dark shadows of the foreground.

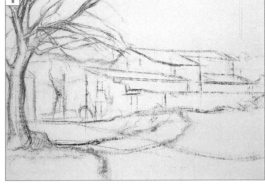

1. We block in the drawing with charcoal, allowing us to work more confidently and to make potential corrections with a cotton rag.

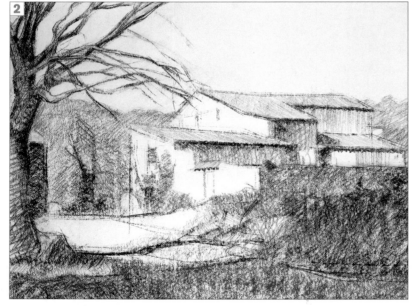

2. We break off a piece of black chalk and add the shadows without applying too much pressure. It's best for the grain of the paper to remain visible. Over the black shading, we apply blue on the foreground, and with the sanguine bar barely touching the surface, we color the roof of the house and the vegetation in the background.

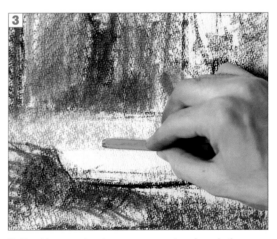

3. To add a warm touch, we use orange to color only the areas of light. We work with the whole side of the stick, pressing harder on the vegetation and working gently on the façade of the house.

A selection of colored chalks, although less varied than a soft pastel palette, is excellent for making bright drawings with soft, luminous colors.

PHASE 2:
BLENDING AND DETAILING

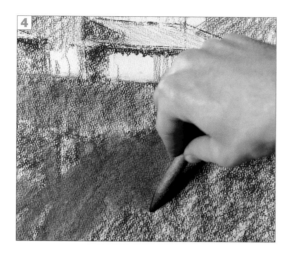

4. When we pass the blending stick over the color, it becomes denser and brighter. It is best to rub with the stick flat, without applying too much pressure, to preserve the medium grain of the paper.

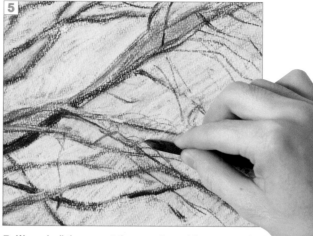

5. We work all the areas at the same time, adding green and brown tones to the vegetation, in a very subtle, light manner. Once the overall color has been established, we address the details, adding contrast to the form of the tree in the foreground and drawing the branches.

6. In this last phase of the drawing, we resolve the details by working with the tip of the chalk, which will make it easier to draw the texture of the grass, the tree branches, the shingles on the roof, and the shape of the windows. The lines should be very subtle and in harmony with the previous layers of color.

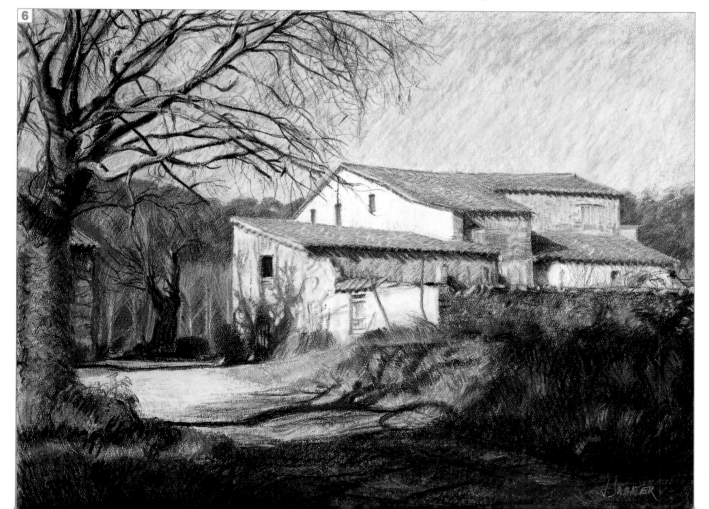

STUDYING FORM THROUGH SHADING

The line is a very beautiful medium by itself, but its possibilities as a vehicle for representation are very limited when it comes to tonal differences. Drawing anything with shading alone, without a preliminary pencil sketch, is a challenge that every beginner must face. Shading should not be defined by lines—it should have character, a personality of its own. Drawing with shading should be a synthesis of light and shadow, achieved through tonal or color contrasts.

■ Victor Hugo (1802–1885), *Landscape with Fortress and Bridge.* The composition encompasses large, dynamic, suggestive areas of shading. The graphic elements introduced by the artist provide some detail.

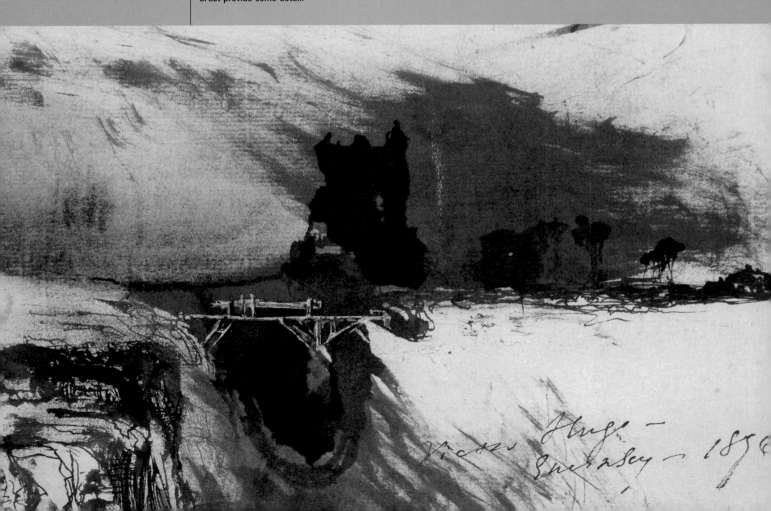

"Shading tries to capture the differences between light and shadow, between warm and cool, between static and tension. The shaded areas are dark masses in motion." Victor Hugo, 1857

Shading is suggestive

To resolve a drawing with color shading, the artist must analyze the play of light and increase the contrast of the different areas to define the edges of each object. That is the starting point from which the drawing is constructed using trial and error, with new areas of shading to better define the previous ones, superimposing applications of color that become increasingly smaller. The shadows should suggest no detail, so the forms emerge thanks to the combination of diffused warm and cool tones of various intensities.

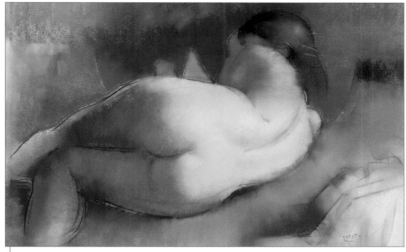

■ The line is hardly visible in this painting; the volumes get their definition thanks to the skillful contrast and blending of the colors.

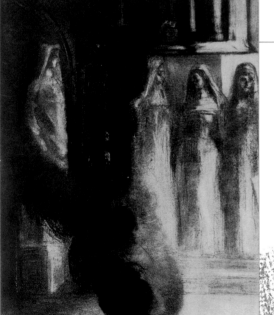

■ Odilon Redon, *The Black Torches.* In this drawing done with blended and contrasted shading, the artist attempts to convey the light surroundings created by the torch.

Laying out the shadows

To draw with color shading, you must learn to distinguish different tonal areas, those that have a similar tone and that can be distinguished from the others. This will let you construct the drawing with well-defined areas of shadow. When you are ready to do the same with color, you will almost unconsciously be able to define the areas of light, which will be represented by the white of the paper. These drawings, which are based on blended and diffused areas of color, allow a wide margin of error; you can blend and cover the mistakes by working over them again.

■ Areas of color create the shading, contrast, and volume.

Flat shading

et's revisit a subject that we covered briefly in previous chapters, which is working with values to create shading, using the side of the drawing stick. One of the most interesting ways to learn to shade a drawing is by using smooth strokes with any of the dry drawing mediums (charcoal, chalk, or pastels). The shape and the edges of the shaded areas should be our focus when blocking in the structures, especially when the model offers a strong contrast between light and shadow. The idea, therefore, is to represent shading by rubbing with the side of the stick, bypassing any details and simplifying the range of tones.

■ We can create wide areas of shading by rubbing with the stick lengthwise.

Dragging the drawing stick

The fastest way to cover the paper is by dragging the stick lengthwise, making a wide line that lets the texture, the grain of the paper, show through. You will have better control of the shading if you break the bar into pieces of various sizes, allowing you to vary the stroke. The intensity of the shading will depend on the pressure that you apply on the stick. Before beginning to draw, it is a good idea to practice tonal scales, gradations, and homogenous shading to check the dragging effect on the paper on which you are going to work.

■ When sketching you should not only consider the lines; it is also important to understand the value of shading and its role in the composition.

■ If you rub the stick repeatedly over the same area, the shading will be homogenous.

■ Pressure is gradually reduced to create a tonal scale.

■ Without lifting the stick from the paper, we increase the pressure as we move laterally to make the gradation.

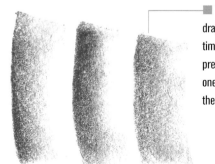

■ The stick is dragged several times with more pressure on one side than the other.

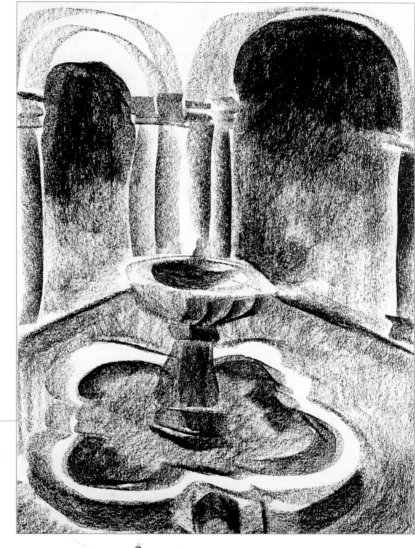

■ The greater the pressure applied on the
stick, the more intense the tone.

Using the texture of the paper

When you drag the bar of charcoal or chalk over
a heavy-grain paper that has a very pronounced
textured surface, the pigment only adheres to
the high surfaces, to the top part of the grain,
providing a very unique textured effect. The
dark shading, since it does not completely
blacken the surface of the paper, appears to
consist of several areas created by numerous
dots separated by white spaces, which gives
the drawing a blurry, atmospheric effect.

■ Working with the stick
flat on heavy-grain paper
produces very distinctive
grainy shading.

■ A tonal drawing made
exclusively with a black
charcoal bar held flat on its
side or angled. Gradations
have been created by varying
the pressure on the bar.

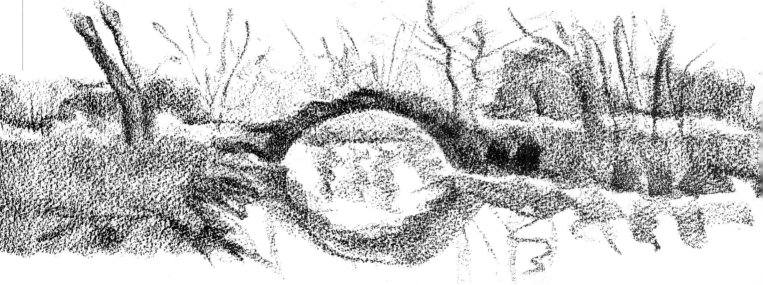

Shading with pigment

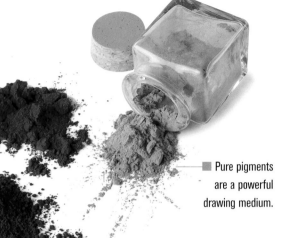

■ Pure pigments are a powerful drawing medium.

When you apply powder pigment on paper, the resulting effect is very different from shading done with a stick of charcoal or chalk. The working method also differs, because the powder is rubbed onto the paper, either with a cotton ball impregnated with it or directly with your hand, smeared with your fingertips. This is the most direct approach possible because your hands touch the paper; they are in constant contact with the surface of the work. You can spread the pigment, shade an area, blend it, and model it with a simple movement of the hand. Preferably, shading with powder should be done on fine- or medium-grain papers, to achieve uniform coverage without having to apply too much pressure.

■ The first marks represent the shadows on the model. Using a cotton rag charged with powder pigment, we rub only the darkest areas.

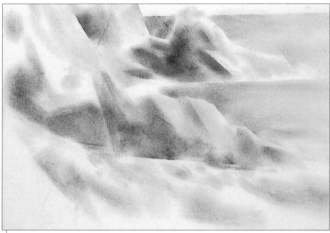

■ With a second application and the help of a piece of paper, we intensify the values of the shaded areas. By doing this we will obtain straighter, sharper profiles, which lend a volumetric effect to the piece.

■ To make straight lines when you shade with pigment, use the edge of a sheet of paper and rub over it with the cotton ball charged with powder.

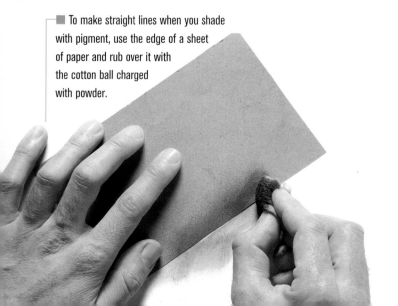

■ When the sheet of paper is removed, you will see that the edges are straight and well defined.

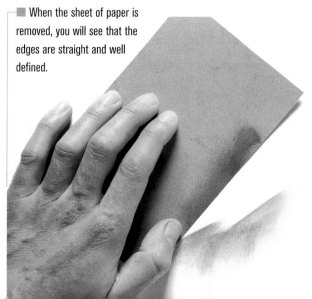

To get started in drawing with pigments, it is best to define the main areas with very soft shading that will be gradually darkened with new layers. By starting with light shading, you will build confidence.

WORKING WITHOUT HARD EDGES

Applying powdered color with a cotton ball is a way of abandoning the line as a constructive element of the drawing and of shading without hard edges. This treatment always appears diffused, with soft, imprecise edges.

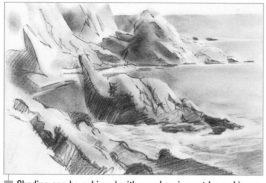

■ Shading can be achieved with powder pigment by making a few lines for the outlines of the rocks and hatch lines to darken the most shaded areas.

■ Ochre and sanguine powder pigments are used to do the illustration.

■ When you use pigment for shading, your fingers become natural drawing tools. You can use any finger, depending on the width of the area you are working on.

■ When working with powder pigment, you can use an eraser at the end to open white areas and to restore some lines.

Building up colors

Drawings can be done with dry pastel colors if you use them with confidence and energy. However, when you want to represent a theme with color shading, it is not enough to distinguish the lighted areas from the shaded ones; you must also group areas according to like colors. It would be a mistake to represent all the color nuances found in the model. Coloring with pastels forces the artist to choose certain chromatic qualities, the ones that provide the best color combinations, and that can be superimposed without losing their freshness.

■ Wide strokes of color are juxtaposed to form a surface of vibrant colors.

When working with color shading, it is a good idea to select what is important, that which has chromatic or compositional value, and to put aside what does not have value for the development of the painting.

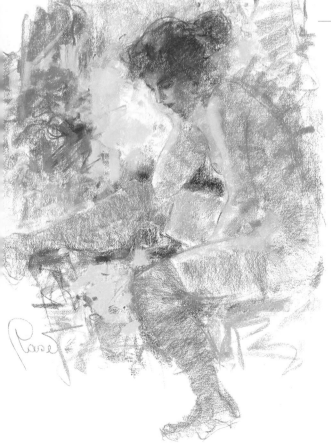

■ A pastel drawing created with color shading. The figure stands out because of the contrasting colors of the skin and the background. In some areas, a soft line drawn under the shading is visible.

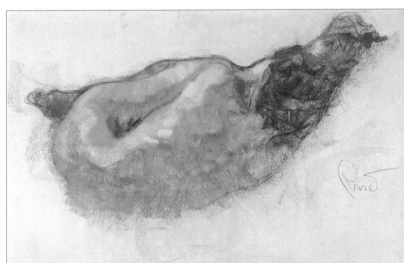

■ The construction of the figure in general and the skin in particular is done through the juxtaposition of warm colors. A few lines added to the colors complete the definition of the figure.

Unfinished forms

In general, drawings made with the shading technique have an unfinished look. Leaving a drawing unfinished does not necessarily indicate lack of skill on the part of the artist but rather that the forms were not completed on purpose. There is a reason for leaving a drawing unfinished: The idea is to capture the masses that give structure to the model, ignoring the minute details that can be hard to draw, especially if you are working with a stick held flat, a rag, or your fingertips. Besides, the nature of shading with colors is spontaneous, impressionistic, and of great chromatic freedom; the protagonists are the colors and the volume, and the details simply minor additions.

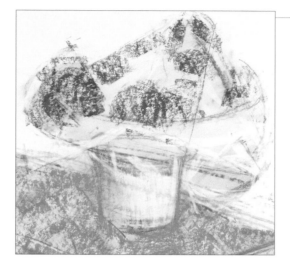

■ In this floral theme the masses are determined by sketching the edges of the main areas of color. We then use them to make the first applications of color.

■ Your fingers are the best tools for blending and spreading pastel colors.

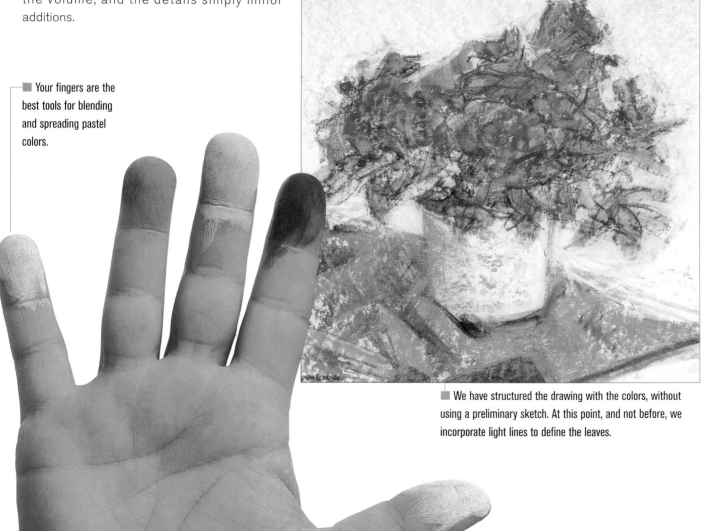

■ We have structured the drawing with the colors, without using a preliminary sketch. At this point, and not before, we incorporate light lines to define the leaves.

Coloring with washes

■ Keep several ink colors on hand and choose the most appropriate one for each model.

1. Once you begin to draw, the process should be quick and without hesitation. You should not make any preliminary drawings.

The speed with which a wash can be made with a brush is incomparable; it is the fastest drawing technique there is to capture the model. Making washes with a brush requires the ability to synthesize, which means that the artist has to be able to resolve the subject in an abbreviated manner, finding a way to define the forms with just a few expressive brushstrokes. Colored inks and watercolors are very fluid and make it possible to resolve the forms quickly, expressing them with gestural, spontaneous lines and linking brushstrokes together.

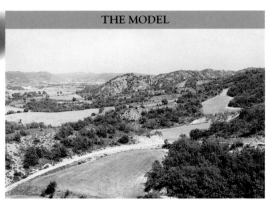

THE MODEL

■ A landscape with marked tonal differences between the golden wheat fields and the more somber trees.

2. The strokes should be quick and dynamic, and they should reflect the darker tones of the landscape.

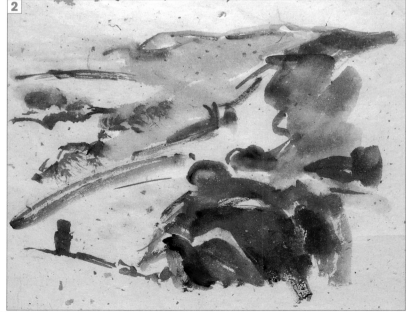

3. Now we will change the color of the ink for new results. This landscape is an extreme example of synthesis; it has been done with long, gestural brushstrokes.

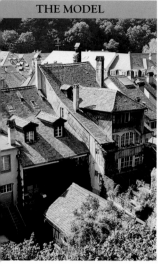

THE MODEL

■ A bird's-eye view of city rooftops offers numerous representational possibilities.

Direct brushwork

It is important to learn how to draw directly with the brush, to tackle a blank sheet of paper without a preliminary drawing. You should establish the areas of shadow and the outlines first, leaving the areas of light blank. The varying amounts of water used to mix the colors will result in nice tonal variations. If you work on a medium-toned paper, at the end, when the wash is dry, you can add a few highlights to represent the light.

1. We apply the color directly with the brush, without making a preliminary pencil drawing. First, we lay down a very soft wash for the roofs and then a darker one for the façades.

■ It is important to use a generous amount of color and apply it freely and decisively.

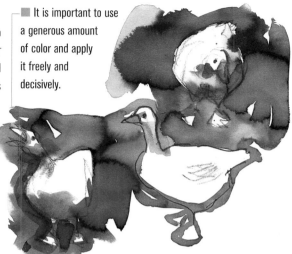

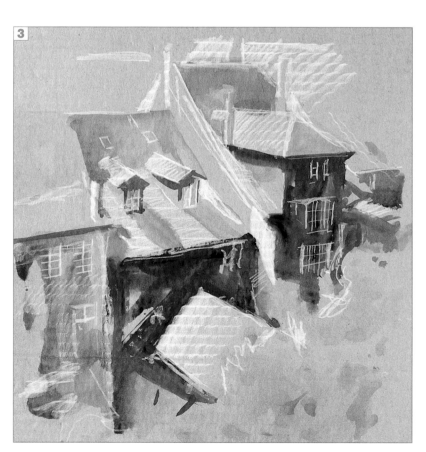

2. We wait a few minutes for the washes to dry completely. Then, with a white pencil we make highlights where the light is brighter.

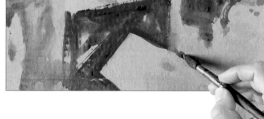

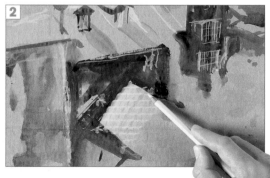

3. It is better not to be too detailed; the treatment has to look unfinished for the drawing to maintain its simplicity and effectiveness.

Painting

Mastering color

The time has come to delve into painting techniques, into the kingdom of color. Painting cannot be understood without understanding color and the many ways of applying it: the subtleness of watercolors, the creaminess of oil paints, the versatility of acrylics, the immediacy of gouache… Obviously, the experience of working with a variety of media widens the possibility of artistic expression. This section contains a brief presentation of painting materials and an extensive survey of techniques, complete with detailed explanations and advice on mastering all of the skills that are indispensable for using color properly.

THE BASIC MATERIALS

*B*efore you begin to paint, it is a good idea to spend some time choosing and preparing your materials. Familiarizing yourself with them and experimenting beforehand is essential to determining the effects that you will be able to achieve. Knowing your painting materials will help you use them more effectively, facilitate interpretation, improve your ability to create textures, and give you more control over your work. Next, we will briefly explain the most common painting techniques; we will study their creative possibilities, main characteristics, and application methods. The better you understand the versatility of paints, the more painting approaches you will be able to develop.

■ In painting, everything is defined by color: its application, effects, and contrasts. Knowing the materials is essential to using them correctly and to achieving a good effect.

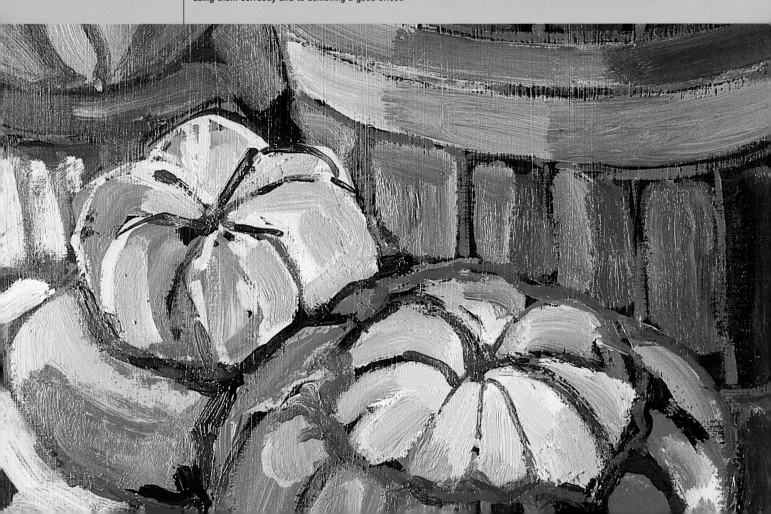

It is important to understand the medium and its qualities; otherwise you will not be able to put into practice many effects and techniques.

Painting with brushes

One of the main tools for painting is a brush. It can be considered an extension of the hand; it is responsible for spreading the paint on the support, mixing it, and blending it together. A good brush should hold a generous amount of water (in the case of watercolor brushes) or pick up thick, creamy paint (brushes for oil or acrylic paint), and to hold the charge until the moment of application. The rest depends on the arm movements of the artist.

■ The main tool in painting is the brush. You should master mixing colors with it and controlling its movements on the canvas.

Paint quality

The range of colors for any medium available nowadays is very wide and can be acquired in a variety of formats (bottles, tubes, and cakes). It is a good idea to choose wisely because buying cheap paint often turns out to be expensive. Many inexpensive colors are of poor quality, not very opaque and containing too much agglutinant binder; when they dry they turn yellow or crack, and they do not age well. It is not necessary to buy the most expensive brands either; medium-quality products that are reliable and affordable will work. The best way to decide which paints to buy is to ask at the art supply store.

■ It is a good idea to know how the paint responds in every situation. This will enable you to create a wide range of effects and applications.

Watercolors: painted veils

The entire watercolor technique is based on the colors' solubility in water. Watercolors can be purchased dry (in the form of cakes) or creamy (in tubes). Dry, they have to be mixed with water to soften them; creamy colors, on the other hand, are easier to dilute with water. There are two other formats—tablets and liquid watercolors—however, we do not recommend either one. The former are of school quality and have low tinting power, while the latter have too much high tinting power, making it difficult to achieve very subtle tones with them.

Glazed color

The main quality of this medium is the transparency of the colors. They are used in the same way as washes. The principle consists of painting from lighter to darker, applying transparent glazes. We use diluted colors, so if several colors overlap, they will blend together: Superimposing red and blue will produce violet; applying blue over yellow, green, and so on.

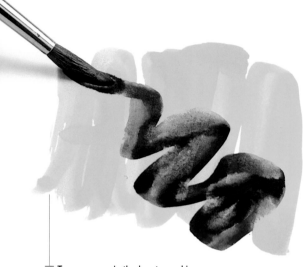

■ Transparency is the key to working with watercolors.

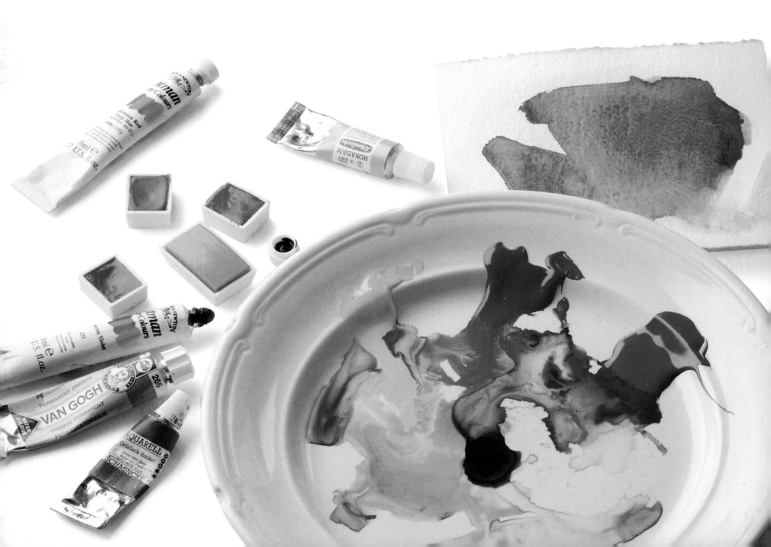

Painting on paper

The natural support for watercolors is paper, but not just any paper—it must be sturdy enough to withstand washes. Papers come in different thicknesses or "weights": The larger the work that you want to paint, the thicker the paper should be. Also, it should be white or only slightly tinted, because watercolors are transparent and incorporate the light that reflects off the surface of the white paper.

Common brushes

Watercolors require very special brushes that will hold a lot of water, retain it, and recover their shape after the brushstroke. They are available in different types of hair; the most expensive is sable, although the most affordable ones made of synthetic bristles also give good results. Round brushes are the most versatile, as they can be used for wide brushstrokes and to paint lines with the tip. Square brushes are used to paint large areas, and they are not suitable for details.

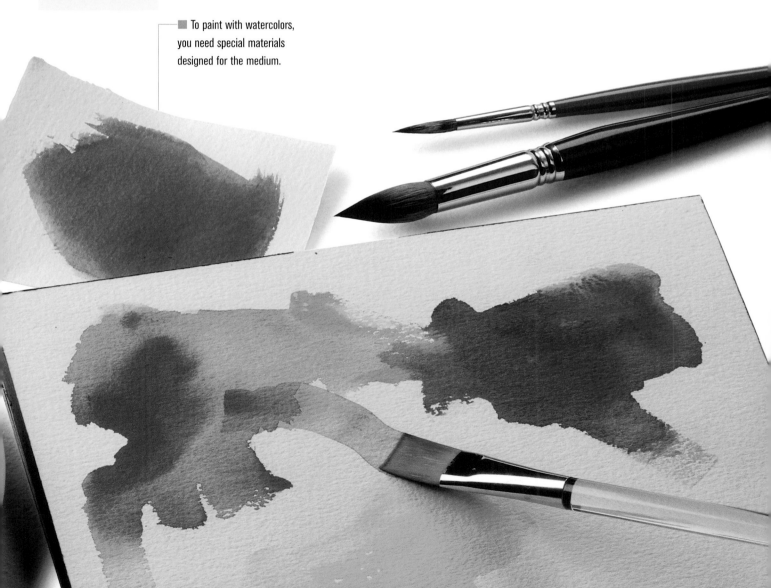

To paint with watercolors, you need special materials designed for the medium.

**MASTERING
COLOR**
THE BASIC
MATERIALS

PAINTING

100

Versatile acrylics

This medium contains the same pigments as oils and watercolors, but they are diluted in an acrylic agglutinant made from a synthetic resin that, when dried, forms an elastic layer similar to plastic. The most outstanding characteristic of acrylic paints is their versatility. The paint can be used diluted with a lot of water, as if it were a watercolor, or very thick as an impasto, with rich texture effects. Their other great advantage is that they dry very fast, which makes it possible to finish a painting in one session, superimposing layers of paint while barely mixing them. This, however, can also be a drawback, because their quick drying time does not allow much time to work with the paint on the support, forcing the artist to paint quickly and perhaps, sometimes, hastily.

■ Acrylic paints are very versatile and chameleon-like; they can be applied in many different ways simply by changing their consistency.

THE FALSE OPACITY OF ACRYLICS

Acrylic paints share some of the characteristics of oil paints, but they do not cover one color with another very effectively. They may appear opaque when the paint is wet, but when they dry they become somewhat more transparent, and you may be able to see through to underlying brushstrokes or colors.

Selecting acrylics

Acrylic paints come in different formats so the artist can choose the one that best suits his or her needs. If the work is small or medium in size, tubes are the most suitable format. If the work is large, it is a good idea to buy bottles, which are available in different sizes. Every brand comes labeled with the characteristics of the color. It is not a good idea to purchase inferior-quality acrylics because they have low tinting power and they become too transparent after they dry.

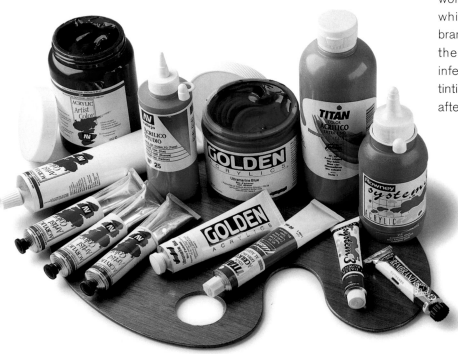

■ A wide range of acrylic paint formats is available to meet all your needs.

A very clean medium

Acrylic paints have very little odor and they are water-soluble, which makes them a very clean and easy medium to paint with at home. They do not require special brushes or supports; the same brushes used for oil painting also work for this medium. As for the support, acrylic paints adhere well to any surface (cardboard, paper, canvas, wood, and more). Once you are finished painting, cleanup is easy with soap and water, as long as the paint has not dried.

Controlling consistency

Several substances can be added to acrylic paints to change their consistency, making them more or less glossy, iridescent, granulated, or thick. They are known as mediums. These products are not required for painting with acrylics, but it is a good idea to be familiar with them in case you need to use them one day. The most important ones are the glossy and matte mediums; gel, gesso, and modeling paste for adding volume; products to make the paint more transparent for washes; and retardants to prolong the drying time of the paint.

■ The same wood palettes used for oil painting can be used for painting with acrylics, but the white ones are the best, especially for working with washes.

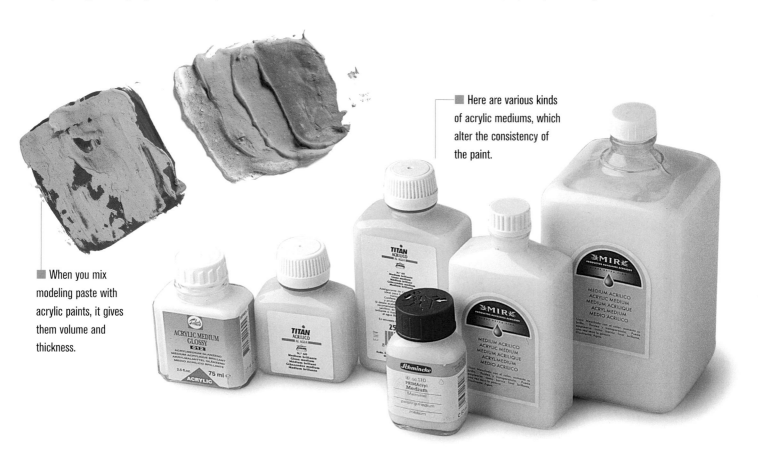

■ Here are various kinds of acrylic mediums, which alter the consistency of the paint.

■ When you mix modeling paste with acrylic paints, it gives them volume and thickness.

MASTERING
COLOR
THE BASIC
MATERIALS

PAINTING

102

Oils: king of paints

New painting media emerged during the 20th century, but none of them were able to surpass the popularity of oil paints, which are made of pigments and linseed oil. Most manufacturers offer two kinds of oils: ones that are designed for artists, which are high quality, and ones intended for students, which are more affordable. The former have a higher level of pigment to give them the proper consistency; the latter, on the other hand, contain additives that reduce the amount of pigment, so they produce a convincing effect at a lower cost.

■ Oil paints are creamy and have good consistency.

A slow-drying paint

What makes oils stand out from the other paint media is their luminosity and creamy texture, which remains unchanged when the paint dries. Oil paints dry relatively slowly and with little color change, which makes it possible to even out, mix, or blend the colors and to make corrections easily. You are not limited to linear brushstrokes; you can apply glazes, washes, areas of color, atmospheric effects, and impastos (very thick layers of pigment). With oils you can create very rich chromatic effects through tonal contrasts and chiaroscuro.

■ They are usually available in tubes, in both student quality and professional quality.

■ Their slow drying process makes it possible to touch up or blend colors applied hours earlier. It is definitely the best medium for corrections.

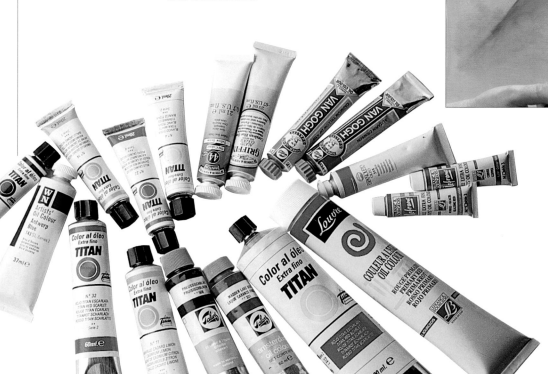

PAINTING

MASTERING
COLOR
THE BASIC
MATERIALS

103

Oil paints are creamy and thick, which makes it possible to apply them while leaving traces of the brushstrokes. This adds great interest to the painting.

CUTTING OUT EXPENSES

You can combine professional-quality paints with others of lesser quality in the same painting. Simply replace the colors from the cadmium or cobalt family with similar colors that are equally effective.

Requirements

To begin painting with oils, you will need eleven tubes of paint in the following colors: titanium white, cadmium yellow, cadmium red, madder rose carmine, yellow ochre, burnt sienna, amber sienna, titanium green, sap green, cyan blue, and dark ultramarine blue. You will also need a few filbert bristle brushes in various sizes, a bottle of solvent or mineral spirits, a wood palette or a flat surface on which to mix the colors, and an old cotton rag.

■ The creamy consistency of oils allows the brushstrokes to show when the painting dries.

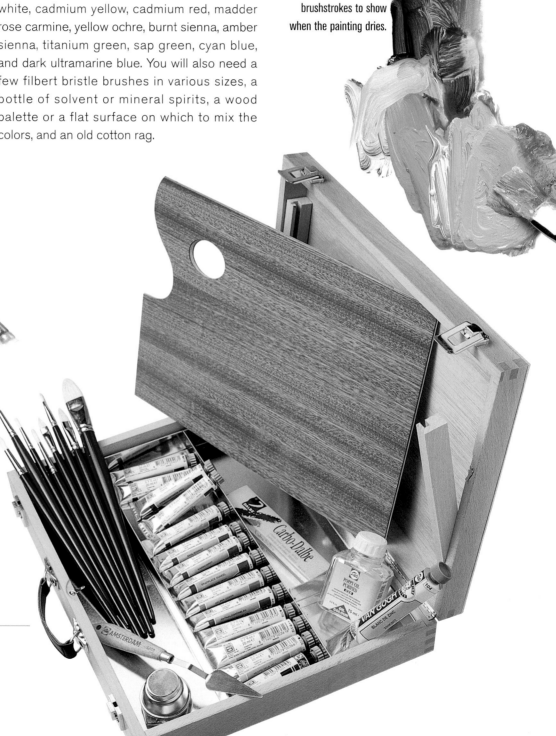

■ Oil painting materials can be purchased separately, although the well-known manufacturers offer boxes that have a complete assortment of everything you need.

Working with oils

Getting started in oil painting is not difficult, but it is important to know a few basic things—how to control the consistency and mixtures of colors—before tackling more complex themes.

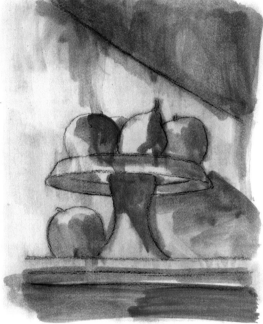

■ At the beginning, oil paints are mixed with mineral spirits. This allows the artist to lay out the first contrasts and to correct the painting as often as needed without wasting any paint.

Using mineral spirits

Oil paints can be diluted with essence of turpentine or with mineral spirits. This more fluid mixture is generally used to apply the first colors on the canvas. It dries fast and provides a color base that is sufficiently stable for subsequent applications of thicker, more opaque paint.

Malleable paint

Usually, after the first colors are put down, oil paints are used directly out of the tube, without mixing them with mineral spirits. This makes them more malleable and conserves the freshness of the line and the brushstroke. The thickness of the paint makes it easier to mix on the support and makes it possible to create clear contrasts between the different color areas.

■ The paint is thick and easy to apply when no mineral spirits are added to it.

■ Mineral spirits dilute the paint and turn it into a thin layer that dries fast.

PAINTING

**MASTERING
COLOR**

THE BASIC
MATERIALS

105

Impastos

It is possible to create paintings with a heavy texture by applying small amounts of oil paint with a brush or a spatula. For the paint to acquire an impasto look and have some volume, it should be applied thickly, dabbed on with the brush or the spatula and deposited on the surface of the painting without pressing. Since oil paints do not shrink after they dry, any accumulated paint will remain intact.

Mixing by dragging

To understand the possibilities of oil paints, it is a good idea to learn how to mix the colors on the support. First, you take a color and apply it with loose, creamy brushstrokes. More paint is applied over this, mixing with some of the paint underneath and turning into a new color. The opacity of the paint allows painting light tones over dark.

■ Color impastos can be applied with a brush; however, the best tool for working with this technique is the spatula.

■ If you apply a single thick brushstroke over a wet color, the new layer of paint is fairly opaque. But if you repeatedly rub the brush over the wet paint, it drags up some of the color underneath, creating a mixture of the two colors.

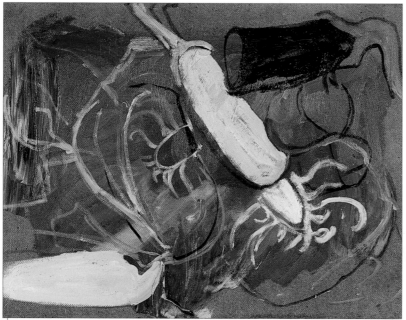

■ After the first phase of painting with mineral spirits, the normal approach is to work with thicker, more opaque paint. The areas painted with mineral spirits simply become a background or decorative element.

FORM THROUGH COLOR

*C*olor is one of the most expressive and personal elements of painting. Used properly it gives a distinctive character or flavor to any theme. Learning to apply different color values and knowing how to combine them is the first step to achieving a successful piece. To paint well, an artist has to learn how colors act and react, how they relate to each other when they are mixed, how they can be used to make contours, forms, or perspectives... All of these skills are necessary to use color successfully.

■ Maurice Vlaminck (1868–1940), *The Seamstresses.* The forms are constructed with contrasts between the different color fields, without any contours or outlines.

Interaction between colors

Colors should not be considered in isolation but in the context of the other colors around them. All colors are affected by other colors nearby, so each new application changes the relationship with the existing colors. A color may appear darker if it is surrounded by another that is very light, just as a dark tone will seem lighter if it is surrounded by darker colors.

Colors have an order

A color is not applied to a painting randomly; it follows an internal logic. It must fit into a predetermined order, to a scheme that results in the delicate balance of all the parts, a harmonious result. Color tends to behave in a certain way, and the beginning artist is forced to understand that to avoid making serious mistakes.

Even though this may seem complicated, with time artists develop color preferences or tendencies that stay constant and that mark their styles.

"Color is nothing if it does not relate to the theme and does not heighten the effect of the painting through the imagination."
Eugène Delacroix

■ Joaquín Sorolla (1863–1923), *Cape of Sant Antoni in Xabia.* Each color brushstroke in this painting is not viewed by itself but as a whole; it makes sense when viewed all together.

■ Colors cannot be considered in isolation. For example, the gray circle looks lighter when the surrounding color is violet and somewhat darker when it is orange.

Composition through color

Colors help organize the painting visually. The proper distribution of colors is key for a work to make sense. A painting appears clearly structured when the relationship between the colors and the contrasts is in harmony. In this chapter, we will present three important ways for organizing and laying out colors on the canvas: according to their light and intensity, their focus of interest, and their proximity.

Composing with light and shadow

Contrasts between light and shadow attract the viewer's attention and provide an immediate sense of the layout and the content of the painting. Therefore, to construct a painting in a balanced way, the first thing to take into consideration is where to place both the lightest, brightest colors and the darker, less luminous ones.

■ The most basic way to lay out a composition is by distributing the areas of light and shadow evenly.

■ The distribution of light and shadow is fundamental for understanding the painting. For example, notice how the feeling of these two interiors is completely different if we alter the source and distribution of the light.

Light and color not only possess a magic and special appeal on their own, but they also play a practical role: They contribute to the organization of the painting and make it easier to understand.

The focal point

Composing with color allows you to highlight the main elements of the theme, the ones that should catch the viewer's attention. The best way to achieve this is by reducing the intensity of the colors that surround the focal point so that it stands out by contrast. Make sure that the brightest colors are only used in the area of the painting that needs to be emphasized; if you use colors of similar intensity and contrast in several areas, the result will be confusing.

Composing a landscape

In the distance, color loses its saturation and appears lighter, acquiring blue or violet tones. The closest areas are brighter, and in them ochre, oranges, and yellows are predominant. This means that colors are warmer in the foreground and cooler in the background. It is important to keep this in mind when laying out colors in a landscape.

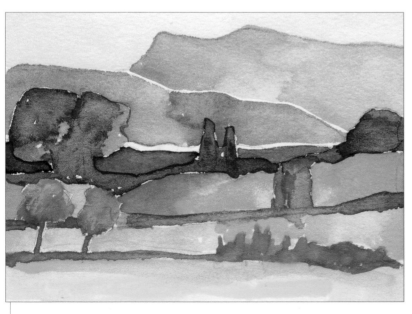

■ We make a basic layout of the composition with the colors organized in relation to their distance to the foreground. Then, we apply them to the landscape following the same order.

■ If you wish to establish a focal point with color, you must introduce a striking color note—for example, an orange between a range of blues and violets. It catches the viewer's attention right away, becoming the focal point of the painting.

Forms and background

The distribution and intensity of the colors in a painting are the main reasons that the forms of the model stand out. Defining the relationship between the forms and the background using color contrast forces us to simplify, to pay attention to the juxtaposition of colors, and to modify them, if necessary, to better define the outlines of the objects.

Colors set different planes apart

When two surfaces with similar colors are next to each other, the resulting image is confusing; the outlines and the forms blend together without clear separation between the planes. This often happens when the vegetation of a landscape painted from nature has a similar range of greens. To prevent this, the colors can be modified to give them warmer or cooler tones, depending on the light, that clearly define each plane.

■ For this group of red-hued trees to be clearly visible against a red background, it would be best to change the color of the background completely so the forms stand out more.

■ A monochromatic approach with soft contrasts does not distinguish the trees in the foreground from those in the background.

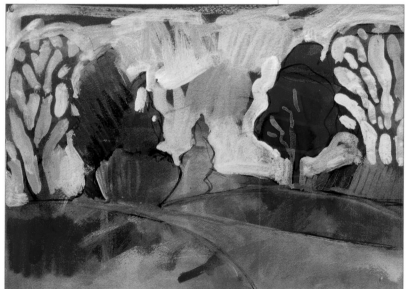

■ This representation is more harmonious, but the color distribution is random, and the oranges in the foreground and the background do not allow the two trees in the foreground to stand out sufficiently.

PAINTING

MASTERING
COLOR
FORM THROUGH
COLOR

111

BLURRED BACKGROUND

You can paint the background out of focus while detailing and defining the objects in the foreground. To create this background the colors are blended together to conceal any clear outlines.

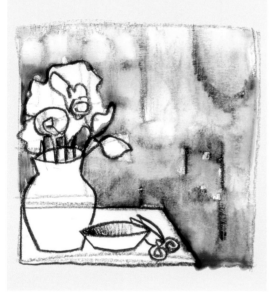

Separating the forms from the background

To define an object properly and make it stand out against the background, paint the figure and the background in two contrasting colors (colors that are very far away from each other on the color wheel). The effect is even more pronounced if one color is more luminous than the other. The most effective contrasts occur when an object in a lighter color is painted against a dark background, or when the foreground is painted with warm colors and the background with cool colors.

Changing the background color

One factor that helps objects stand out is the color of the background. The perception of the model varies according to the color that surrounds it. Let's look at a simple model done with a range of harmonious colors. If we paint the background dark, the objects appear more isolated and brighter; if we paint the background bright red, the painting becomes less subdued, more colorist, and the objects acquire greater importance.

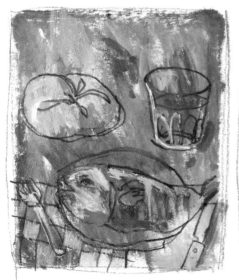

■ We will change the background of a still life done with a harmonious range of blues, greens, and yellows. You can see that, against a similar background, the objects do not stand out very much.

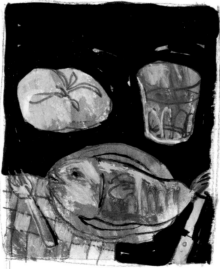

■ To make the objects stand out more and look brighter, we paint the background deep black.

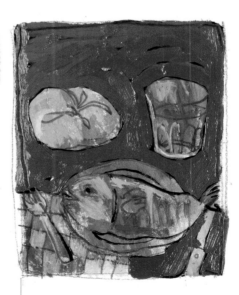

■ We use red (the complementary color of green), to repaint the background. This restores the light of the background and makes the objects look brighter and stand out as a result of the contrast.

MASTERING
COLOR
FORM THROUGH
COLOR

PAINTING

112

Modeling with colors

Modeling defines the volumes of forms through the correct application of light and shadow values. To achieve this, each brushstroke must conform to the shape of the object in terms of size, direction, and value.

Each color has many shades

A beginner tends to relate color to the object that is being represented. For example, if we will paint vegetation, we think that a couple of tubes of green paint are all that we are going to need. This is not the case. The color of any object contains many other colors. So, to the green of the vegetation we can add ochre, blue, or carmine, depending on how the light falls on it, which is why colors tend toward one tone or the other.

■ Modeling does not necessarily have to be done with light transitions of a single color. You can use different colors as long as you distribute them properly.

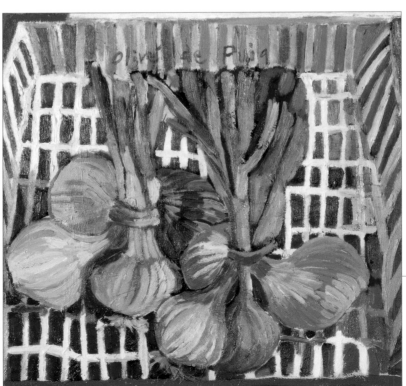

■ A group of dull brown and violet onions comes to life thanks to the wide variety of colors that the artist has used in their modeling.

Modeling with gradations

Creating tonal differences is the main approach to modeling objects, especially when they are painted with a restricted range of colors. The different tones describe the relative lightness or darkness of an area. Therefore, the areas of light are painted with lighter colors and the areas of shade with darker colors. If you work an object with a range of hues that go from lighter to darker, progressively forming a gradation, the object will acquire shape and volume.

Using a brush

To model an object with color brushstrokes, you should use the brush very carefully, as if you were touching the object itself with your hand. The brushstroke should follow the direction of your hand. When modeling, the transition from light to shadow, whether through painting or hatching, can range from a soft blend to abrupt contrast. In any case, the modeling will be successful as long as there is a scale of values.

■ To model an object with gradations, we assign a value to each area that expresses the amount of light that falls on it. Gradations help model objects and give them volume.

Modeling makes objects stand out, giving them the illusion of three-dimensionality.

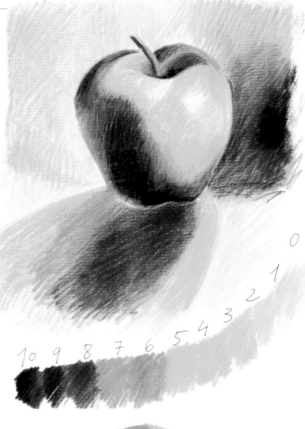

 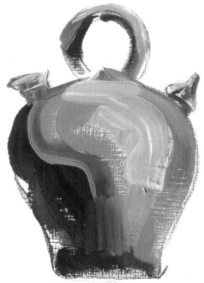 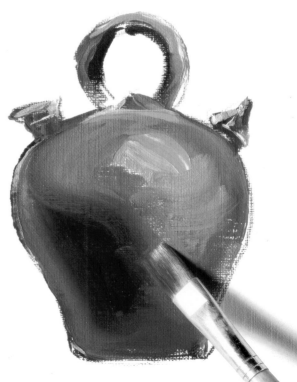

■ In this sequence, you can see the direction of the brushstrokes that recreate the volumetric shape of the object. At the end, the colors are blended together to convey the feeling of the smooth surface.

MASTERING
COLOR
FORM THROUGH
COLOR

PAINTING

114

Monochromatic and harmonious colors

Many beginners work on a small area of a painting until it is completely finished, then they continue with the next one; this results in a confusing collection of colors that bear little relationship to each other. We recommend that you work on all the parts of the painting at the same time. This way, you will be able to compare the colors often, which will help you obtain a harmonious painting.

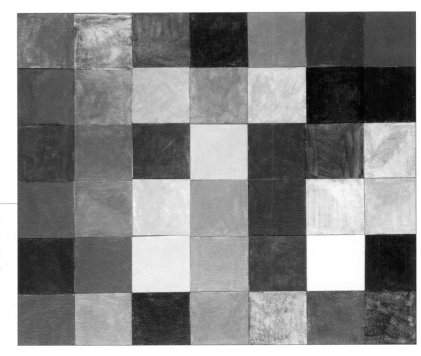

■ If you work with variations of the same family of colors—in this case, blues—you will create a natural harmony.

■ The goal is to achieve different tones by mixing blue with other colors that are nearby on the color wheel.

How colors harmonize

A painting will be harmonious when there is little differentiation—that is, when there is no excessive contrast—between the colors used. Colors of the same family have a close relationship that creates a natural harmony, which is why it is better to work with colors that are close to each other on the color wheel. Colors that share similar characteristics or undertones go well together when painted next to each other.

To harmonize is to relate the different parts to each other to create cohesion, to create unity from variety.

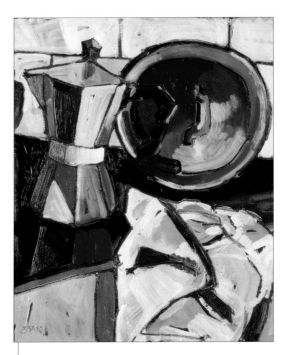

■ Combining colors of the same family of blues results in a harmonious painting. By using similar colors, it is easier to control the distribution of color and the effects created by the light.

AVOIDING MONOTONY

Combinations of similar colors are pleasing to the eye and easy to achieve; however, avoid excessive unity, as it results in monotony.

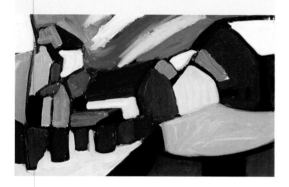

Monochromatic harmonic ranges

It is possible to create an entire painting with a single color by just changing its value and tone. If the value is modified using black and white or a complementary color, it will be monochromatic. If you also change the tone, you are working with a simple harmonic range, or with a dominant tone. In this case, the base color is mixed with other colors to create shades while maintaining the character of the dominant tone. Very interesting harmonic, monochrome paintings can be achieved with just a few changes of tone and value.

◾ Harmonious colors are created by mixing a dominant color with its neighbors on the color wheel.

◾ Neutral colors result from mixing saturated colors with white, brown, gray, or their complements. The colors obtained are more subdued, have less clarity, and go well together.

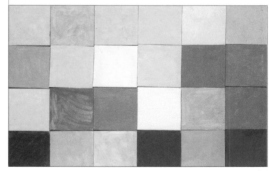

◾ A watercolor done with a combination of neutral colors. Tan is the dominant color and the blues and violets appear infused by brown tones.

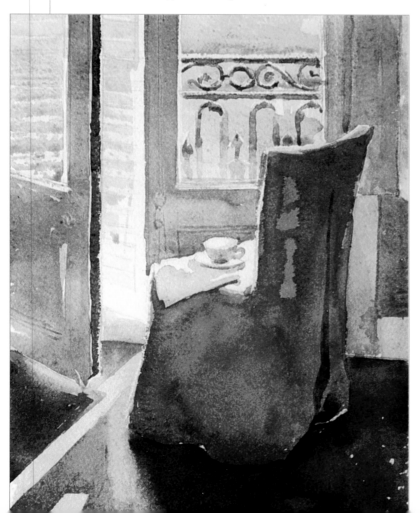

Neutral colors

The neutral color range consists of gray and brown tones. They are made by mixing saturated colors with the two colors above or by combining two secondary colors and adding a small amount of white. When neutral colors are combined in a painting, the resulting color scheme is very beautiful. No color stands out too much and there are no striking contrasts. All the colors are present in one way or another but they are subdued, and the chromatic power is very subtle since the emphasis is on the light values.

Expressionist colors

An expressionist painting is characterized by purely chromatic contrasts expressed in large areas of vibrant, saturated colors. There are no areas treated with grays, browns, or dark colors; light and shadow are expressed through the contrast of oranges, blues, and greens. The following exercise is a clear example of this approach to painting with colors that are always bright, light, and luminous. Instead of mixing the colors on the palette, you can apply them in pure form directly on the support with short brushstrokes, almost in a Fauvist style.

THE MODEL

■ We are going to transform an interior dominated by gray and brown tones into a spectacle of colors.

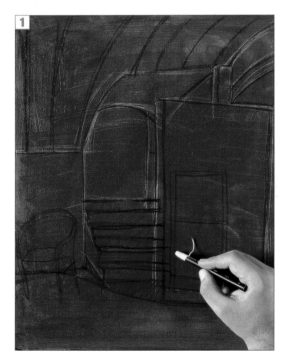

1. We cover the background with medium green, using acrylic paint to speed up the drying process. With a black pencil we draw the elements in the interior.

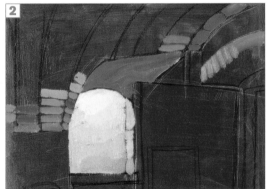

2. Now we introduce oil paints. We begin by painting the light of the background with a series of orange tones. With short brushstrokes, we paint the bricks on the ceiling.

3. The colors of the ceiling appear organized, painted with variations of ochre and brown with a clear orange undertone. Each brushstroke leaves a space in between where the green of the background is visible.

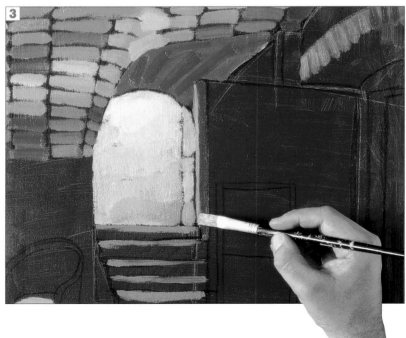

The expressive use of color turns an everyday scene into an image that has a personal style and is much more striking.

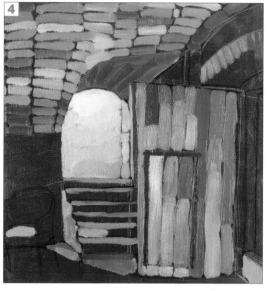

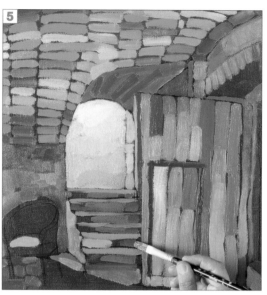

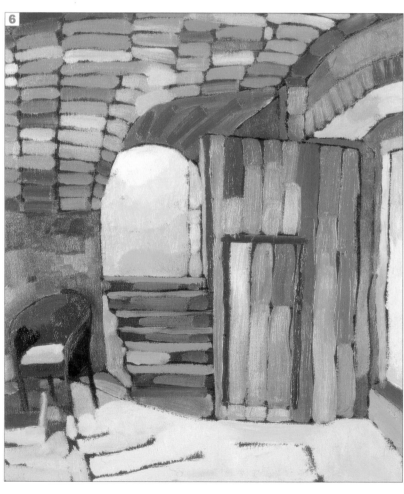

4. On the door, the brushstrokes are vertical and thick. Again, we leave a small space where the color of the background is visible. These green vertical lines help us describe the cracks between the wood planks.

5. Now we tackle the areas of shadow, which we paint with medium blue. On the stairs and the floor, the colors will have a greener undertone.

6. We finish this expressionist painting with a white-green on the floor and a light yellow for the doorway. The green background helps outline the profiles of the forms.

COLOR COMBINATIONS AND CONTRASTS

*F*orm is created through contrast of colors and tones. Without contrast there is no perception, and therefore, no expression. However, to ensure good expression you do not necessarily need to have very strong contrasts. Sometimes, a subtle difference in tone or light can convey great emotion. Since contrast is based on differences, the goal then is to create those differences according to a poetic or expressive intention.

■ André Derain (1880–1954), *Boats in Collioure.* The strong contrast between reds and blues helps define the location of the boats on the beach.

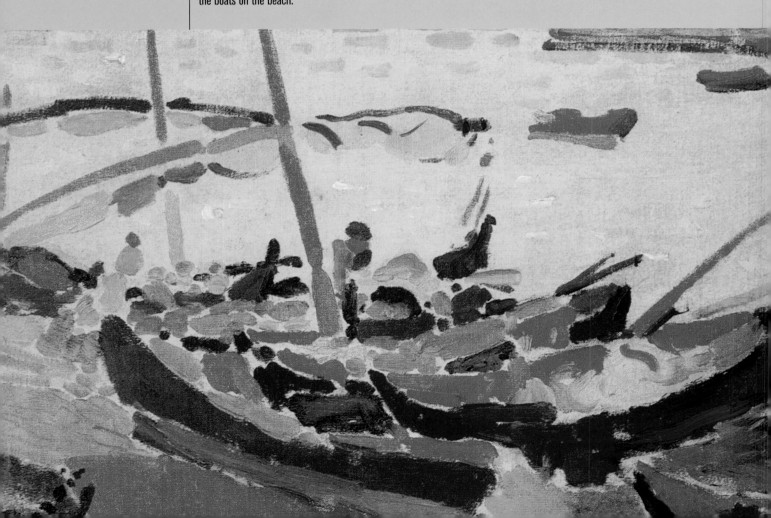

PAINTING

MASTERING
COLOR
COLOR COMBINATIONS
AND CONTRASTS

119

"Yellow can express happiness and, then again, pain. There is flame red, blood red, and rose red. There is silver blue, sky blue, and thunder blue. Every color harbors its own soul, delighting or disgusting or stimulating me."
Émil Nolde

FORCED LIGHTING

Lighting is often forced to create greater contrast between colors. To do this, the colors are lightened more than usual to achieve exaggerated shading effects or the combination of hard and soft shadows on a single plane. This can be useful to emphasize a detail or to surprise with dramatic light. Most paintings of night scenes have forced illumination.

■ Interaction and contrast between colors are indispensable in the construction of a painting. For this purpose, it is a good idea to experiment with different interpretations and ways of applying paint.

Light and color contrasts

Contrasts of light occur more than any other kind in painting; their purpose is to define light and shadow clearly, establishing two distinct areas. This concept is not incompatible with contrasting colors; on the contrary, both types of contrast are very compatible. In fact, often they are both found in the same painting. Therefore, you can distinguish two different areas not only by using warm and cool colors but also by lightening or darkening some of them to increase the difference between the two areas.

■ Mikalojus Konstantinas Txiurlionis (1875–1911). In addition to the color contrasts, the forced light plays an important role in this painting.

The emotional component of colors

One of the most important aspects of color is its emotional component, capable of stimulating our senses. The right selection of colors is fundamental for conveying a specific feeling to the viewer. Colors can stimulate and influence our state of mind; red expresses passion, green nature and harmony, blue calm and cool, brown firmness and stability, yellow warmth and purity… Many of these colors are perceived the same way in different cultures, giving them a symbolic and psychological meaning that affects the way people see the painting.

The paint is applied smoothly in the form of geometric shapes to avoid distracting from the chromatic experiment with unnecessary details and textures.

Synthesis of colors

When the colors of a model are complex and varied, the artist may choose to treat color in synthesis. To do this, first it is important to analyze the distribution of the colors, their similarities and intensity. Then, each area has to be simplified, connecting shades with a smooth stroke of color, leaving out the gradations. The chromatic impact depends on simplifying the colors as much as possible. The best way to understand synthesis is by experimenting with it.

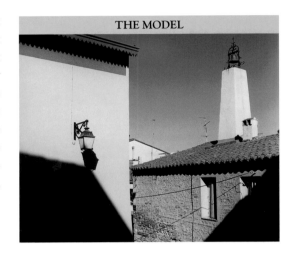

THE MODEL

■ Synthesizing means simplifying the representation of an object as much as possible. An example is this tree, which was painted with a single stroke of oil paint and sgraffito added with the handle of the brush.

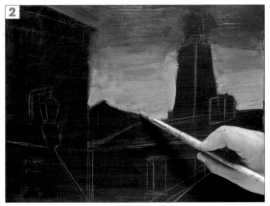

■ A village scene with façades transformed by the effect of light and shadow.

1. We draw the rural theme with a white colored pencil over a dark background, so that the lines will stand out better.

2. Using acrylic paints, we cover the sky with a gradation of blues, darker above and somewhat lighter below. The light in the sky helps define the silhouettes of the buildings.

3. We paint the lighted façades of the building and the small bell tower with yellow ochre mixed with white and light gray. The paint is smooth and the areas of color are well defined and simplified.

4. We have painted the other façade with a different shade of ochre, and resolved the chimney and the house in the background with white. We have used orange sienna on the roof, where a few simple lines hint at its angle and the forms of the shingles.

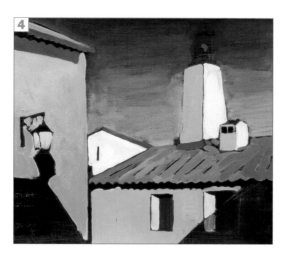

5. After resolving each part of the painting with large areas of uniform color, we include the small lantern and barely suggest a few shingles and the form of the top of the bell tower.

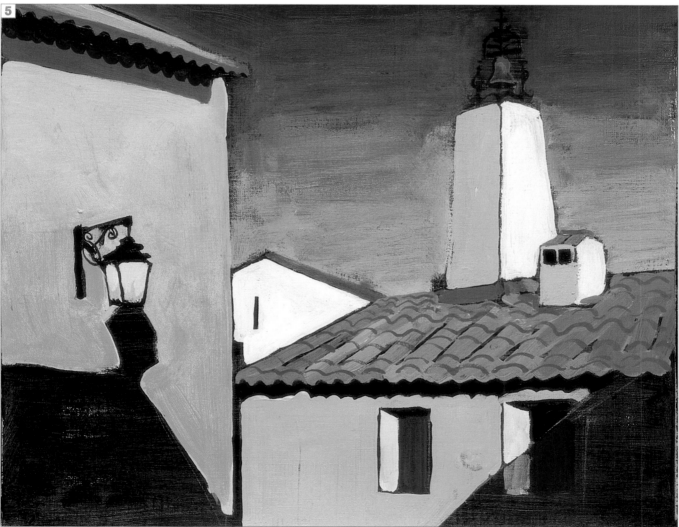

**MASTERING
COLOR**
COLOR COMBINATIONS
AND CONTRASTS

PAINTING

122

Contrasting color ranges

■ A cool chromatic range is a family of colors that includes blue, violet, and a few greens.

Chromatic ranges are families of colors that go well together. A painting with only one color range can look cold and monotonous. The best way to liven it up is by contrasting two ranges that are opposite each other on the color wheel. The best contrast is one that counters warm and cool colors, which can either be saturated or somewhat neutral. Let's look at a couple of examples.

Cool colors and warm colors

Warm colors are those that appear to emanate warmth: red, carmine, orange, yellow, and their combinations. Sienna colors can also be considered warm because they have a yellowish or reddish undertone, like ochre and natural sienna.

Cool colors are ones that relate to vegetation, sky, and water, and include saturated green to violet blue, with all the turquoise tones and blues in between. Colors that are not very saturated or vivid tend to look cool, especially if they are related to the range of blues and greens.

■ A warm chromatic range is a family of red, rose, orange, and yellow colors that go well together.

■ The contrast of warm and cool colors in this painting achieves a clear spatial distribution, with the closest objects painted with warm colors.

HOW TO COOL WARM COLORS

Warm colors can be cooled by adding white, black, or both at the same time. The resulting colors continue to be warm, but they are less warm.

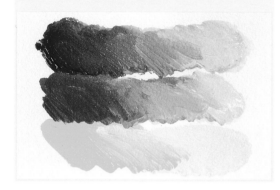

Contrasting color ranges

Contrasts between warm and cool color ranges can be used to describe forms and to create the illusion of space and depth. The opposing nature of two color ranges conveys distance between them. Generally, cool colors suggest distance with respect to the foreground of the painting; they are used more in the background of the painting or for the distant planes of a landscape. Close objects or the areas of a painting with more light are represented with warm colors, most vividly when they include yellow. Expressionist painters took advantage of this contrast between color ranges to express distance or to direct the viewer's eye to the focal point of the painting.

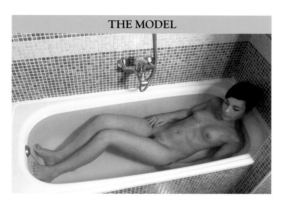

THE MODEL

■ Bath scenes with female figures were a very popular recurring theme among colorist painters of the early twentieth century.

1. After making a very loose drawing of the model, we adjust the colors. We apply warm tones around the face to direct the viewer's eye to that area.

2. Once the painting is finished, we see that the warm colors are concentrated in the area around the face and the cool colors are mixed more moderately in other areas of the painting, creating a very rich, luminous harmony.

Contrasting complementary colors

When two complementary colors are juxtaposed they make each other stand out. They create a very vibrant sensation in which both colors become more brilliant. Complementary colors have nothing in common; they are opposite each other on the color wheel, canceling each other out and creating tension, as if they are competing for attention. Artists keep this effect in mind and tend to juxtapose complementary colors in their paintings to give them greater vitality and intensity.

■ These three groups of colors, consisting of one primary color and one secondary color, are the purest complementary colors. Every artist should be familiar with them.

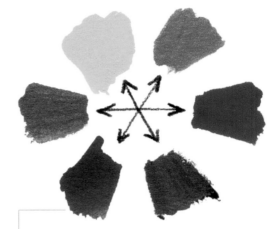

■ Complementary colors are opposite each other on the color wheel and produce the highest possible contrast.

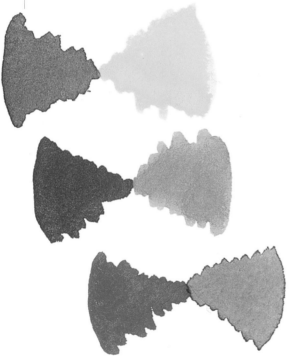

Opposite colors

There are three main groups of complementary colors, each made up of one primary color and one secondary color: blue and orange, red and green, yellow and violet. Each pair of colors produces the highest possible degree of contrast. It is a good idea to remember them, because work that follows this principle is based on the juxtaposition of these six colors, with some tonal variations, of course.

Same tone

To get the maximum contrast effect between two complementary colors, the colors should have the same undertone and intensity. If, on the other hand, there is a marked tonal difference between the colors, the contrast will be less noticeable, losing intensity as a result. For this reason, you should learn how to adjust the tones of complementary colors properly.

■ When there is a great difference in intensity between two complementary colors, the vibrant contrast is reduced. To recover the contrast, the two colors should both have the same value.

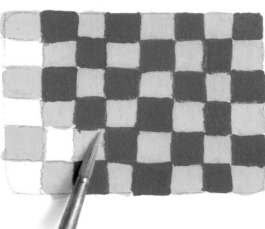
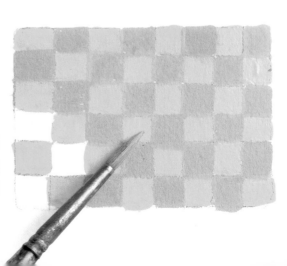

PAINTING

**MASTERING
COLOR**
COLOR COMBINATIONS
AND CONTRASTS

125

CAUTION: MIXING COMPLEMENTARY COLORS

When two complementary colors are juxtaposed, the contrast can be bright and expressive, but when they are mixed together they neutralize each other, producing muddied colors like grays and browns. Therefore, it is not a good idea to mix them if you want a luminous, colorist painting.

Adjacent complementary colors

If a less striking contrast is desired, adjacent complementary colors can be used instead of absolute complements. When complementary and adjacent colors are used, the combination is referred to as adjacent complements. For example, blue is the complement of orange, and its adjacent complements are blue-violet and blue-green. True complementary pairs are not the same as those in theory; they are determined by the circumstances, and the shades will always vary.

■ These colorful façades, with a projected shadow, will be painted with complementary colors.

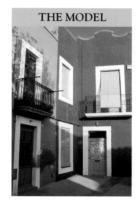

THE MODEL

1. The artist's first instinct is to paint with warm, saturated colors, with the basic complementary colors.

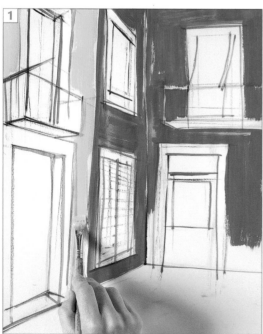

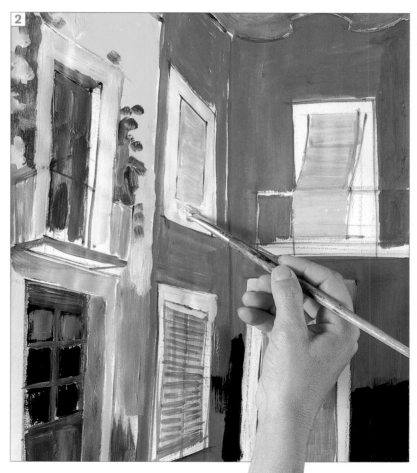

2. As the painting progresses, secondary colors come into play as brief tonal alternatives, adding greater variety to the painting.

Shadows with complementary colors

In colorist work, you can paint shadows with complementary colors. For example, a lemon, which has a very bright yellow color, will have a violet shadow, while an apple painted with carmine red will be represented with a green shadow. Fauvist painters used this complementary color principle often to make their paintings stand out with exaggerated color schemes.

1. We first make a preliminary pencil drawing. Then, we mark the outline of the model with thicker, firmer lines using a round bristle brush charged with a small amount of oil paint mixed with mineral spirits.

PHASE 1:
PREPARING THE BACKGROUND

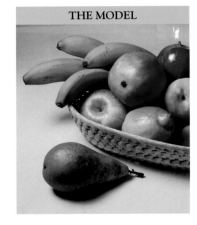

THE MODEL

■ The composition is very simple, a still life with fruit of various colors.

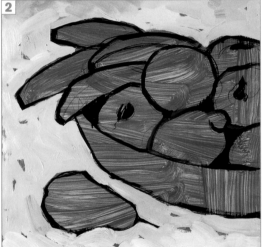

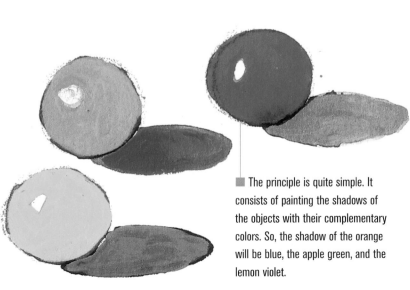

2. The first colors are applied to cover the background; we use violet paint mixed with a generous amount of white. We leave a few areas unpainted so the underlying color can be seen.

3. With thick, opaque oils, we paint the light areas of each piece of fruit. The colors used are brighter and more saturated than in real life.

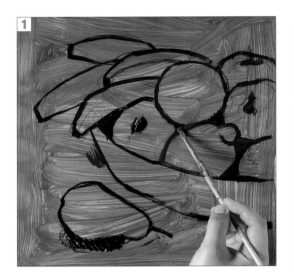

■ The principle is quite simple. It consists of painting the shadows of the objects with their complementary colors. So, the shadow of the orange will be blue, the apple green, and the lemon violet.

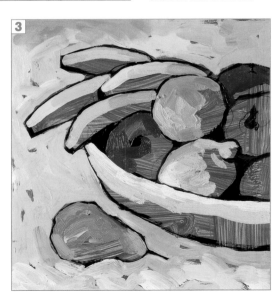

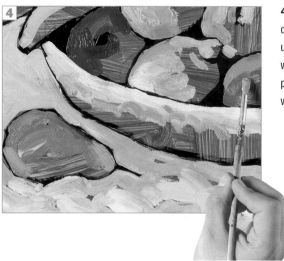

4. The fruit should not be constructed with smooth, uniform colors, but rather with brushstrokes that provide small color variations.

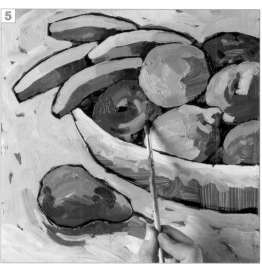

5. We paint the shadow of each piece of fruit with its complementary color. So, if the apple is red the shadow will be green, for the yellow bananas and lemons it will be violet, and so on.

6. Finally, we paint the blue shadows of the mango, which has an orange undertone. To obtain a good complementary contrast, the shadows of the colors should not be dark, but bright and vivid.

Optical color mixing

The basic principle of optical color mixing consists of applying a series of colors with small individual dots, which are then mixed "by the viewer's eye" and converted into the expected colors and shades. The colors seen up close look like individual dots of paint; however, when viewed from a distance the colors are mixed optically and appear brighter than if they had been mixed on the palette. This is because they do not interfere with each other, and the vibrancy of the individual colors is not lost when viewed as a whole.

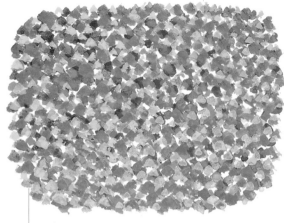

■ With pointillism, a surface that at first looks orange may contain small brushstrokes of opposite colors, like blue.

The smaller the colored dots the more evident the optical mix.

Superimposing colored dots

The technique of working with superimposed colored dots was inherited from the Divisionist painters, who believed that every surface is divided into a myriad of shimmering colors that come together to form a single overall tone. For example, an orange object might include small touches of red or blue. Since there is minimal color intervention, they blend optically and fuse together, forming unified shades or ample gradations when the painting is seen from a few feet away.

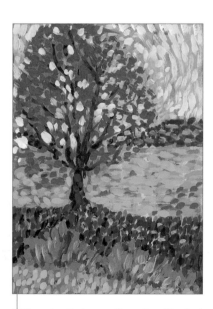
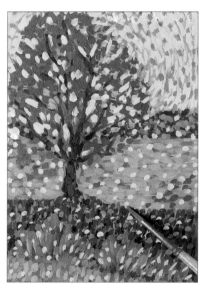
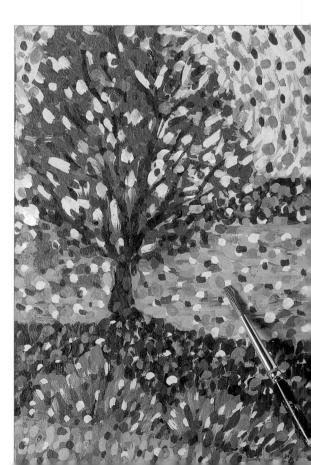

■ To work with dots, we first paint a blue background on the support. The first colored dots are quite homogenous and large. As the painting progresses we add new colors to the previous ones, and the dots become progressively smaller in size.

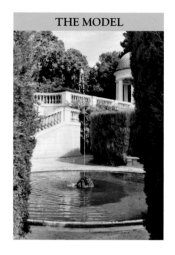

THE MODEL

Pointillist garden

Now we are going to put the application of color with the pointillist technique into practice. This means that the colors of the model will not be painted directly but by mixing numerous colored dots on the surface of the support. Therefore, you must learn to see the colors that are not presented by the model; in other words, you should envision the colors that from a few feet away will offer a convincing chromatic feeling. It is a good idea to begin painting with acrylics; the quick drying time of each colored dot will prevent the colors from mixing with each other.

PHASE 1:
PREPARING THE BASE

■ The pointillist effect can also be achieved with short brushstrokes; however, this requires a larger format of painting.

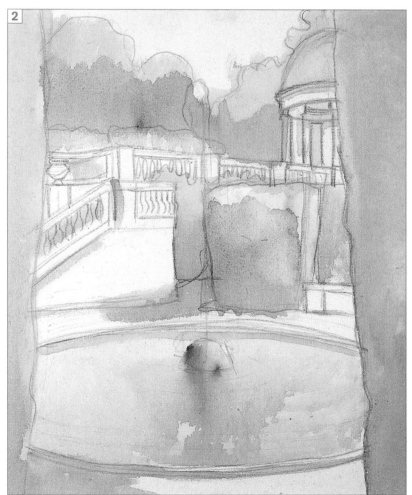

1. With a 2B pencil we sketch the model. The vegetation can be drawn freely, but it is important to pay close attention to the architecture.

2. We reduce the impact of the white of the support by covering a few areas of the scene with a blue wash.

POINTILLISM

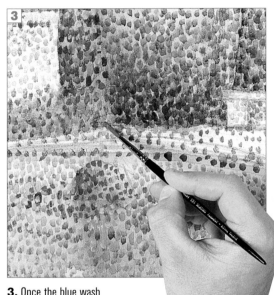

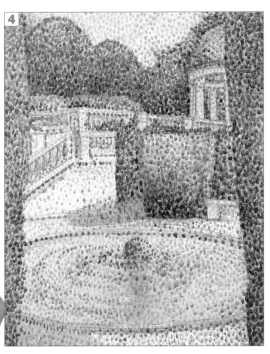

3. Once the blue wash has dried, we apply the first blue and green dots, which should cover the surfaces completely.

4. In the areas of shadow, dots are painted very tightly together, while in the areas of light, the brushstrokes are more relaxed.

HOW TO BLEND THE EDGES

With the pointillist technique, the separation between two colors can be clear and well defined or irregular, forming a gradation. We can see in the three examples below how the edges between the two colors are softened by letting the dots from one side invade the adjacent area little by little.

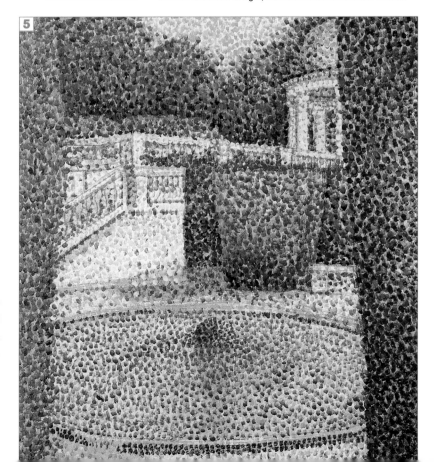

5. The areas of light on the vegetation are painted with yellow and orange. On the shadows of the bushes, on the other hand, blue is the predominant color.

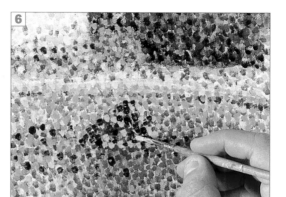

PAINTING

MASTERING
COLOR
COLOR COMBINATIONS
AND CONTRASTS

131

PHASE 3:

THE SHIMMERING EFFECT

6. We introduce intense blue and brown colors to darken the shadows and to highlight a few profiles, which will help maintain the definition and contrast of the different areas.

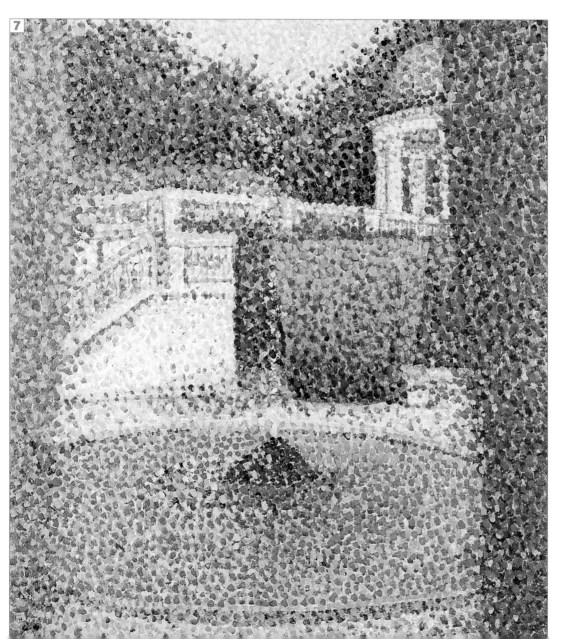

7. The accumulation of minute colored dots provides an amazing effect. It looks like a painting made up of very small, shining light reflections that make the entire surface vibrate. Look carefully at all the color combinations in each area.

Landscape with anticerne effect

The anticerne effect refers to the white or saturated color from the background that shows between the brushstrokes of paint that define the model, producing a striking and expressive effect. If the color "between" the painted colors is visible throughout the painting, it also adds great overall harmony. It is a very interesting effect with which all beginners should experiment. Let's use the following exercise as a guide to understanding this method better.

PHASE 1:

FIRST COLORS ON A SATURATED BACKGROUND

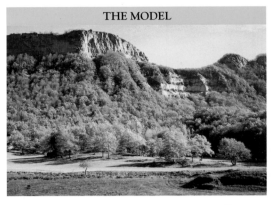

THE MODEL

■ The model is a serene view of an autumn scene with predominant orange and ocher tones.

1. The color selected for the background is a very saturated orange. This first layer of color can be painted with acrylics so it dries quickly. Then, we sketch the theme with a pencil.

2. From this point on, we will use oil paints. We cover the sky and the grassy area in the foreground with thick paint. The colors should be luminous and leave some areas of the background color visible.

With the anticerne effect, the color of the background can be seen through the brushstrokes, transmitting energy and greater vitality to the painting.

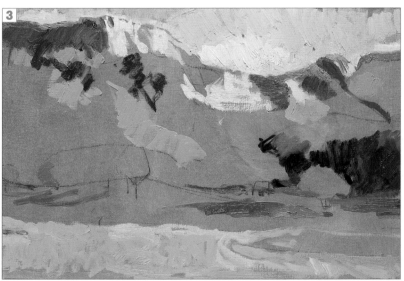

3. We define the light and dark areas on the mountains with ochre mixed with white and dark violet, respectively. Again, we allow the background to come through by leaving some areas unpainted. The orange from the background helps define the outlines of the hills.

PHASE 2:
OPAQUE BRUSHSTROKES

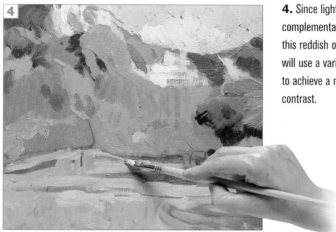

4. Since light green is the complementary color of this reddish orange, we will use a variety of greens to achieve a more striking contrast.

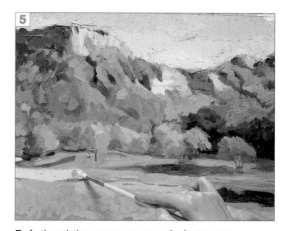

5. As the painting progresses, we apply shorter, more overlapping brushstrokes until the vegetation is almost completely covered, defined by the contrast between areas of color.

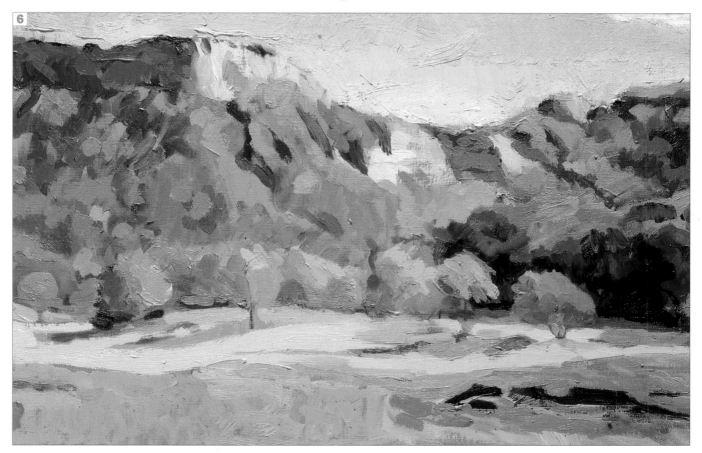

6. This landscape has been represented by overlapping colors without details, and it has a marked colorist look as a result of the traces of orange distributed throughout the painting.

MASTERING
COLOR
COLOR COMBINATIONS
AND CONTRASTS

PAINTING

134

Color application techniques

There are many ways of applying color on the support. Each technique derives from a specific style and affects the final result of the work; this means that the chosen approach will determine whether the painting is naïve, impressionist, expressionist, or synthetic in style. Before we continue with more exercises, let's look at some of the main methods for applying and manipulating paint on the support. We will begin with the wash technique and finish with oil paints.

WASH TECHNIQUES

■ Applying gradations with washes is ideal for representing the volume of flat surfaces.

■ These hatch lines work like glazing. They can be applied with watercolors or with acrylic paints.

■ Block painting with color consists of constructing the subject with a series of smooth color blocks.

■ Glazes are translucent color washes that are applied one over the other to obtain deeper colors.

■ In painting wet on wet, one color is applied beside another that is still wet so they blend together to create gradations.

■ Pointillism can be done with washes or with opaque paint. The technique is based on the juxtaposition of numerous colored dots that are mixed by the viewer's eye.

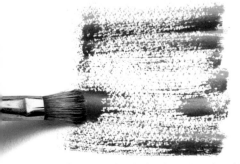

■ Painting with a dry brush consists of applying the paint almost dry so the color breaks up, leaving striated marks.

■ Watercolor and acrylic paint can be splattered on the paper with a brush to give a dotted effect.

■ When paint is applied on a wet surface, the edges bleed and the color integrates with the color of the background.

OPAQUE TECHNIQUES

■ Paint mixed with mineral spirits is normally used during the first phase of the painting to cover the support quickly.

■ A tonal scale is created by changing the color gradually with small, well-defined tones of color.

■ Neutral colors can be made by applying short brushstrokes of juxtaposing colors, generally painted in the same direction.

■ Striated colors are created by applying a quick brushstroke of paint with a small amount of mineral spirits. The best results are obtained on paper.

■ The sgraffito technique can be used with oils and acrylics. Some of the paint is removed, leaving the color underneath exposed.

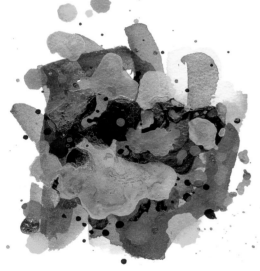

■ Color can be applied in a whimsical way, forming drips and puddles. This is a hallmark technique of acrylic paints.

■ To form bands by dragging, paints are aligned on the canvas and then dragged in the same direction at the same time with a spatula.

■ This is impasto done with a brush. The tip of the brush is charged with a generous amount of thick oil paint and applied gently, with the brush held at an angle.

■ Paint can be applied as an impasto with a spatula. The colors appear very textured, and the painting acquires a three-dimensional quality.

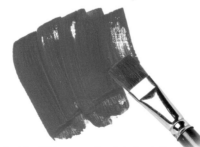

■ Applying thick, opaque brushstrokes is the most common technique in oil and acrylic painting. The paint should be thick, not diluted.

■ Blending consists of mixing colors together by repeatedly brushing the surface of the support.

Expressive brushstrokes

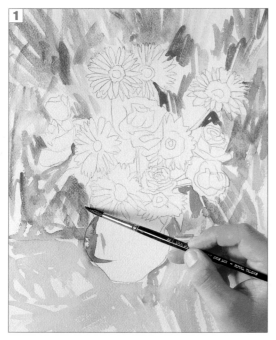

The best way to bring a painting to life and give it movement and spontaneity is to use quick, gestural brushstrokes. The brush marks should be clearly visible, overlapping each other in a carefree way to convey the same dynamism to the entire surface of the painting. Flower themes are the ideal subject for representing color very freely. You can achieve excellent results by working with quick, colorist brushstrokes, as long as you keep in mind the intention and direction of the brushstrokes. Let's look at an exercise with an expressive approach done with watercolors.

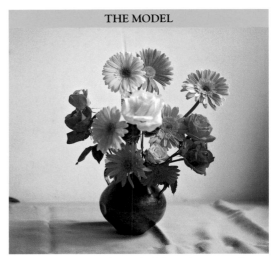

THE MODEL

■ Still life themes with flowers lend themselves very well to an informal, gestural approach.

PHASE 1:
WASHES

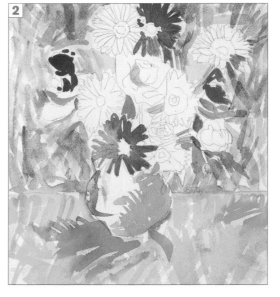

1. With the pencil sketch finished, we begin to cover the background with blue and violet washes. We do the same with yellow ochre on the table. The paint does not cover the white paper completely.

2. After letting it dry, we add new gestural brushstrokes with green washes on the background. We paint the flowers with radial brushstrokes that go outward from the inside of the flower.

3. Each flower is painted its own color. Some areas are left unpainted because they will be defined later. The brushstrokes should be concentric and, if possible, somewhat vigorous.

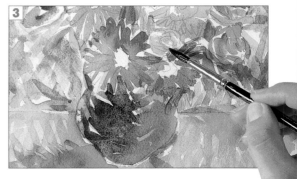

A painting is expressive when it has life and internal vitality, when the figure is as convincing as the real object and is not reduced to a cold representation.

PHASE 2:

SHAKING UP THE SURFACE

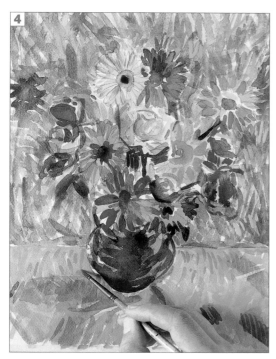

4. It is time to move the brush around. We juxtapose new, less diluted brushstrokes with the previous ones to give the flowers more color and variety.

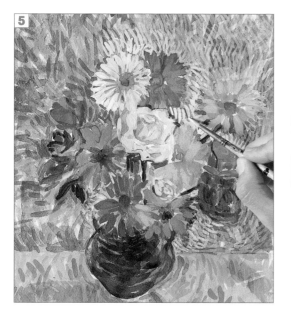

5. When the washes are dry, we cover the background with thin brushstrokes of white gouache, which become more transparent when they dry.

6. The paint and the brush marks have saturated and filled up the surface. The overlapping brushstrokes make the colors vibrate, giving the painting an illusion of movement.

Painting

From transparent to opaque

To paint well with washes, the artist must master, in addition to mixing and combining colors on the support, techniques for controlling water, because washes and water are intimately related.

Water is not only used to dilute paints, but it is also the basic medium for their application and manipulation. In fact, wash techniques can be classified by how much water is used in the process. It is important to be careful with washes because this technique, which appears very simple at first, requires ability and patience. It is the first step to getting started with watercolors, gouache, and acrylics.

PAINTING WITH WATERCOLORS

The fluid nature of watercolors makes them less stable than other painting media, but they compensate for this with the wide range of beautiful effects that can be achieved, which sometimes occur by accident. Watercolors are one of the most versatile painting media, but they can also be quite difficult. Water determines the consistency of their color, their tone, their transparency, and how they mix with other colors. This dependency on water makes watercolors an art form with particular technical characteristics that differ to a certain degree from those of drawing.

■ Mariano Fortuny (1838–1874), *Patio of the Pilatos House in Seville.* The area that is to remain white is left unpainted. The brush is kept away from it.

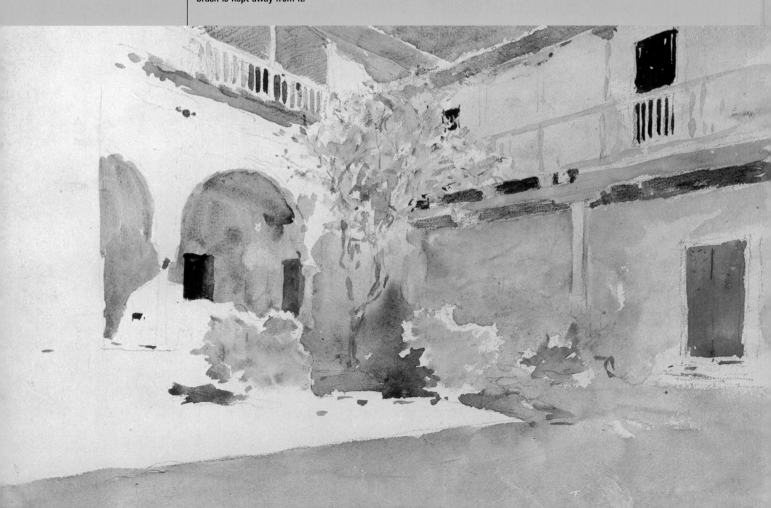

PAINTING

**FROM TRANSPARENT
TO OPAQUE**
PAINTING WITH
WATERCOLORS

141

*Transparency is an important factor in washes because changes in
the tonal intensity of the colors depend on it. The transparency of
the colors makes it possible to reduce the tone to the point of making
it almost indistinguishable from the white of the paper.*

VARIETY OF TEXTURES AND EFFECTS

A great variety of effects can be obtained with watercolors, from using the paper's texture to your advantage, to creating uneven brushstrokes, to using accessories, like sponges, masking fluid, sandpaper, and even bleach, to alter the consistency of the painted surface.

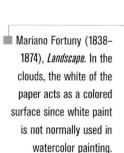
Mariano Fortuny (1838–1874), *Landscape.* In the clouds, the white of the paper acts as a colored surface since white paint is not normally used in watercolor painting.

Using less water makes watercolor paints more intense and the lines firmer and more contrasted.

Delicate and luminous

Watercolors are the most delicate and elegant of all the painting techniques. It is the perfect medium for capturing nature's subtle light and colors. The transparency of the watery colors makes the white reflective surface of the paper stand out, giving the painting a unique luminosity. White does not exist in watercolors, so the paint is diluted with water to make it more transparent through its relationship to the white of the paper. The areas that are left unpainted are indispensable for representing the light's reflections. As new washes are layered over the reflective surface of the paper, the colors become richer and darker because the white paper becomes less visible.

Extending the washes

Watercolor technique is simple. In principle, it simply consists of soaking the wet brush with paint and applying it on the paper, extending it with more water to make a gradation. At first, the paint is applied with very light washes, which are made darker as the work progresses. Painting with dark colors from the beginning could make an area darker than it should be, forcing the artist to darken the rest of the painting to maintain the correct overall tonal relationship.

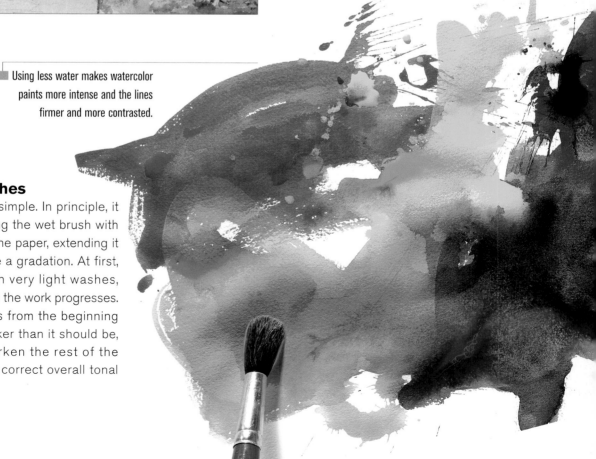

Two flowers on a blue background

When a model has very few elements, it is much easier to paint; there are fewer colors and the main difficulty consists of knowing how to create contrasts with just a few tones. In the next exercise we will apply smooth washes first with the basic colors for each area, and then we will study in detail the areas of light and shadow. We will represent the different shades and intermediate tones with superimposed washes.

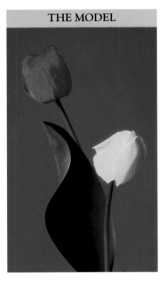

THE MODEL

PHASE 1:

FIRST

WASHES

1. We paint the background with a half-and-half mixture of cobalt blue and cerulean blue. This will make the flowers stand out vividly. It is important to stay inside the lines when painting the flowers.

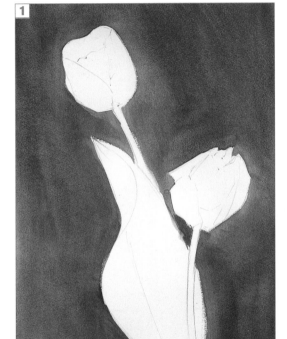

■ Consisting of a pair of flowers and a leaf on a blue background, the theme includes the three primary colors plus green.

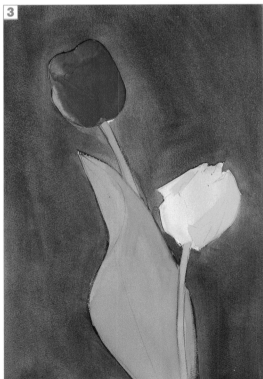

TWO TYPES OF BRUSHES

The larger washes are painted with a medium round brush. It can be combined with a thin brush to paint the contours of the flowers, carefully staying inside the pencil line.

2. We paint the base color of the flowers with two flat washes mixed with a small amount of water. Our goal is to cover the white of the paper as quickly as possible.

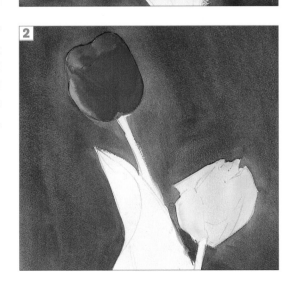

3. We mix a medium green and yellow to paint the stem and the leaf. This creates a luminous green foundation that can be darkened easily in subsequent phases.

PAINTING

FROM TRANSPARENT
TO OPAQUE
PAINTING WITH
WATERCOLORS

143

PHASE 2:
SHADING AND VALUES

■ We use six basic colors in this exercise: cobalt blue, cerulean blue, cadmium red, cadmium yellow, medium green, and Hooker's green.

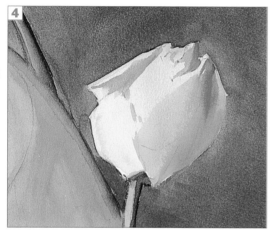

4. When we add a touch of red to yellow, we obtain an orange tone that can be used to paint specific areas of the flower on the right to define light and shadow. This is done when the previous layer of wash is dry.

5. The previous green is darkened slightly with Hooker's green, and we paint the inside of the leaf, defining the areas of light and shadow.

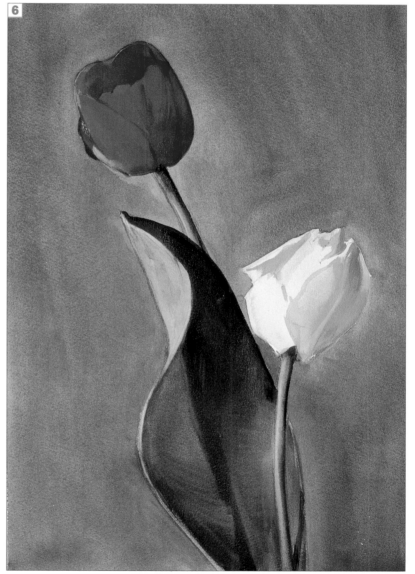

6. With a red that is slightly tinted with blue, we paint the shadows of the red flower. The same blue is added to the previous green to darken the wash. Then we paint the darker areas of the leaf with several layers of this color.

**FROM TRANSPARENT
TO OPAQUE**
PAINTING WITH
WATERCOLORS

PAINTING

144

Seascape: applying color by area

In the following exercise we will learn how to paint a seascape with flat tones divided into areas of color without the need for further painting. Follow this exercise closely, as this approach is often the starting point of many other techniques.

PHASE 1:

**INITIAL
SMOOTH
WASHES**

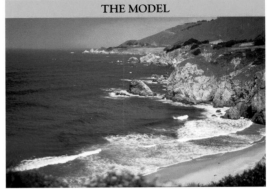

THE MODEL

■ Seascapes are the preferred theme of many artists who enjoy painting outdoors.

1. We sketch the scene without any shadows. The pencil drawing should be very clear, as each area of color must have clear outlines.

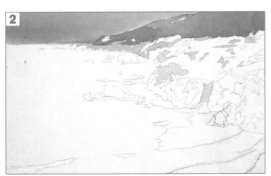

2. We paint the sky with cerulean blue and cobalt and apply a smooth wash over the mountains in the background with a violet tone. The spaces in between will be painted with the warmest, greenest yellow.

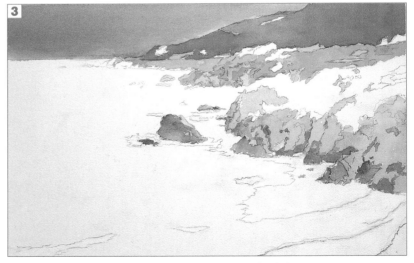

3. With a mixture of sienna and ultramarine blue, we obtain the ideal gray for the cliffs. In the background there is another transparent green, lighter than the first one. When the paint is dry, we darken the rocks with another layer of the same gray.

FROM TRANSPARENT
TO OPAQUE
PAINTING WITH
WATERCOLORS

145

FILLING EACH SPACE

4. As we get closer to the foreground the green gets darker. This is achieved by adding less water to the mixture each time, until we reach the dark green bushes.

■ When the wash requires great precision, it is necessary to use a medium or fine round brush.

A WELL-STRUCTURED DRAWING

The difficulty of this exercise resides in the drawing. It should be very structured with a clear definition of the forms to show us where each tone, color, and contrast should go. The pencil drawing should be strong and visible because it will be our reference during the entire process.

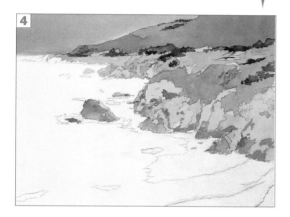

5. We use white wax on the foam of the waves. Then the large area representing the sea is painted with a very light green-gray.

6. When the washes are dry, we again paint the foam of the waves breaking on the beach and the rocks. We introduce a new blue wash on the sea; notice how the areas treated with wax are unpainted. To finish, the sand is painted with very diluted gray.

**FROM TRANSPARENT
TO OPAQUE**
PAINTING WITH
WATERCOLORS

PAINTING

146

Spring: a looser approach

I n the previous exercise we used a technique based on well-structured, almost rigid, areas of color. Now we are going to go a step further and experiment with a more spontaneous approach, letting the color blend on the support. To create fresh colors, paint should be used sparingly and water generously. Too many mixtures tend to overload the colors, giving them an earthy appearance and diminishing their vibrancy.

THE MODEL

■ The main appeal of this model is the saturation of the greens and the chromatic tension achieved with the red flowers.

PHASE 1:

**DISTANT
AREAS**

1. Painting the sky requires using generous amounts of water. The color is distributed unevenly, leaving some bright white areas unpainted for the clouds. Taking advantage of the fact that the paper is already wet, we paint the profile of the mountains with blue.

2. We combine different gradations of green to suggest the vegetation in the distance. The treetops will be lighter than the base.

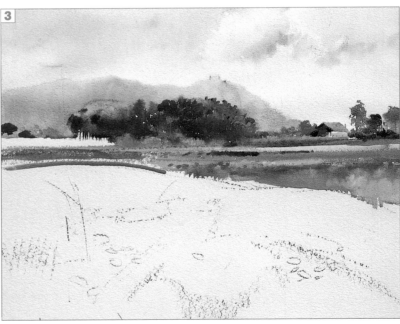

3. The fields far away, the ones that are located below the line of trees, are layered stripes of color, a series of straight, perfectly horizontal lines.

PAINTINFG

**FROM TRANSPARENT
TO OPAQUE**
PAINTING WITH
WATERCOLORS

147

PHASE 2:
FLOWERS AND GRASS

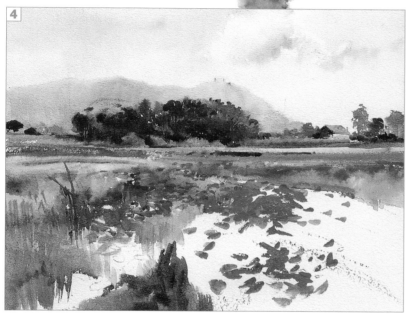

4. We paint the closest group of flowers by accumulating smudges of red color. When painting the grass, we leave small areas for the details of the flowers unpainted.

5. We resolve the grass with vertical brushstrokes of different greens and ochres, adding just the right amount of water for the colors to blend.

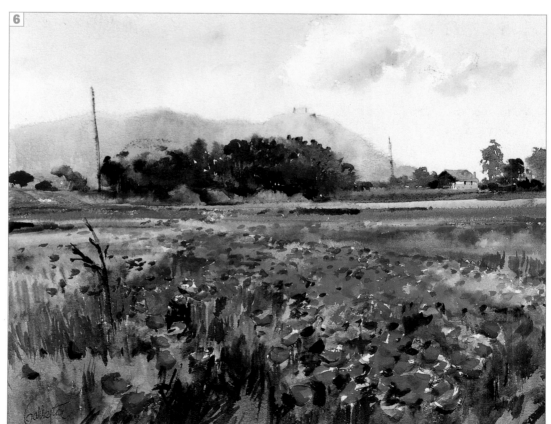

6. The closest poppies are defined by suggesting their petals and dark centers. We add more green, carefully, in the white areas between the flowers.

Still life with dry brush techniques

In the following step-by-step exercises, we will see two opposite ways of working with watercolors: with the dry brush and by mixing colors on wet. We begin with the exercise on dry, which consists of painting with the color minimally diluted in water. This produces a broken, textured, grainy color that does not cover the white of the paper completely. Brushstrokes on dry are more effective if the paper has a little bit of texture or grain.

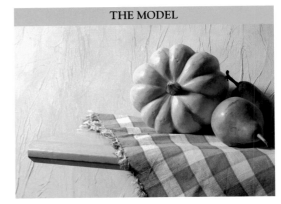

THE MODEL

■ Two pieces of fruit and a vegetable on a shelf with side lighting, which creates contrasting shadows.

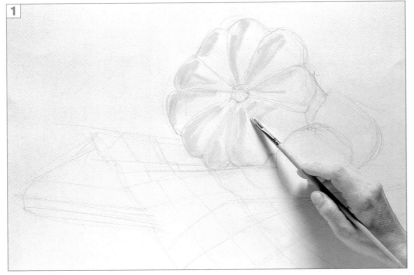

PHASE 1:

PAINTING BY RUBBING

1. We paint the lighted areas of the squash inside the pencil drawing with lemon yellow. It is a good idea to use bristle brushes, because soft-hair brushes will wear out quickly from repeated rubbing.

2. We define the forms on the squash with new ochre tonalities and with greens and browns on the pears. The idea is to rub with the brush almost dry, with the paint minimally diluted.

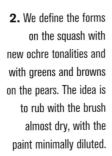

The paint adheres to the grain of the paper and gives the feeling of a granulated, sandy surface. It is applied thick, very undiluted.

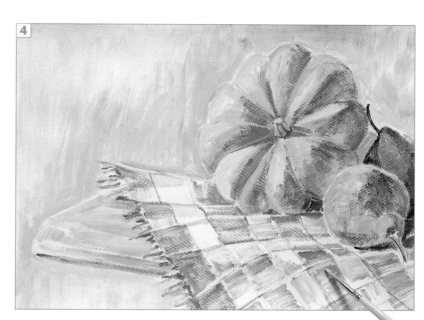

PHASE 2:
PAINTING FAST

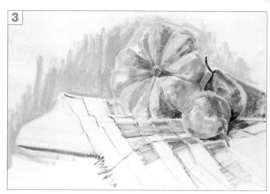

■ For the dry technique it is better to work with compressed watercolors instead of paint from tubes; this way the paint adheres to the wet brush without adding water.

3. New colors are added to complement the previous ones. We cover the background and lay out the tablecloth. The brushstrokes are fast; the grainy effect will disappear if the work is done slowly.

4. The areas of light and shadow should remain well defined through contrast. The squares of the tablecloth are painted with gray-brown mixed with a dash of green.

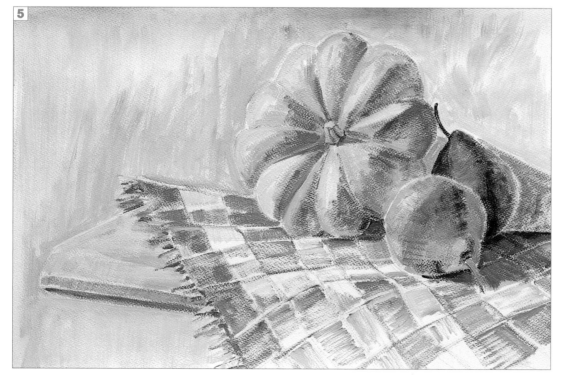

5. As the colors are layered, the white of the paper will disappear and the elements will look more compacted. Make sure that the objects do not blend together, which will cause confusion.

Still life: painting on wet

The following exercise is the antithesis of the previous one because we are going to paint a still life mixing the colors directly on the support, that is, on wet. Mixing colors together while they are still wet makes the paint flow better, allowing the colors to mix with each other randomly. The result has a foggy, airy appearance without rigid brushstrokes; the colors blend together forming soft gradations.

PHASE 1:

MIXING ON WET

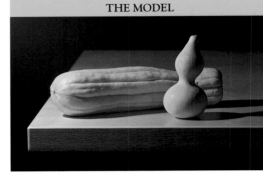

THE MODEL

■ The model has some similarities with the previous exercise. It consists of two pieces of squash of different shapes, with a clear chiaroscuro effect.

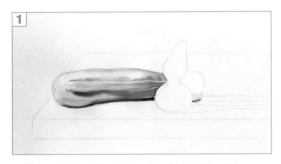

1. The pencil sketch is simple and undetailed. We paint the long squash with yellow and ochre as the base colors, which are mixed on wet with carmine and blue.

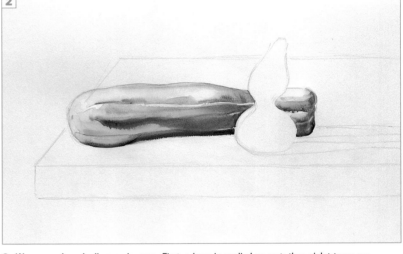

2. We proceed gradually area by area. First, a base is applied on wet; then violet tones are added to the shaded areas. We apply the colors progressively, making light tonal transitions.

■ This sequence shows the correct way of mixing colors on wet. First, the base color is applied, in this case yellow. Then, a small amount of blue and red is added. Finally, they are mixed with the wet brush, extending the wash as desired.

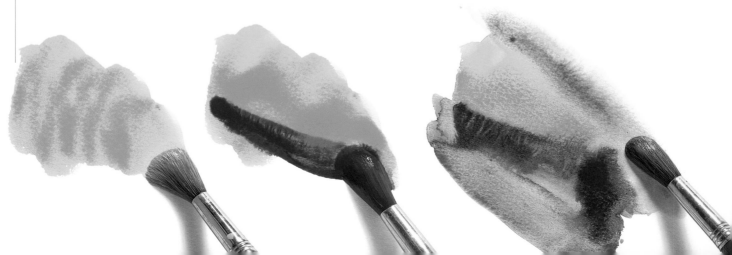

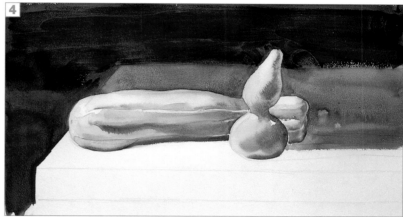

PAINTING

FROM TRANSPARENT
TO OPAQUE
PAINTING WITH
WATERCOLORS

151

PHASE 2:
FINISHING THE BACKGROUND

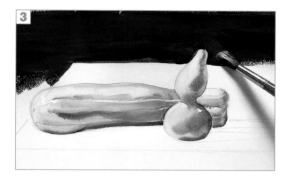

3. After letting the washes on the squash dry, we paint the background dark with a more opaque, less diluted violet-brown.

5. Now we only need to paint the same dark background color below the table; this time we will do it when the previous washes are completely dry to achieve a contrasting and well-defined contour.

4. While the brown paint of the background is still wet, we paint the table with yellow and carmine in equal proportions, adding a small amount of blue. This way, the profile of the table appears purposely blurry.

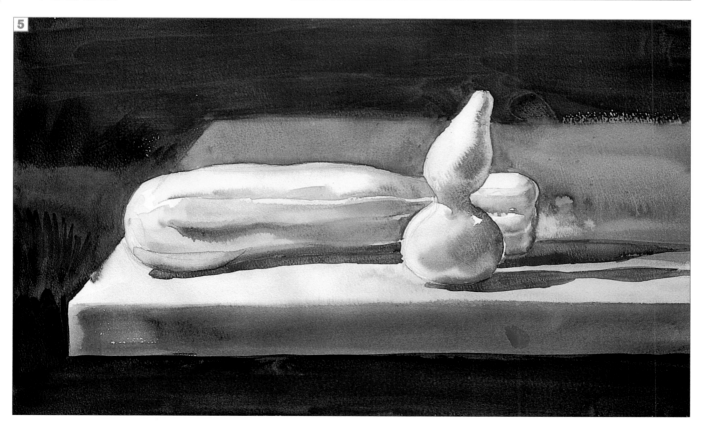

PAINTING WITH OILS

*O*il paints have a thicker consistency and opacity than watercolors. They are thick and pasty, and very easy to manipulate, mix, and correct when a mistake is made. All this allows you to easily control a large area of the canvas with the brush. It is the ideal medium for learning to paint, the best choice for a beginner, because progressive gradations of color can be easily achieved. This is possible because the paint stays wet long enough to withstand color additions.

■ Erich Heckel (1883–1970), *A White House in Dangast.* In oil painting, the direction of the brushstrokes is very important, as seen in the work of the German Expressionists.

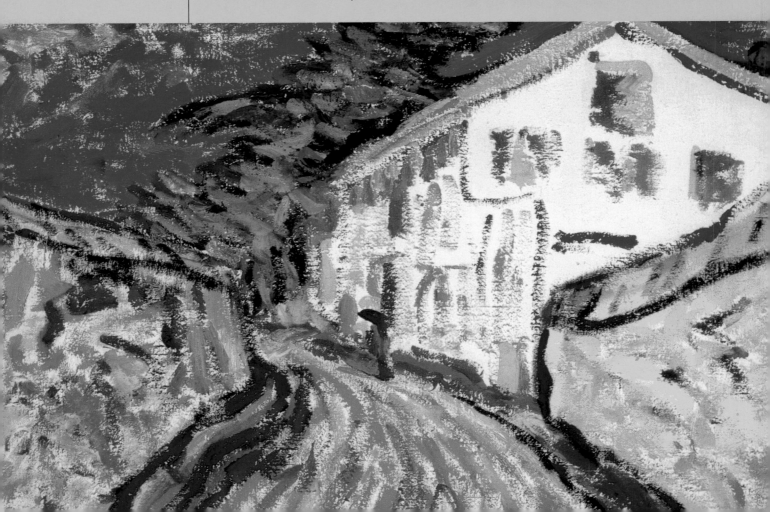

PAINTING

**FROM TRANSPARENT
TO OPAQUE**
PAINTING
WITH OILS

153

*The range of textures and effects that can be achieved with
oil paints is very wide, from creamy, wet brushstrokes to
dry touches of pigment on a very textured canvas.*

ADDING COLORS ACCORDING TO THE THEME

When arranging colors on the palette, you can widen the selection with one or two more colors depending on the theme. For example, for a seascape, you could add another blue; for vegetation, a different green. Such additions will give you more tonal variety.

The importance of the brushstroke

One of the main appeals of oils is the visible mark left by the brush. Their flow, their mastery, and their vitality convey a special freshness to the surface of the painting, giving it a textured effect. The feeling of movement is associated with the direction and the vigor of the brushstroke, which we should consider if we expect to transfer those sensations to our painting. There are many types of brushes, each with a specific function. Some are used to apply splashes of color, others to make small additions, and yet others are ideal to create homogenous surfaces.

Preparing the palette

Before you begin to paint, you must arrange the colors on the palette. There is no need to fill up the palette with every color available; you should only include the primary colors (cyan blue, magenta, and yellow) and white, along with three or four more colors that will help you get richer mixtures (ultramarine blue, ochre, burnt sienna, and sap green, for example). The colors can be arranged by temperature or in the order of the color spectrum. To mix the colors, drag the paint to the center of the palette and stir it until you get a smooth mixture.

■ Paul Gauguin (1848–1903), *Children in the Garden*. The slow drying time of oils allows the artist to manipulate the colors on the painting; the resulting tones are infinite.

FROM TRANSPARENT
TO OPAQUE
PAINTING
WITH OILS

PAINTING

154

Still life: a monochromatic approach

A monochromatic treatment is an excellent choice for a still life, because you can obtain different tones from the combination of only a few colors from the same family. This will help you understand the best way to lighten and darken colors. We are going to paint the following still life basically with a single color, burnt sienna. We will introduce three additional colors—ochre, white, and black—to add richness to the colors and to lighten and darken them. In a painting with a monochromatic tendency, the correct evaluation and mixture of colors is as important as the way in which the brush models the volume of each object.

**PHASE 1:
TECHNIQUE
WITH MINERAL
SPIRITS**

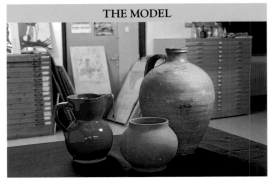

THE MODEL

■ A simple still life with three ceramic pots of similar colors, lit from the side.

1. The forms are defined clearly with a line made with a charcoal stick. A line that divides each object in two will help us paint them symmetrically and proportionately.

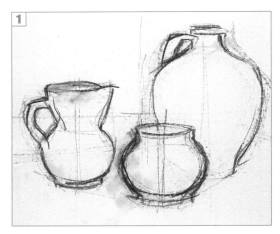

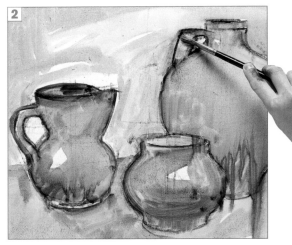

2. The first areas of color applied with a mixture of burnt sienna and mineral spirits establish the placement of the forms on the support and create a stable color foundation, so the subsequent colors will set better.

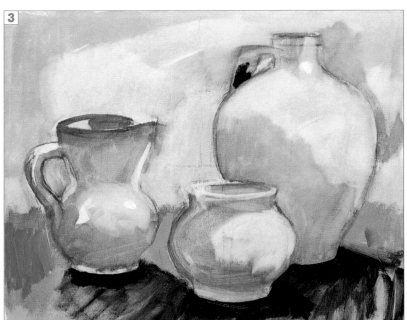

3. While the paint is still wet, we remove part of it from the lighted areas of the ceramic pieces with a cotton rag.

PAINTING

FROM TRANSPARENT
TO OPAQUE
PAINTING
WITH OILS

155

■ We repeatedly dab with a soft-hair brush to blend two colors together until we create a soft gradation that does not show any brushstrokes.

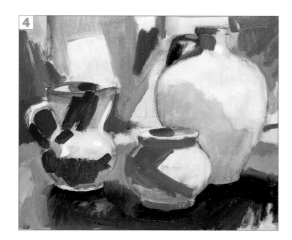

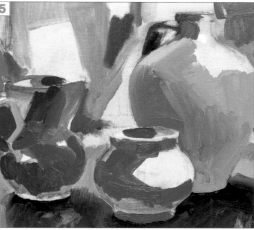

PHASE 2:
PAINTING AND MODELING

4. After setting apart the areas of light and shadow with the mineral spirit mixture, we apply the first opaque colors. During the first stage, we avoid covering the areas of light.

5. We resolve the volume of the ceramic pieces with new applications; we only need to lighten the initial colors gradually as they get closer to the lighted area of the object. The background is treated abstractly.

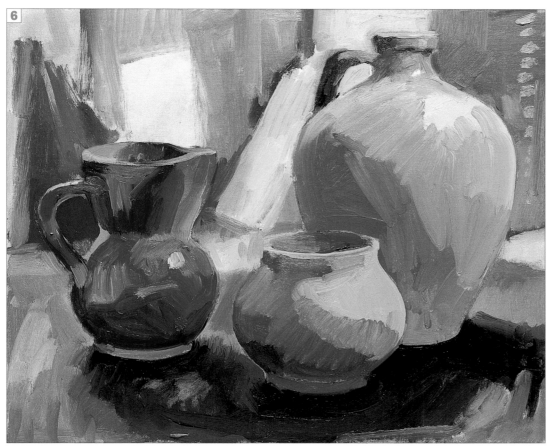

6. To achieve the final modeling effect of the piece on the right, we mix the different colors with a soft brush. The transition from light to shadow on the ceramic piece in the center is obtained with a tonal scale.

**FROM TRANSPARENT
TO OPAQUE**
PAINTING
WITH OILS

PAINTING

156

Landscape: a synthetic treatment

When the color structure of the model is complex and varied, you may want to synthesize it. For example, a scene that has vegetation with a variety of similar color values can be simplified into areas of color that are clearly separated. This approach will allow you to apply large color planes with different textures, so each one is set apart from the one next to it.

Simplifying the planes

Before you begin painting with oils, it is important to know how to simplify the landscape with a few decisive lines that lay out the main composition. The approach should be geometric and minimalist, leaving out textural details and anything that is too complex. Once the drawing is finished, the paint is applied in big blocks of color, without gradations or details. This gives you great freedom in choosing colors. It is not necessary to follow those of the real model; you can include whatever your imagination dictates, including making them more saturated and vivid.

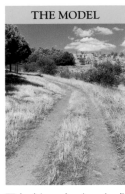
THE MODEL

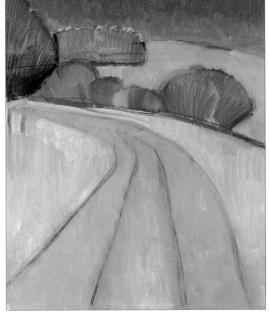

■ Applying colors in a simplified manner is a powerful tool for constructing a landscape.

■ We begin with a simplified drawing that sums up the main features of the landscape. We paint each area with more saturated colors than the real model. This will give us an idea of how the colors interact.

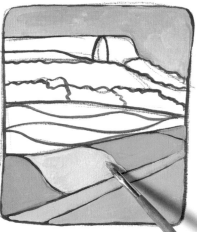

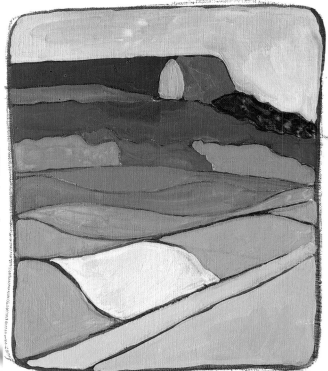

Garden with patches of color

With oil paints you can synthesize the forms of any theme—in this case a garden—with just a few colors and very little detail. The shapes of the vegetation, although flat, are represented by areas of textured color. This approach could be the starting point for any landscape regardless of the difficulty, especially because you can quickly see the first phases of the painting.

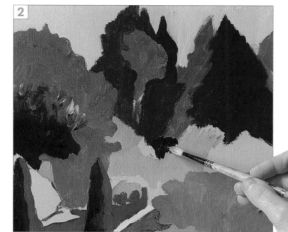

2. We assign a color to each area, making each one different from the adjacent one. The oil paints are applied smoothly and without visible brushstrokes.

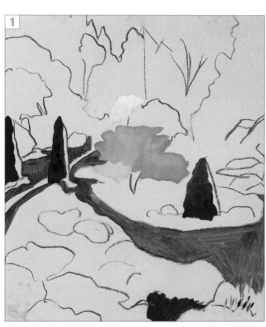

1. Over a gray support, we sketch the masses of vegetation very simply with a few quick squiggles. Each area is covered with flat paint.

"Do not mimic nature. Art is synthesis and abstraction. Take from nature what you envision in your dreams…. Pure color demands complete sacrifice." Paul Gauguin

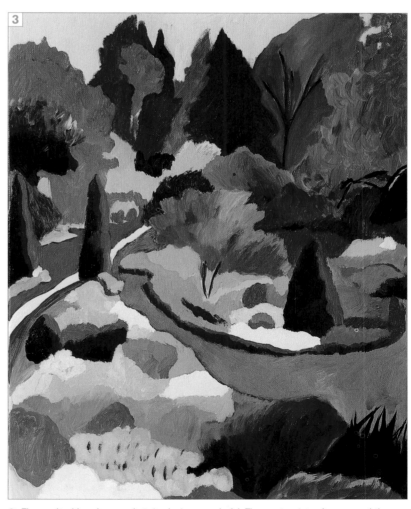

3. The result, although somewhat simple, is very colorful. The great variety of greens and the colorful accents for the bushes covered with flowers add a striking note.

**FROM TRANSPARENT
TO OPAQUE**
PAINTING
WITH OILS

PAINTING

158

Two boats

A seascape is a traditional subject in painting, especially in coastal areas where the image of the sea is a constant. With this scene with two boats, we will learn different ways of handling the brush to apply different textures to the surface of the water, the rocks, the sand, and the boats. Each element presents a particular texture and specific properties that you will learn to replicate with a brush. The sequence of steps given here should be followed to obtain a particular type of texture.

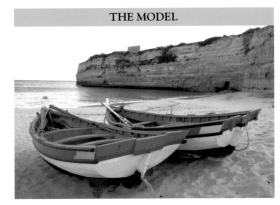

THE MODEL

■ These two brightly colored boats are on the beach in soft light, without any contrast.

**PHASE 1:
BASE COLORS**

1. Spend some time drawing the scene, especially the boats. We will paint the sky and the sea with blue mixed with mineral spirits. The background of the cliffs and sand is painted with yellow ochre.

2. The texture of the sea is painted with horizontal brushstrokes and a small amount of white that mixes with the existing ultramarine blue. The blue tones will be a little bit darker at the base of the rocks.

3. With a rose color greatly lightened with white, we prepare the base color for the sand. By adding ultramarine blue, we will obtain the ideal gray to represent the shadows of the boats. Notice the first hints of shadows on the rocks.

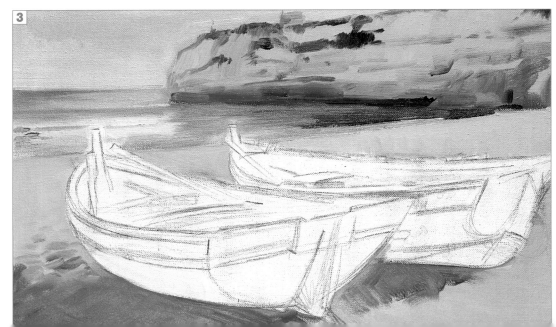

PAINTING

**FROM TRANSPARENT
TO OPAQUE**

PAINTING
WITH OILS

159

Texture is the finish of the painted surface. It is created through a series of repeated effects and brushstrokes. It gives the painting a tactile quality and makes objects appear three-dimensional.

LIGHT AND TEXTURE

Light is responsible for conveying texture. It does this by shining on certain surfaces and being reflected back, absorbed, or dispersed into a myriad of luminous points.

PHASE 2:

PAINTING AND REPLICATING TEXTURES

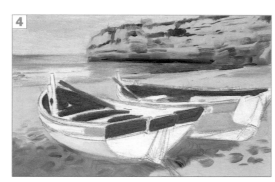

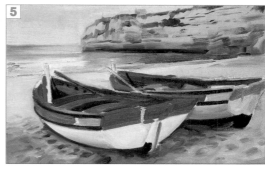

5. We finish painting the boats with bright colors. The contrasts of the shadows are highlighted with dark colors, especially inside the boats. The touches of color on the sand should have little contrast, just enough to make out the footprints or indentations.

4. The brushstrokes on the rocks are loose. They are applied by gently rubbing with the tip of the brush. The dabs of color on the sand are applied by tapping softly with the brush. The boats are painted in sections, with smooth brushstrokes.

6. We go back to the foreground area to add more texture to the sand and enrich it with new earthy tones. Different light and dark colors are applied until a three-dimensional effect is achieved. To finish, the sterns of the boats are painted with a blue color lightened with white to emphasize the bright light.

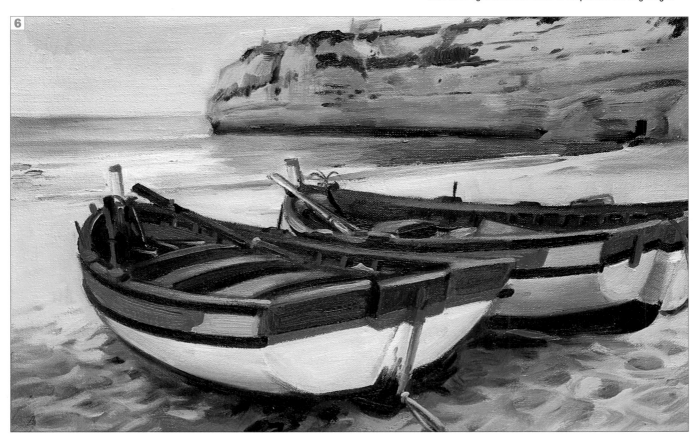

FROM TRANSPARENT
TO OPAQUE
PAINTING
WITH OILS

PAINTING

160

Cityscape in browns

Let's look now at how to treat geometric structures, which are the dominant feature in this urban scene, and how they are translated into color to create a harmonious and coherent painting. We will use a series of earth tones because that is the predominant color range of the model. We will leave out unnecessary architectural details and textures, which means that the approach will be very synthetic. To avoid details, we will give the painting a blurry look, where the profiles are not clearly defined.

PHASE 1:

LAYING OUT THE COMPOSITION

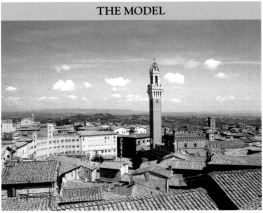

THE MODEL

■ This is a view of the rooftops of the city of Sienna with a dominant harmonious range of brown colors.

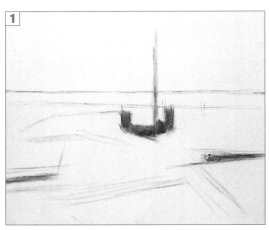

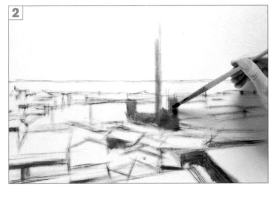

2. We continue drawing with burnt sienna. The houses are simplified with geometric blocks. The first shaded areas are filled in with masses of color, which help define the composition better.

1. It is not necessary to do a preliminary drawing. The first lines are painted with a dry brush. This initial layout of the composition establishes the horizon line and the most significant vertical building.

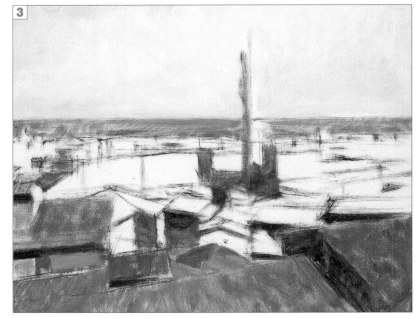

3. To suggest the effect of distance, we paint the area closest to the horizon gray. The sky is also very light gray. Raw sienna is used to paint the façade on the left. Notice how the brushstroke is dry and does not cover the white of the paper completely.

PAINTING

**FROM TRANSPARENT
TO OPAQUE**
PAINTING
WITH OILS

161

PHASE 2:
MIXING SIENNA COLORS

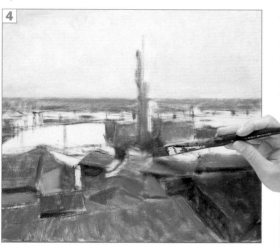

Color schemes based on sienna or brown are particularly warm. These colors are normally used in contrast with blue tones to compensate for their heaviness and to break up the monotony.

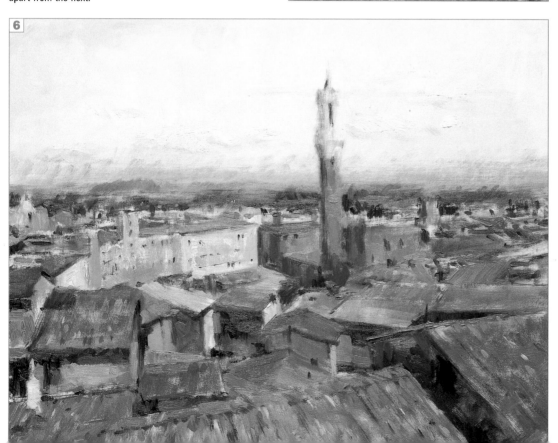

4. The foreground is painted with various tones ranging from yellow ochre to burnt sienna, including raw sienna and English red. There are very few tonal variations, which is why we will emphasize the shadows to set each roof apart from the next.

5. All white spaces have been covered completely. The buildings nearby are darker while the distant ones are lightened with whiter mixtures.

6. Blue peeks through the sky while a very light violet covers the horizon. Details are added to the closest façades, and the shingles are suggested with soft lines that are not too detailed.

FROM TRANSPARENT
TO OPAQUE
PAINTING
WITH OILS

PAINTING

162

Practicing an impressionist brushstroke

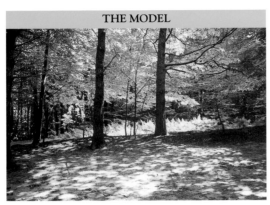

A shady forest dominated by green that will be translated into an explosion of colors.

PHASE 1:
LAYING OUT
WITH BLUE

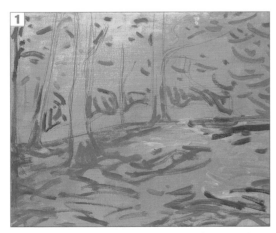

1. We have covered the support with a layer of ochre acrylic paint. When the color is dry, the scene is sketched out with ultramarine blue mixed with a small amount of white. The shaded areas are covered with blue.

Short individual brushstrokes of saturated color applied directly on the support give the painting a lively look and a more modern, creative touch. Oil paint is the best medium if you wish to leave a brush mark, because its pasty consistency produces a lasting mark. The colors of the following exercise are mixed on the palette and applied quite pure, with quick, spontaneous brushstrokes.

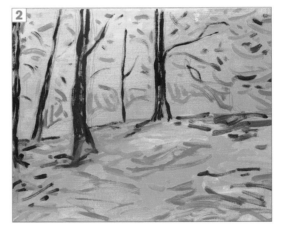

2. We work the most shaded areas with bright ultramarine blue and a small amount of carmine. The tree trunks and the direction of a few of the main branches are painted with the resulting violet.

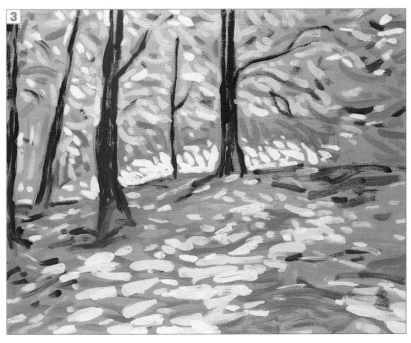

3. The first contrasts between light and shadow appear on the ground, painted with yellow greatly mixed with white. We paint the sunrays that come through the leaves with dashes of saturated yellow.

PAINTING

**FROM TRANSPARENT
TO OPAQUE**
PAINTING
WITH OILS

163

■ A brush charged with paint should not brush or rub repeatedly over an area. The new paint can become muddy from mixing with the color that is already on the support and ruin the work.

PHASE 2:
EXPLOSION OF COLORS

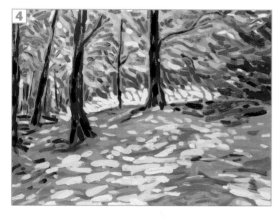

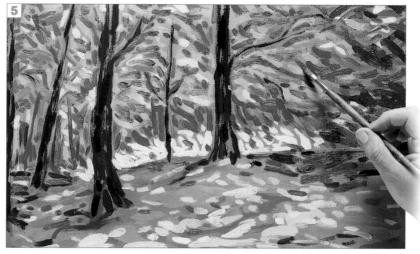

5. We introduce several dashes of carmine red here and there, many more in the areas of light and a few representative ones on the shadows on the ground. Although this color is not present in the model, it makes the scene livelier.

4. This is the moment to add the green vegetation. The leaves on the trees are painted with medium green following the same direction of the branches.

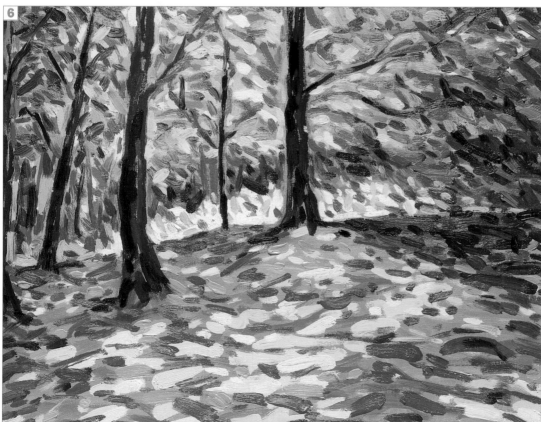

6. As the painting progresses the color combinations will be more varied and the brushstrokes will be shorter. Don't forget that the direction of the brushstrokes should replicate the surfaces they represent.

Painting over a dark background

The method of painting over a dark background offers many appealing possibilities to the beginner. Traditionally, these backgrounds are used when light is a very important factor, so they are constructed from the point of view of light; that is, the goal is to add light to the painting rather than shadows. The model that we use here does not have a great variety of colors, so it will be very easy to follow the process. However, be careful when mixing colors and differentiating areas of light and shadow.

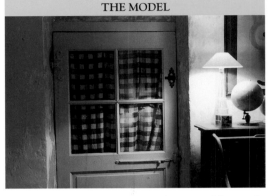

THE MODEL

■ The inclusion of the light source in the corner of the room is very dynamic.

1. Over a background painted black, we sketch the main lines with ultramarine blue directly with the brush. The colors for the light range from broken white to bright orange.

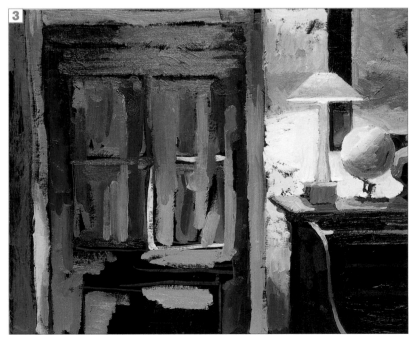

2. The doorframe is painted with variations of violet and ochre, mixed with white. The colors of the window are warmer, where violet mixed with sienna is the predominant color. The brushstrokes are opaque and applied from top to bottom to suggest the wood grain.

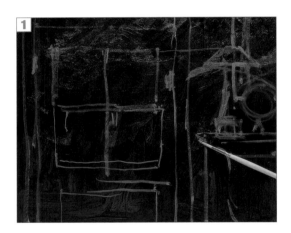

3. The areas of light are represented with gradations (see the transitions from light to shadow on the sphere on the right). The sienna colors of the frame contrast with the violet variations of the door. Everything is constructed with colors.

With a dark background, the paint should be thick and opaque to maintain the characteristics of the color and the brush marks.

■ Gradations are the key to representing spheres. The brushstrokes should be rounded and the paint creamy.

■ The dotted pattern of the curtain is resolved with different intensities of green.

■ The lines are not painted; instead, they are obtained by leaving a small space between the colors through which the dark background can be seen.

■ The forms, like those of the piece of furniture, are defined through contrast, without lines or contours.

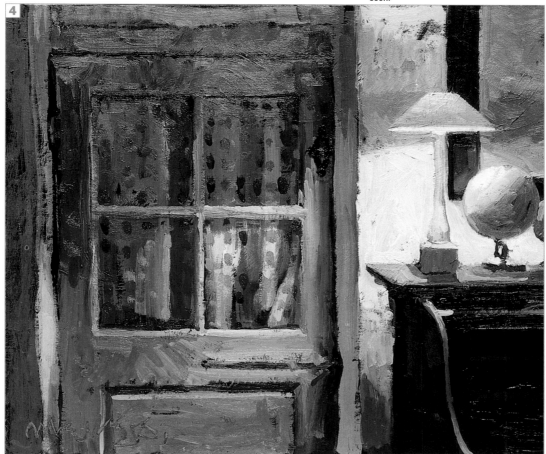

4. Warm colors dominate the areas of light, and blues and violets the areas of shade. This is similar to the contrast between warm and cool colors seen before but without the saturation.

■ The paint should not be very diluted if we wish to create a textured effect or allow the background to be seen between the brushstrokes.

■ The different intensities of light form a tonal gradation.

**FROM TRANSPARENT
TO OPAQUE**
PAINTING
WITH OILS

PAINTING

166

Glazed cliffs

Glazing is used to create deeper and more luminous colors. By superimposing layers of diluted, semitransparent paint, the white light of the support is reflected. If one color is applied over another, a third color is created. This technique is an ideal way to create smooth transitions between colors without leaving visible marks caused by the movement of the brush. One of the main problems of working with oil glazes is that the drying time for each layer is very slow. The painting will require several days to dry between steps.

■ Our model is a series of seaside cliffs with interesting contrasts of light.

PHASE 1:
COVERING THE WHITE

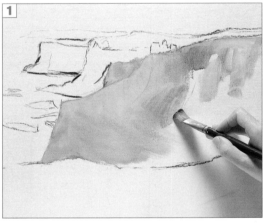

2. Each of the areas is painted with colors mixed with mineral spirits. The tones are variations of ochre, orange, and sienna, which are mixed with a touch of green to reduce their saturation.

1. We use a charcoal stick to draw the outlines of the cliffs. With a mixture of yellow ochre, carmine, and green mixed with mineral spirits, we apply the first layer of color to the middle section.

3. The sky is covered with violet gray and the water with green ochre. The objective of this first phase is complete: to cover the white of the paper completely with paint mixed with mineral spirits. We let the paint dry.

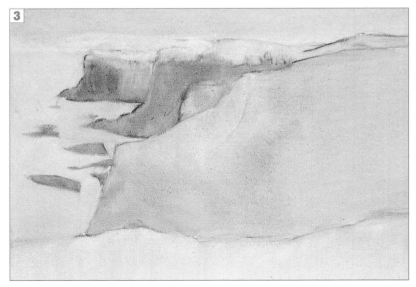

PHASE 2:
PAINTING WITH DRYERS

SPEEDING UP DRYING

Usually, glazes are created by diluting the paint with mineral spirits. However, it is better to dilute it with a small amount of Dutch varnish or dryer, as this will make it glossier and dry faster.

5. With cobalt blue mixed with Dutch varnish, we paint the sea, diluted on the horizon and thick near the coastline. New light green glazes cover the initial yellow.

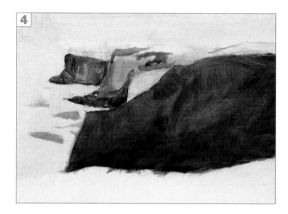

4. From this point on, new applications should be diluted with a dryer or Dutch varnish. We apply heavy black-green and brown glazes to highlight the contrasts and set the areas apart.

■ Notice the possibilities provided by super-imposing different oil glazes, light on light colors and dark on light. Also, you can lighten a glaze with a dry brush or rag when it is still wet.

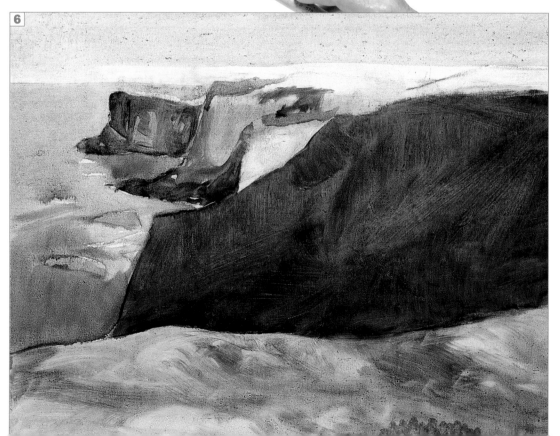

6. Green transparent brushstrokes are applied on the grass of the foreground. We pass the dry brush over the light colors to remove part of the color and represent the texture of the grass with brush marks.

FROM TRANSPARENT
TO OPAQUE
PAINTING
WITH OILS

PAINTING

168

Winter landscape: painting snow

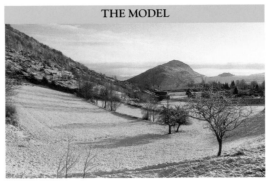

Color backgrounds can be extremely useful in many cases. They help break up the white of the paper and make the color brushstrokes more visible and contrasted, especially in a landscape with snow. Painting with white over a white background can be difficult; that is why we have decided to change the color of the background to violet, which is present in the shadows of this landscape. We will let the background show through the white brushstrokes and become an integral part of the scene, adding color accents to a painting with a very limited color palette.

THE MODEL

■ We have chosen a winter landscape where the snow has some color and shadows and is not just the usual blinding white.

PHASE 1:
THE LAYER OF SNOW

2. The layer of snow that covers the landscape is painted with a generous amount of white tinted with violet and yellow. The color is applied somewhat dry, leaving open spaces through which the color of the background can be seen.

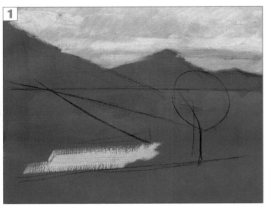

1. When the layer of violet color from the background, which has been painted with acrylics, is dry we lay out the model with a bar of charcoal. Then, we begin painting the sky with gradations of white and yellow.

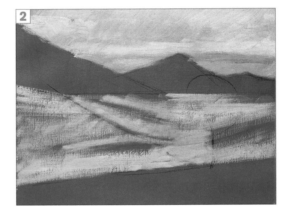

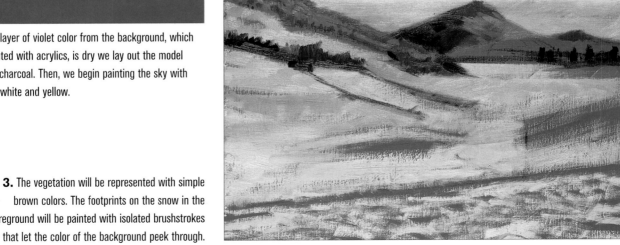

3. The vegetation will be represented with simple brown colors. The footprints on the snow in the foreground will be painted with isolated brushstrokes that let the color of the background peek through.

PAINTING

**FROM TRANSPARENT
TO OPAQUE**
PAINTING
WITH OILS

169

■ It is not always necessary to paint snow white. Variations can be obtained by mixing white with a small amount of yellow and blue.

PHASE 2:
VEGETATION
AND IMPASTOS

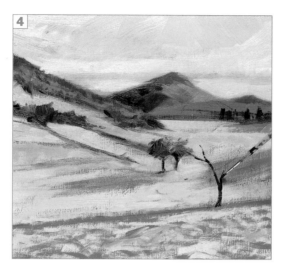

4. With a thin round brush charged with burnt sienna, we draw the shapes of the closest trees. There will be less definition in the middle ground.

■ The shadows on the snow are painted with blues or violets. They will have more or less contrast depending on the intensity of the sunlight.

5. On the closest tree we add a few touches of ochre to represent the light on the branches. On the footprints we add thick new strokes of white mixed with ochre, violet, and even blue.

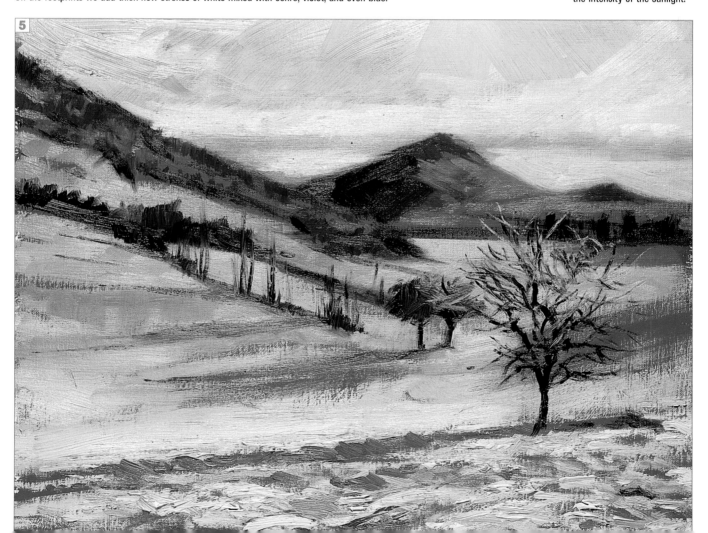

FROM TRANSPARENT
TO OPAQUE
PAINTING
WITH OILS

PAINTING

170

Painting over another painting

The great advantage that oils have over any other media is that they are opaque and easy to correct. Any painting, when dry, can be painted over. This is exactly what we are going to do: paint a creative, expressive still life over a canvas that has been previously painted. This is something that artists often do, painting over work that they do not want to keep. The most common approach is to cover the painted canvas with an even layer of paint to prevent the previous work from interfering with the new painting. But the other alternative is to take advantage of certain aspects of the old painting for the new one.

PHASE 1:

PREPARING THE SUPPORT AND SKETCHING

THE MODEL

■ A small coffee table with a coffeepot and two cups, the typical elements of a breakfast scene.

■ Before we begin to paint we need to plan the model, taking into account the size and placement of each element. A simple pencil drawing in a notebook should be enough.

1. The painting that we are going to recycle is a cityscape. We will turn it upside down to avoid distraction from the previous subject, so that we will only notice the forms and colors.

PAINTING

**FROM TRANSPARENT
TO OPAQUE**
PAINTING
WITH OILS

171

PHASE 2:
INITIAL DRAWING AND PAINTING

One of the main advantages of oil paints is that, when they are applied very thickly, barely diluted, they cover the previous colors completely and can be modified and corrected as much as needed.

2. With a charcoal stick we draw the elements over the painted canvas: first, the circle that represents the table and then the objects on it. To visualize the lines better, we apply a few brushstrokes with oils.

3. We begin to repaint over the lines, incorporating blocks of color to prevent the colors below from distracting us. The inside of the milk bottle, the cup, and the glass are addressed first.

4. We continue covering the tabletop with orange and pink colors to make the objects look as if they were floating. Then we continue painting the objects with light, opaque colors.

PHASE 3:
THE CREATIVITY OF COLOR

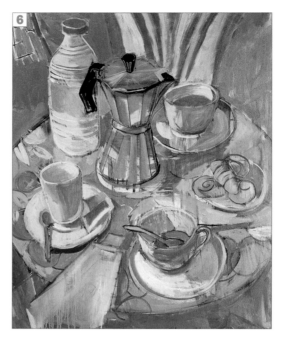

6. As we continue painting it becomes obvious that certain elements of the previous painting have been incorporated into the new one—for example, the napkin has the angle of the roofs, and the curvature of the street suggests the back of the chair.

5. We cover the space outside the table with blue and violet paint; this way, the underlying paint will not distract us and we will be able to concentrate on applying new colors to the central area of the composition.

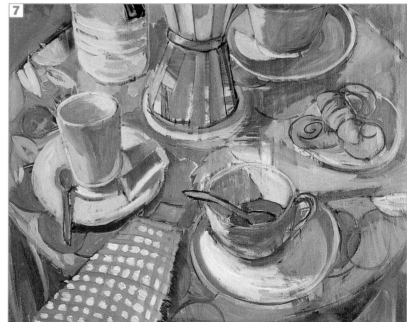

7. In terms of color, we have used contrasting complementary colors. Greens have been placed next to the reds, and the yellows contrast, for the most part, with the masses of violet blues.

PAINTING

**FROM TRANSPARENT
TO OPAQUE**
PAINTING
WITH OILS

173

ELIMINATING BUMPS AND TEXTURE

The approach presented here can be very difficult if the painting has thick paint or texture. If the recycled painting has uneven areas or brush marks, they can be eliminated by rubbing them with sandpaper to make the surface smooth again and ready for painting.

PHASE 4:
MODELING AND SHADING

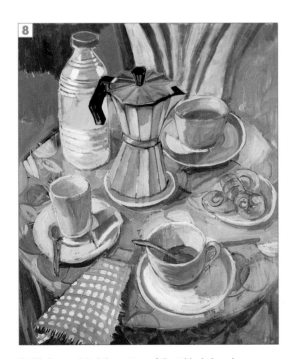

8. We have painted the pattern of the tablecloth and the napkin with saturated colors. The cups stand out against it because they have a dominant, grayer tone. Here, the colors have been modeled; they are thoroughly blended and smooth.

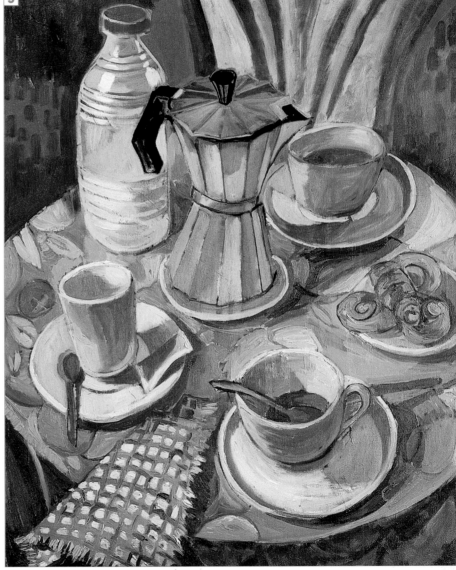

9. We leave the darkening of shadows and details like the fringe of the napkin, the coffeepot's lid, and colors on the tablecloth for the end. When the paint has dried, nobody would suspect that it was painted over a cityscape.

ACRYLIC PAINT

*W*ith acrylic paint you can replicate and even surpass many of the results obtained with other pictorial media. It is a strong, flexible paint that can be scratched, diluted, dripped, sprayed, and splattered on the support. Acrylic colors are comparable to the other media as well.

Given that acrylics are a relatively new medium, manufacturers have been able to use the best, most modern pigments together with traditional ones. Another important characteristic is their elasticity after they dry and their resistance to the effects of light, which means that the colors do not change with time.

■ David Hockney (1937), *A Bigger Splash*. Beginning in the sixties, acrylic paint was adopted by many artists to make large paintings.

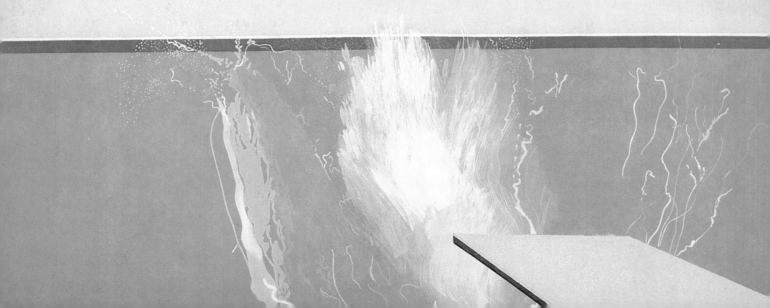

The luminosity and consistency of acrylic paints produce color ranges that are superior to any other medium. Iridescent and fluorescent colors, which are very popular in the advertising field, are available in addition to the traditional ones.

COLORS DARKEN

A particular feature of acrylic paints should be kept in mind. When the colors are wet they look lighter and more saturated than when they dry. This means that, after drying, colors lose intensity and get darker.

Opaque acrylics

The paint that comes directly out of the tube is opaque. To maintain the opacity of the paint you must avoid mixing it with water and only add acrylic products to it that are also opaque by nature, like gesso, modeling paste, or pumice. Or, you can always resort to white. White is a very opaque color, which, mixed with another color, results in a lighter and more opaque version of it. With white, you can conceal or cover any area of dry paint that needs to be corrected. You can also cover the background evenly, without any visible brush marks, as seen in the exercises with oil paints.

Transparent acrylics

There are two ways of working with transparent acrylic washes: adding water to the paint to create a very diluted layer of color, or mixing the color with a transparent acrylic medium. With the first approach we will obtain delicate washes that look like traditional watercolors; however, excess water can alter the adhesiveness of the paint. On the other hand, mixing the paint with a medium will boost the gloss and intensity of the color, but we will also lose fluidity. Therefore, it is best to combine both dilutents to obtain a layer of acrylic paint that is transparent, intense, and very malleable.

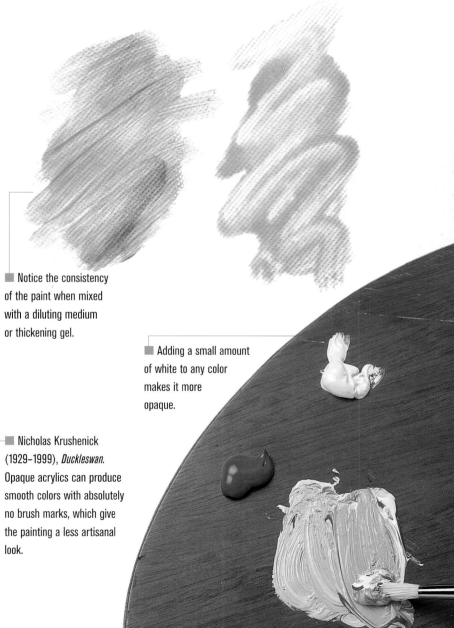

■ Notice the consistency of the paint when mixed with a diluting medium or thickening gel.

■ Adding a small amount of white to any color makes it more opaque.

■ Nicholas Krushenick (1929-1999), *Duckleswan.* Opaque acrylics can produce smooth colors with absolutely no brush marks, which give the painting a less artisanal look.

FROM TRANSPARENT
TO OPAQUE
ACRYLIC
PAINT

PAINTING

176

A look at some applications

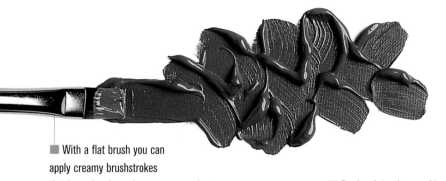

Before we turn to the exercises, let's look at some common acrylic techniques that can be very useful. The different ways of applying the paint and their effects depend on the charge of the brush, the type of brush, and the intention of the arm at each brushstroke.

■ With a flat brush you can apply creamy brushstrokes that leave brush marks.

■ Dry brush involves working with a small amount of paint on the brush. It can be applied to the white support or over another layer of color that is already dry.

■ If you want to blend or create gradations with opaque colors, it is best to work quickly, because acrylics dry very fast, especially on paper.

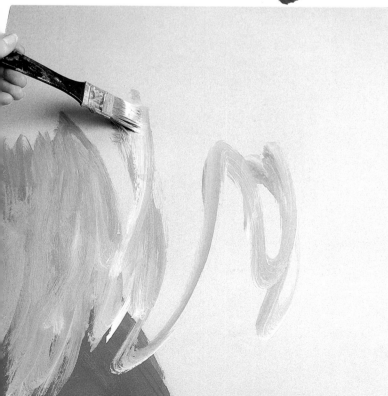

■ With a wide brush and acrylic paint diluted with water, it is possible to work with great fluidity. This method is very appropriate for covering large surfaces.

■ The spatula is also useful when you want a smooth effect.

PAINTING

**FROM TRANSPARENT
TO OPAQUE**
ACRYLIC
PAINT

177

Four different treatments

The best way to explore the versatility of acrylic paints is by painting a very simple model with different color treatments, varying the consistency of the paint. We will draw the model four times, painting the first version with soft washes, similar to the ones we used with watercolors; in the second one, the paint is smooth and opaque (straight out of the tube, without dilutions); we paint the third model with creamy brushstrokes, showing the marks and lines; and the last one is done with a spatula.

"My relationship with the materials that I use is that of a dancer with his partner, of a rider with his horse, of a tarot reader with her cards; only then is it possible to understand the interest that I feel for a brand-new material and my patience for trying it."
Jean Dubuffet

■ The first tomato is painted with diluted washes of acrylic paint.

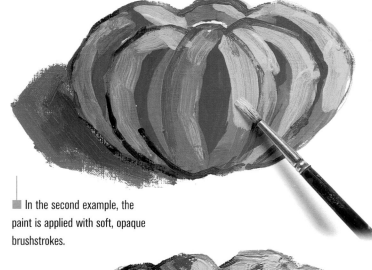

■ In the second example, the paint is applied with soft, opaque brushstrokes.

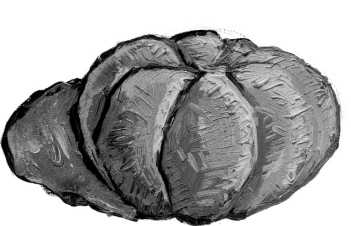

■ With thicker paint and visible brush marks, the model becomes more expressive.

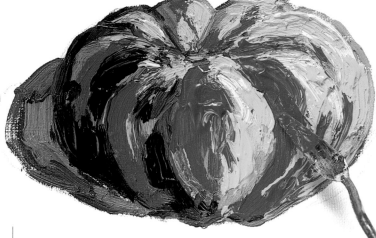

■ The spatula adds power. The thickness of the paint gives a surface relief to the finish.

**FROM TRANSPARENT
TO OPAQUE**
ACRYLIC
PAINT

PAINTING

178

Water lily on a lake

We are going to use a simple model, which does not present great difficulty or too many colors, to practice some basic skills. Complicated compositions that require more experience and skill will come later. The treatment is going to be simplified, and blending and mixtures of colors will be limited. The greatest difficulty will be differentiating each petal sufficiently and synthesizing the interior shapes of the flower without adding too much detail. As for the background, it will be dark, without significant elements that may distract us from the main subject.

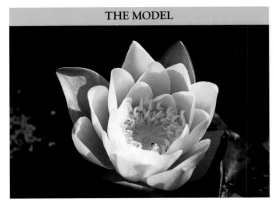

THE MODEL

■ The contrast between the water lily and the dark background is the most striking feature of this model.

PHASE 1:

PAINTING
PETALS

1. We begin by painting the most neutral areas of the flower with white mixed with orange and a touch of green. We make small variations by changing the proportions of each mixture.

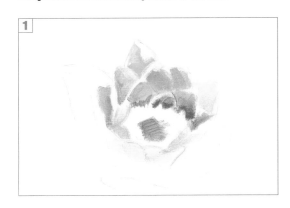

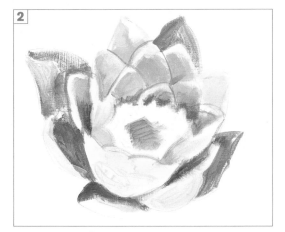

2. By mixing carmine, white, and a touch of orange, we get a rose tone that will be used to paint the outer petals. The brushstroke is quite dry and not completely opaque.

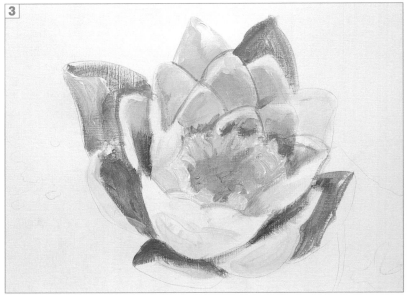

3. With ochre and yellow we paint the center of the flower using concentric brushstrokes. A small amount of white is added to the yellow to represent the highlights.

PAINTING

**FROM TRANSPARENT
TO OPAQUE**
ACRYLIC
PAINT

179

SFUMATO EFFECT

With a small amount of diluted color, we can create sfumato effects with dry brushstrokes. This very distinctive technique involves layers of tiny colored dots.

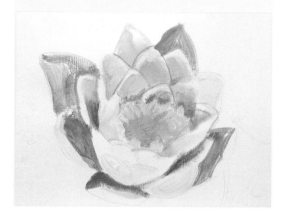

PHASE 2:
COVERING THE BACKGROUND

4. The background is not completely flat; it is made up of different green tones. On the bottom, phthalo green is mixed with a small amount of yellow to make it lighter.

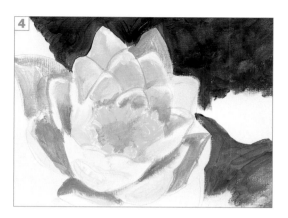

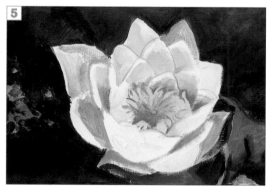

5. To define the dark area of the background, we add raw sienna to the phthalo green. The paint that covers the background is much thicker than the paint we have applied on the petals of the flower.

6. We finish defining the flower with ochre mixed with burnt sienna. With that same color diluted with water and a thin round brush, we define the outlines of the petals with linear strokes.

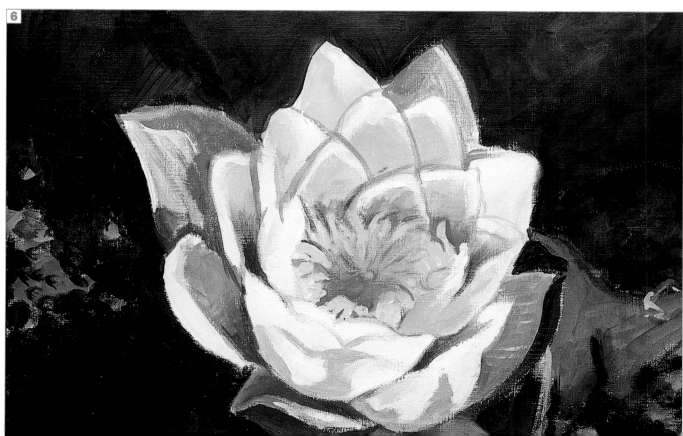

**FROM TRANSPARENT
TO OPAQUE**
ACRYLIC
PAINT

PAINTING

180

Using fluid paint

Now we are going to review another application technique. It consists of diluting the paint slightly with water to help it spread more freely and faster. We do not want the paint to be watery, but rather creamy and opaque, so it is important not to overdo the water. This technique is very suitable for artists who wish to paint large areas of color with minimal contrast and expressive forms. It is very appropriate for a synthetic or stylized approach, not for realist effects. For this exercise we have chosen a female figure, which we are going to paint very liberally, in a Fauvist manner, disregarding any anatomical rules.

**PHASE 1:
FLUID PAINT**

THE MODEL

■ The model is a female figure seated on a sofa, sleeping.

1. We draw the figure with graphite using only a couple of oval shapes. By mixing carmine, white, and yellow we obtain a rose color, to which we will add a small amount of water to make it flow better.

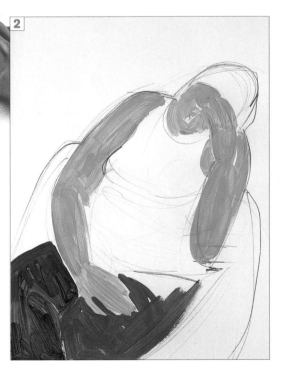

2. The color covers the skin quickly, without nuances or much precision. Using naphthol red and a small amount of sienna, we quickly paint the pants.

3. The blouse is painted with ultramarine blue and carmine, and the sofa and the hair with brown tones. Since the paint is creamy, the first applications are done quickly without paying much attention to detail.

PAINTING

**FROM TRANSPARENT
TO OPAQUE**
ACRYLIC
PAINT

181

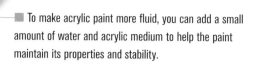

■ To make acrylic paint more fluid, you can add a small
amount of water and acrylic medium to help the paint
maintain its properties and stability.

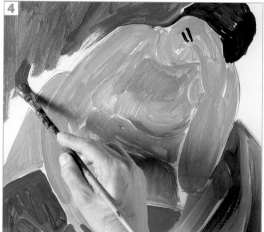

PHASE 2:
BACKGROUND
AND LINE

4. On the background, the
same as on the figure, we
spread ultramarine blue
color quickly and loosely,
allowing the brush marks
to remain visible.

**SKETCHING
TIP**

Working with fluid
paint produces dyna-
mic, sketch-like results,
which are very useful
for the first stages of any
painting or for making
color notes or small
studies, which generally
look unfinished.

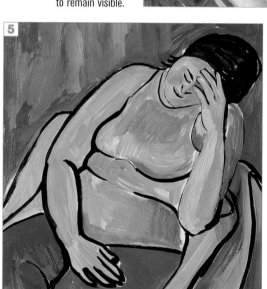

5. With a round thin brush, we introduce linear brushstrokes
done exclusively with large strokes of color. A black line, of
varying thickness, defines the profile of the figure.

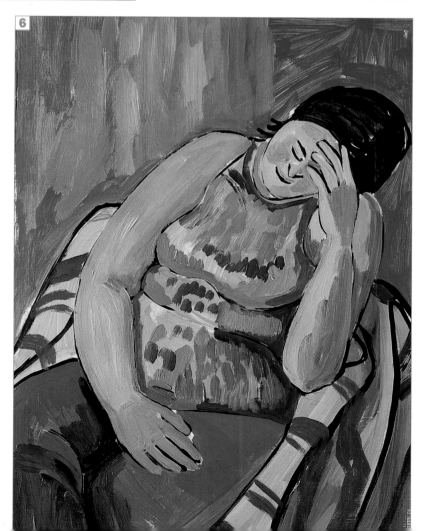

6. Over the previous color foundation we add different values
and new shades. The blouse is covered with short gray
brushstrokes to suggest the texture of the sequins. We shade
the skin and the inside of the thigh with brown paint.

**FROM TRANSPARENT
TO OPAQUE**
ACRYLIC
PAINT

PAINTING

182

Transparent acyrlics

When they are diluted, acrylic colors become transparent and can be worked like washes, providing results that are very similar to watercolors. The best way to make acrylics transparent is to add water and a small amount of acrylic medium. This mixture can produce very thin, transparent color surfaces without causing the color pigments to separate.

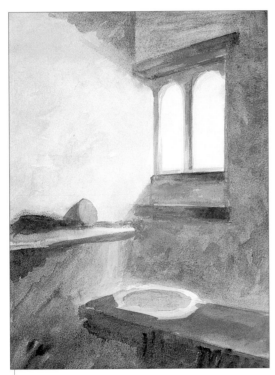

■ A series of brushed glazes blend together, creating a very atmospheric effect in this interior.

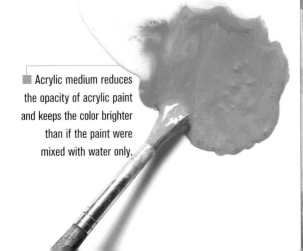

■ Acrylic medium reduces the opacity of acrylic paint and keeps the color brighter than if the paint were mixed with water only.

Working with glazes

Glazes are the most common wash technique, whether with watercolors or acrylics. It is based on applying translucent colors one over the other until the desired colors and forms have been created. If they are worked on a white support, they are influenced by the luminosity of the paper, one of their most attractive aspects. Using the glaze technique with acrylics does not differ very much from other media, but there is an advantage: The quick drying time of acrylics makes it possible to layer several glazes in a very short time.

■ With glazes, the colors are perceived through optical mixture. This means that a new color emerges from several different superimposed colors.

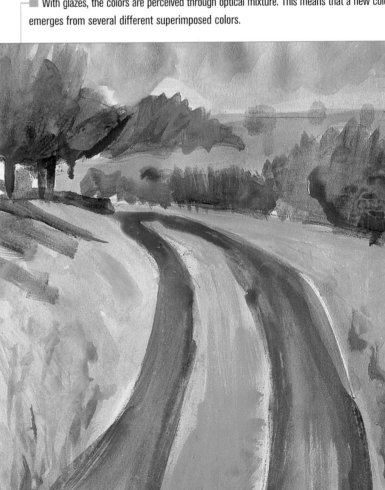

ADVANTAGE OF ACRYLICS

When working with transparent colors, we begin with light colors and then increase the intensity as the work progresses. However, acrylics have an advantage: If an area is too dark we can resort to white to make the colors lighter again.

Transparency with texture

The transparency of acrylics does not conflict with texture. In fact, there are gel mediums that give the paint volume and become translucent when they dry. They can be used to apply texture to transparent colors simply by mixing a wash with the thickening gel until a homogenous mass of color forms, and then applying it to the surface that you wish to glaze. When it dries, the gel becomes translucent; it is tinted with the color of the wash, but the underlying colors can show through.

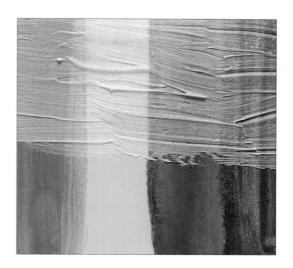

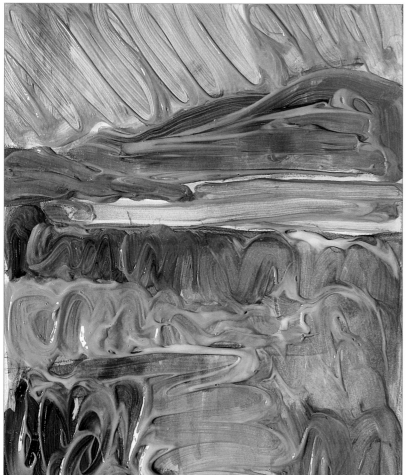

■ A glaze can be applied with gel medium over any painting to form a textured effect. In this case, we wanted to make the painting more expressive by leaving the brush marks visible.

■ You can create very compact, three-dimensional transparencies by mixing a small amount of color with gel. When the glaze is wet, you can manipulate the surface with any tool to create new effects.

**FROM TRANSPARENT
TO OPAQUE**
ACRYLIC
PAINT

PAINTING

184

Flat paint

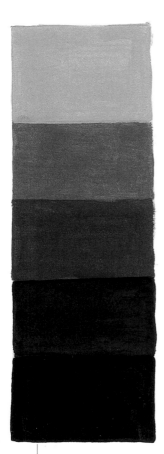

Since acrylics can produce flat surfaces without leaving brush marks, a good method for working with them is to apply the paint in flat layers. This type of painting is done without gradations, with each new layer representing a tonal progression. There is no need to shade the different planes, which are formed through contrasting intense, saturated colors. Many artists use this simplification exercise as an interesting starting point, a preliminary step to developing the subject in detail.

Colors express volume

Since the areas of color are flat, we cannot resort to the normal gradations or chiaroscuro shading to describe the volume of the objects. Instead, we divide the object into areas of uniform color, and assign a color to each zone to suggest a tonal gradation based on the light. The volume is understood through the juxtaposition of the areas of color arranged according to their intensity, from light to dark or vice versa.

■ This tree has been painted with the flat paint technique, synthesizing each area and resolving it with intermediate colors.

■ Tonal scales usually begin with a base color that is lightened or darkened by adding white or black.

■ A tonal scale consisting of five different colors describes the volume of this sphere.

Simplifying the colors

Working with flat areas of color requires careful evaluation of the model to plan the simplification of the colors, identifying the dominant ones, the ones we can eliminate, and the main areas of light and shadow. To be successful with this type of representation, it is important to have a well-structured drawing. The painting that we are going to develop is made of completely flat colors, without any shading; therefore the different areas of the drawing must be perfectly defined by outlines.

■ We make a clearly defined line drawing. The green color is mixed on the palette and applied to the corresponding area.

Even layers

To make flat layers of color with no visible brush marks, you must work with paint that is not very diluted. If the paint is mixed on the palette, it will be easy to see when it is thoroughly mixed, without clumps or streaks. Then we can apply it by building up several superimposed layers until the color has the same value across the surface.

■ We build the volumes and textures of the vegetation, forming tonal gradations that go from dark green to yellow green.

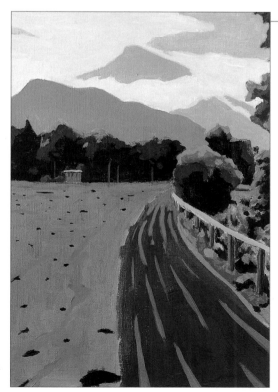

■ To recap, the color is applied within each area, and each color that is added will create a chromatic effect on the adjacent colors.

FROM TRANSPARENT
TO OPAQUE
ACRYLIC
PAINT

PAINTING

186

Composition with chair

The following exercise uses some of the same techniques you have already studied. It begins with a base painted quickly with fluid acrylics, transitioning into a more simplified treatment with areas of color where the brush marks are almost imperceptible. The treatment is not completely realist, because some of the objects have been simplified into geometric shapes, which gives the painting a modern look. It is important to experiment with composition and color application as well.

PHASE 1:

GEOMETRIC SHAPES

It is not always necessary to have a real model. Artists can create interesting compositions from the imagination, with objects and colors that they have in their mind's eye.

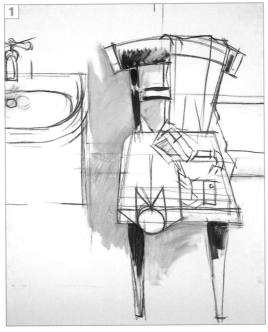

1. We do not use a real model for this exercise; the entire composition comes from imagination. We sketch the chair and the objects placed on it with a stick of charcoal.

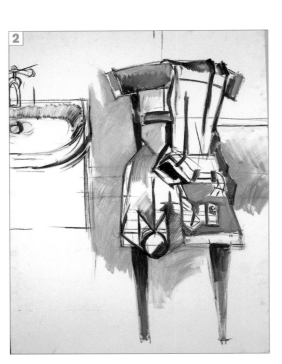

2. We apply the first colors quickly with diluted paint, and the background is covered in yellow. The chair is painted with brown, which is darker in the area of the back and the legs, where it gets dirty from contact with the charcoal.

3. The colors of the background and the floor are applied with very diluted paint—in fact, it is almost dripping. The brushstrokes are quick and purposely blend with the other colors.

PAINTING

**FROM TRANSPARENT
TO OPAQUE**
ACRYLIC
PAINT

187

PHASE 2:
OPAQUE COLORS

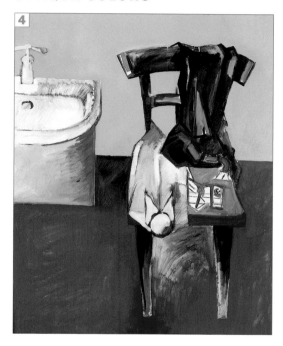

4. Once the first phase is completed, we work with creamier paints, finishing the yellow of the background and the carmine of the floor. The clothes hanging on the back of the chair are painted with cobalt blue and gray.

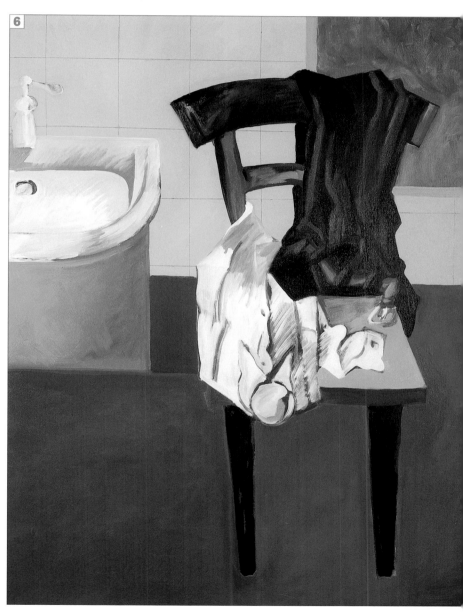

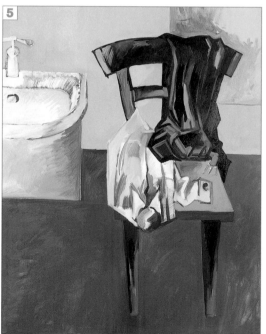

5. We add volume to the clothing with different tones of gray and white. The chair is covered with a more solid color, and we define its outlines with black brushstrokes.

6. We give the background a green undertone and apply new gray and white brushstrokes to add greater definition to the sink. When the paint is dry, we draw squares with a pencil and a ruler to suggest the wall tile.

**FROM TRANSPARENT
TO OPAQUE**
ACRYLIC
PAINT

PAINTING

188

Colorful cityscape

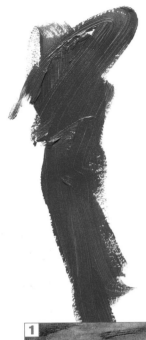

Now we will combine the techniques of painting with large brushstrokes and adding texture using a light spattering effect. These two techniques, when used together, give the painting an interesting blurry, dynamic effect. These are the effects that we turn to when we want to represent an urban scene with people and cars in constant motion. The unfinished character of the painting replicates this real-life dynamism.

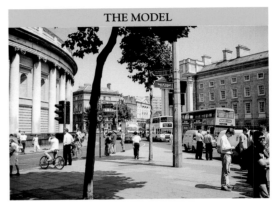

THE MODEL

■ This urban landscape shows moving people and buses. Without a doubt, it is a dynamic composition.

PHASE 1:
COLOR OVER GRAY

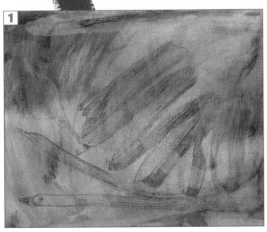

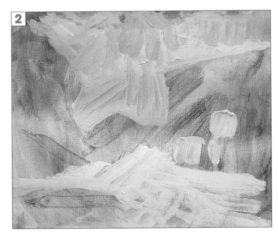

2. Without a preliminary drawing, we spread the color for the sky, a broken white for the street, and three yellow smudges to suggest the placement of the bus. This is a way to make a sketch with the brush.

1. To begin, we cover the background with a crudely applied gray wash, where the brushstrokes are still visible.

3. We will work more surely over this base if we make a sketch with a charcoal stick. The lines adapt to the forms already suggested with the loose painting.

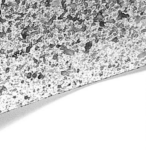

PAINTING

**FROM TRANSPARENT
TO OPAQUE**
ACRYLIC
PAINT

189

■ The spattering effect in this phase is done with diluted paint to create small colored dots.

PHASE 2:
SMALL TOUCHES

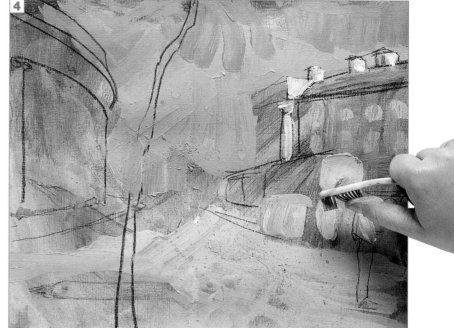

4. Using a very transparent ochre color, we spatter over the sky and the asphalt. This can be done by charging a toothbrush with diluted color and scraping it with your fingernail.

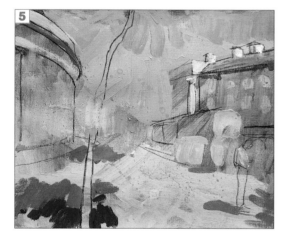

5. We paint the façades with small dabs of pink and white. The charcoal lines are good guides for painting the architectural features.

"Artists understand more and more the relevance of painting loosely for conveying movement and expressivity."
Auguste Renoir

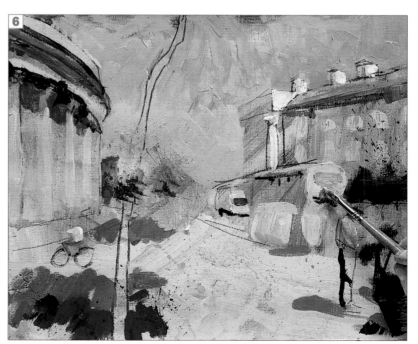

6. With more dabs of violet color, we paint shadows on the asphalt. More flat brushstrokes define the shape of the bus. We avoid any representation of details.

PHASE 3:
VEGETATION AND EFFECTS

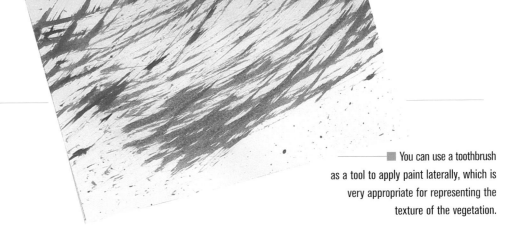

■ You can use a toothbrush as a tool to apply paint laterally, which is very appropriate for representing the texture of the vegetation.

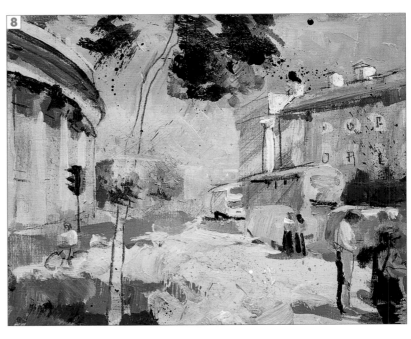

7. We continue applying more color little by little to represent the people and the asphalt. We paint the foliage of the tree in the foreground with the toothbrush instead of using a brush.

8. The cars are represented with a couple of simple passes, without too much contrast. The architectural features are barely suggested. The people are represented with a couple of brushstrokes.

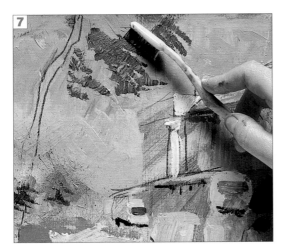

9. The sidewalk is indicated with a wide gray stroke that partly covers some of the previous ones. We paint the tree trunk with varying shades of brown. When dry, apply more spattering on the lower area of the painting.

PAINTING

FROM TRANSPARENT
TO OPAQUE
ACRYLIC
PAINT

191

*"When we drip or splash paint on the
painting, we are projecting our expressivity,
our anger, our gesture."*
Jackson Pollock

PHASE 4:
FINAL
SPATTERING

10. Gradually the spattering
is done with denser, thicker
paint. A medium violet is
applied to the asphalt with
this method to represent the
tree's shadow, and a bright
green on the leaves to create
greater textured effects.

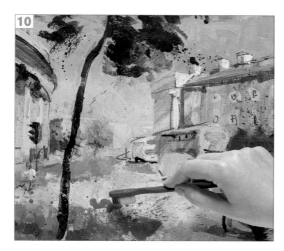

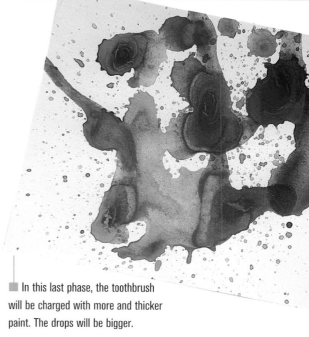

11. It is important to emphasize the sketchy look of the people in the street. The buildings have
very few details, and the spattering gives the theme a fresh, varied, dynamic effect. However, it is
not a good idea to overdo the spattering.

■ In this last phase, the toothbrush
will be charged with more and thicker
paint. The drops will be bigger.

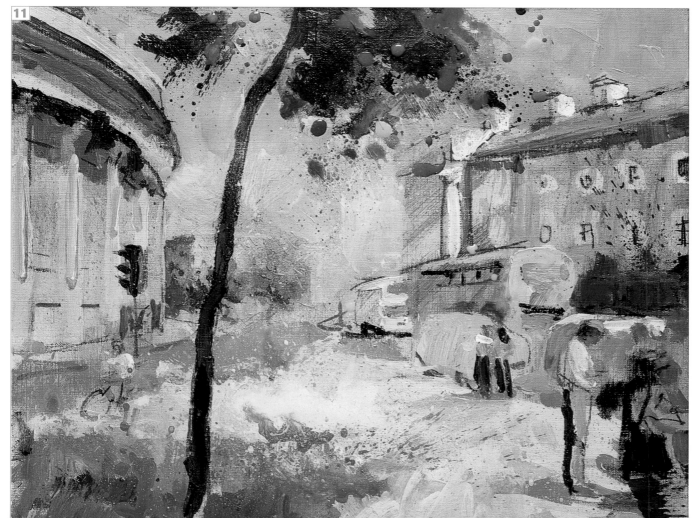

FROM TRANSPARENT
TO OPAQUE
ACRYLIC
PAINT
PAINTING
192

Lake with diluted colors

Now we are going to paint a natural landscape with acrylics. Several points will be covered: how to work with washes, the order in which the colors are to be layered, how much to emphasize the chromatic aspect of the painting, and finally—one of the biggest challenges for a beginner—how to paint the water. If you look at the model, you will see that it has a limited range of colors; the brightness of the greens is combined with the coolness of the violet and gray tones of the water and sky. Our goal is to highlight the colors to enrich the painting.

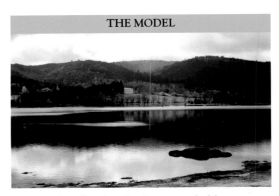

THE MODEL

■ A clear sky reflected on the clean water of a lake.

PHASE 1:
WATERY
APPLICATIONS

1. First, we make a pencil drawing of the model. Then, with a thin round brush we go over the lines with diluted carmine color to make them more visible.

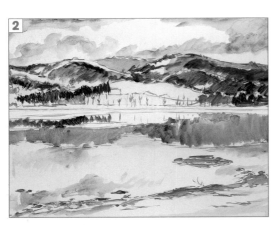

2. The first colors, green and gray on the mountains and violet on the surface of the water, are very diluted. The idea is to do a quick first color impression.

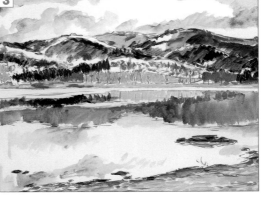

3. In contrasting with the first cool washes, we add yellow-green in the center of the composition and on the bottom of the painting. The color is applied with small brushstrokes, not covering the background completely.

PAINTING

FROM TRANSPARENT
TO OPAQUE
ACRYLIC
PAINT

193

The shapes of the reflections are slightly distorted by the movement of the water. Their color is more or less murky, but always a little bit darker than the real objects.

SMALL BRUSH-STROKES

As the painting progresses, the brushstrokes get smaller, as do the brushes that are used. This small, tight type of brushstroke adds vibrancy to the composition, especially around the vegetation.

PHASE 2:
REFLECTIONS ON THE WATER

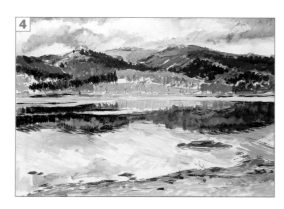

4. The reflections of the mountains on the lake are painted with violet tones. The sky is shaded with a few touches of rose. We complete the green on the mountains with green brushstrokes that are a little grayer this time around.

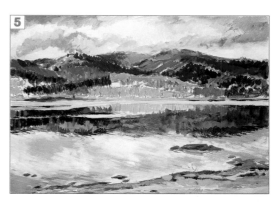

5. We paint the wavy texture of the water by alternating a series of quick violet and white brushstrokes; this will represent a light rolling motion.

6. We add more harmonious touches on the green of the mountains with smaller juxtaposed dashes of color. The areas where the trees are reflected on the water are darker. This painting is completed just enough to maintain its freshness.

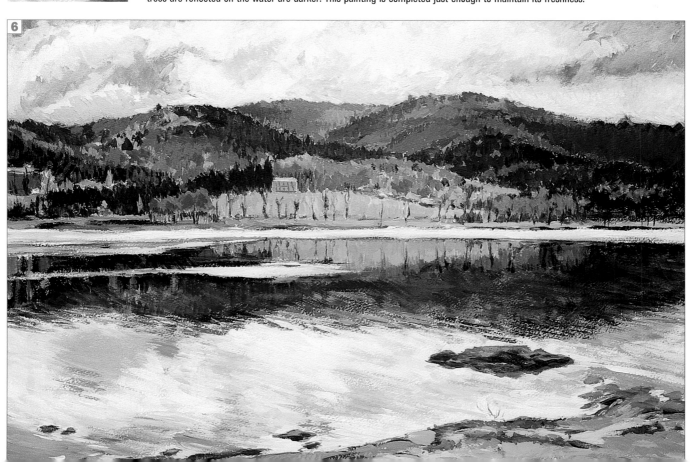

FROM TRANSPARENT
TO OPAQUE
ACRYLIC
PAINT

PAINTING

194

Night scene with colorist technique

When the sun goes down, artists who paint outdoors also conclude their work. But a night scene, especially one in a large city, provides infinite opportunities for capturing images worth painting. This is especially true when the illumination comes from various sources, and different focal points and shadows create surrealistic effects and dramatic scenes. Here, we are going to represent one of those illuminated buildings at night, paying special attention to the light and the colorist interpretation of the theme.

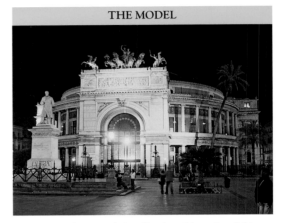

THE MODEL

■ A majestic theater and plaza illuminated by various light sources.

PHASE 1:
RED LINES
OVER BLUE

1. We paint the background with bright blue, forming a gradation. Using almost pure cadmium red paint, we draw the architectural features directly with the brush.

2. The main feature of a night scene is the contrast, so we begin there. The most illuminated areas of the façade are painted with yellow mixed with white, paying attention not to cover the red lines.

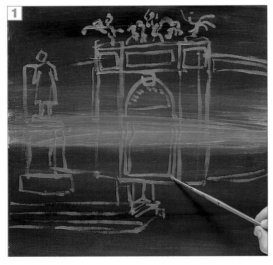

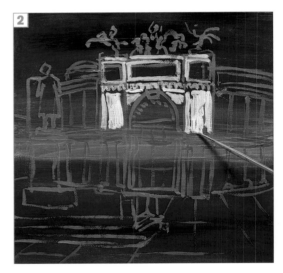

3. It is important to contrast the most illuminated areas with the darkest ones. With black we darken the sky by painting up to the edge of the building, and we add the same black color on parts of the building as well.

PAINTING

**FROM TRANSPARENT
TO OPAQUE**
ACRYLIC
PAINT

195

*The light that illuminates façades and
plazas at night is not as varied as daylight;
it is constant, controllable, and provides
great contrasts.*

PHASE 2:
SHINE AND
REFLECTIONS

4. We paint the monument
in the foreground with flat
paint, adding light and color.
The ground is darkened with
black. When both dry, we
paint the reflections with
dashes of opaque red and
ochre mixed with white.

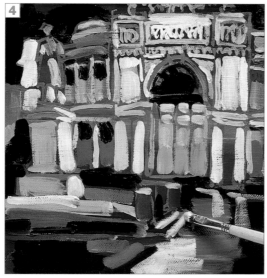

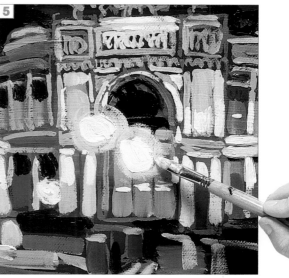

5. We represent the light
from the lampposts with a
circular halo, a gradation
with its lightest part in the
center. The dab of white is
gradated with yellow.

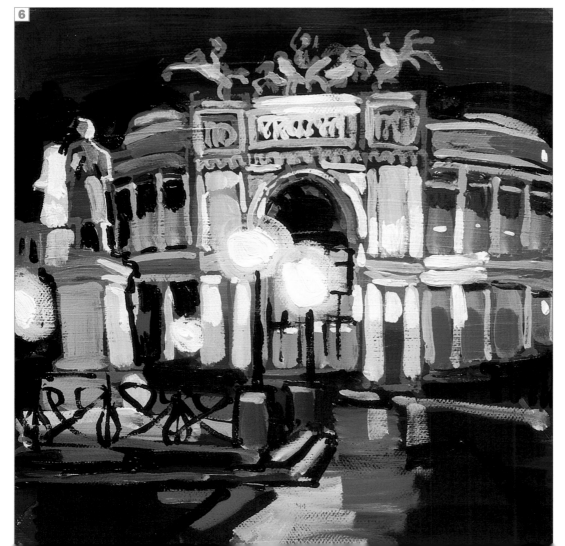

6. We leave for the end the
black areas that represent
the iron fence that surrounds
the monument and the
bases of the lampposts.
Then, we turn our attention
to the small reflections of
light and the architectural
details.

Painting

Brushstrokes and modeling

The brushstroke has a qualifying effect on objects and surfaces. It helps explain the form and the volume, to model the object so it looks coherent; it is not a fussy finish but an integral part of the construction of the painting.

In other words, the shape, size, and direction of the brushstrokes create the objects; the objects conform to the brushstrokes and not the other way around. The presence of brush marks also brightens flat areas of color. The planes become vibrant and acquire greater pictorial quality as a result of the visual texture of the brushstroke, which gives the color surface a unique quality.

THE DIRECTION OF THE BRUSHSTROKE

The fluidity and energy of each brushstroke give the painting a special freshness. The different treatments and possibilities are endless, from playful brushstrokes on a wet surface to dense, voluminous dabs applied with no mixing or manipulation. Each kind of brushstroke gives the painting a very unique look. The impression of movement is created by the direction and energy of the brushstroke. Expressive brushstrokes are the hallmark of oil and acrylic paintings.

■ Vincent van Gogh (1853–1890), *Street in Auvers*. The brushstrokes reveal the artist's creative process, the type of brushes that he used, and more.

PAINTING

**BRUSHSTROKES
AND MODELING**

199

THE DIRECTION OF
THE BRUSHSTROKE

*The brushstroke is the trace, the testament of the
sensibilities and the intelligence of the painter.*

The painter's mark

Brushstrokes allow us to study the creative process of the artist,
because they leave a visible mark on the surface of the canvas.
Analyzing brushstrokes can be very revealing for a person who is
interested in the artist's creative process, in the doubts and
hesitations, in the sudden discoveries and the corrections.

■ Vagram Gayfejan
(1879–1960), *Bouquet of Lilies.*
The brushstrokes unify and
agitate the surface of the
painting in a powerful way.

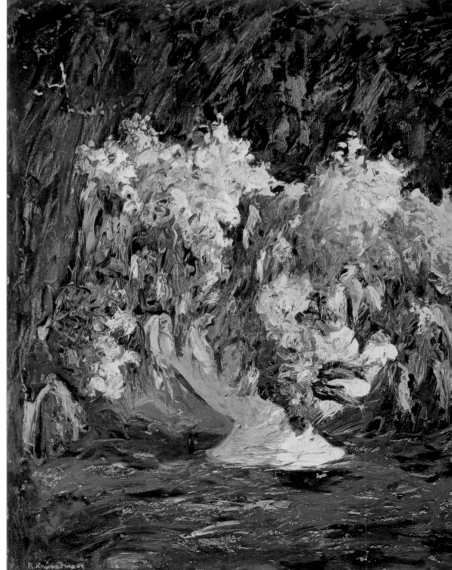

Unifying brushstrokes

The brushstroke can contribute to the unity of
the pictorial surface. An example of this can
be seen in paintings where the brushstrokes
create a scaly texture that affects all the
objects equally, making them part of the same
pictorial fabric. Brushstrokes can be applied
horizontally or vertically, using the natural
movement of the arm and the elbow as axis.
Repeated brushstrokes establish a sense of
rhythm that unifies the painting, which is more
effective if the brushstrokes are applied in the
same direction.

■ To show the brush marks,
the paint should be pasty
and thick.

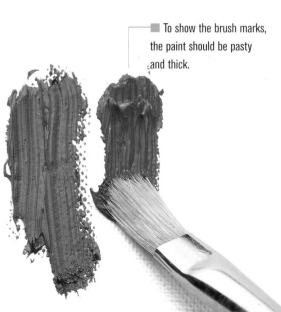

BRUSHSTROKES
AND MODELING
THE DIRECTION OF
THE BRUSHSTROKE

PAINTING

200

Modeling with oil paint

The traditional modeling technique is based on the blending of colors, which gives the objects greater volume and makes them look more solid. The process consists of painting the model with gradations, using a decidedly chiaroscuro approach, so that the artist can go from one color to the next without breaks or interruptions. Modeling can also be done by applying thick paint with the brush—that is, through numerous brushstrokes of different colors that explain the gradual transition from one color to the next. This is less exact than the previous method and livelier. However, overdoing impastos and excessive mixing can become problems, as we will explain here.

■ Here is a guide to help you learn how to model a sphere. First, draw a circle and then apply thee colors inside of it: dark brown, red, and beige.

■ Rub all the colors with a brush, beginning with the light colors and continuing with the darks, never the other way around. The colors blend in gentle gradation.

■ When modeling without blending, the colors are applied with rounded brushstrokes of different tones. The finish looks much more loose.

■ In the traditional modeling technique, the colors are blended together to form gradations, and the lines disappear completely.

The brushstroke varies according to the density of the paint, the dragging power of the brush, and the condition of the lower layers of color.

PAINTING

**BRUSHSTROKES
AND MODELING**
THE DIRECTION OF
THE BRUSHSTROKE

201

**GESTURAL
DRAWING**

You can use brush-strokes to draw with a gestural motion, using rhythmic, quick, play-ful lines that capture the main forms, the essence of the object. This way of painting is done with quick move-ments of the forearm.

Modeling with brushstrokes

In this type of modeling there are no blended or blurred brushstrokes. The volume is represented through the continuous application of different-colored brushstrokes. Problems can arise if the artist does not have adequate experience with this technique.

It is important to avoid excessive brushing because the colors will end up being overly mixed and the paint will acquire a grainy or cloudy appearance. Therefore, you should try to work with a small amount of paste and not to abuse impastos.

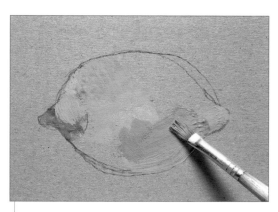

■ Modeling with brushstrokes is done with different-colored brushstrokes that are applied tightly next to each other.

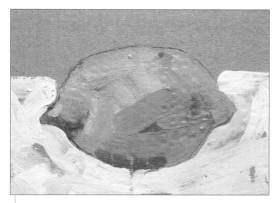

■ The brushstrokes should wrap around the shape of the lemon, each resulting in a different tonal transition that should be clearly visible.

Enveloping brushstrokes

Not only are the intensity and the charge of the brushstroke important but also its direction. In other words, the way a brushstroke is applied will explain the specific volume and texture of each object. There is an unspoken rule among artists according to which the direction of the brushstrokes should wrap around, and explain as much as possible, the volume of the object represented. Therefore, before beginning to paint the model it is important to plan the direction that the brushstrokes should follow in every part of the painting. On flat surfaces, the brushstrokes should be straight and on spherical ones they should be rounded.

■ If you decide to model an object with pasty brushstrokes, it is important to remember that they should conform to the volume of the object. So, a spherical object will be painted with circular brushstrokes.

**BRUSHSTROKES
AND MODELING**
THE DIRECTION OF
THE BRUSHSTROKE

PAINTING

202

Impasto: wet on wet

Painting with thick paint on a wet surface is not only technically difficult; it also accentuates any hesitation on the part of the artist. Impasto is a technique that consists of applying thick paint in such way that the brushstrokes leave a visible impression and create a textured effect. When applying thick oil paint over wet, it is important for the brush to be completely charged with pure, undiluted paint. To prevent the new paint from dragging away the colors below, the paint should be deposited on the tip of the brush and applied decisively and evenly, holding the tip of the brush at an angle, flat against the paper and never straight up.

PHASE 1:

**A BLUE
BACKGROUND**

2. The front of the pumpkin is painted with ultramarine blue mixed with white. The brushstrokes are no longer diluted but thick.

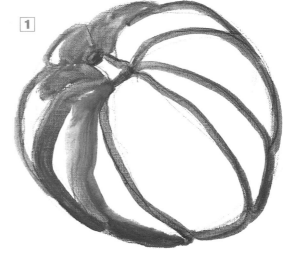

1. We are going to paint a pumpkin with thick paint. First, we do a pencil drawing, and then we go over the lines with ultramarine blue mixed with mineral spirits.

3. Now we paint the rear of the pumpkin with light ultramarine blue; both blues are blended in the middle with a clean brush. The base color is ready for us to begin adding the impasto.

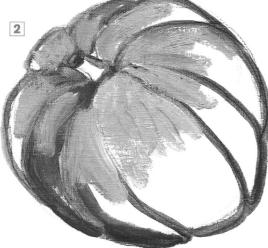

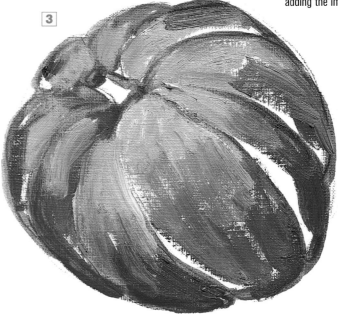

Very thick paint gives the impression of greater freedom and spontaneity, but in reality it needs careful planning.

PAINTING

**BRUSHSTROKES
AND MODELING**
THE DIRECTION OF
THE BRUSHSTROKE

203

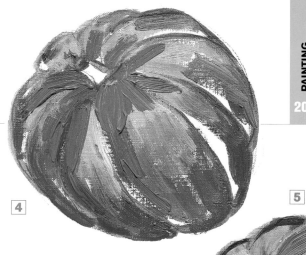

4

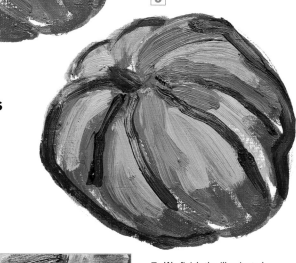

5

A COLOR BASE

Before we begin applying the impasto to the painting, it is important to have a base color covering the support; otherwise, the white canvas will be visible between the brushstrokes.

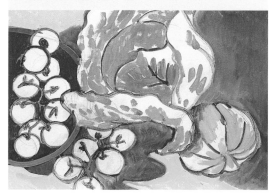

PHASE 2:
THICK BRUSHSTROKES

4. With thick red paint, we begin painting the sections of the pumpkin, holding the brush at an angle to avoid removing the blue plaint that is still fresh.

5. We finish the illuminated part of the pumpkin with new orange impastos, leaving the shaded area blue. With very thick gray-blue, we go over some of the contours and lines of the vegetable.

6

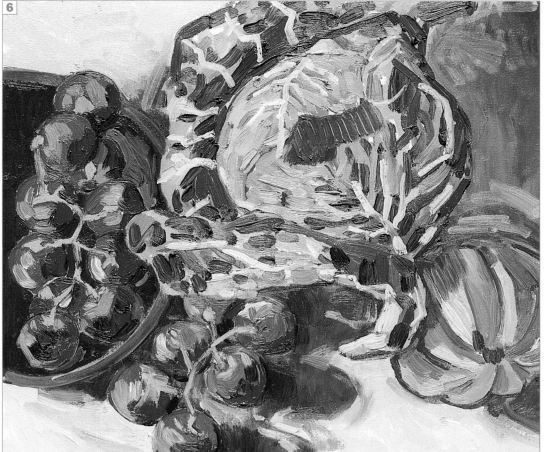

6. In this painting, we have painted the pumpkin as described above. The other elements have also been resolved with thick paint on wet.

Modeling a group of apples

Now we are going to learn how to model a group of apples. Even though the brush will hold less paint this time, the gesture of the brushstroke and the direction of the brush marks will be equally important in explaining the roundness of the fruit. Oil paintings executed with directional brushstrokes produce an impressionistic image, characterized by powerful color and the marks of the brush on the fresh paint.

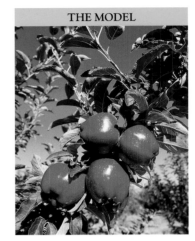

THE MODEL

PHASE 1:
SKY AND LEAVES

■ There is no need for an elaborate composition to practice modeling with brushstrokes; this group of red apples will serve the purpose.

■ For the leaves we mix emerald green, permanent green, and cadmium yellow, to which we add a small amount of white.

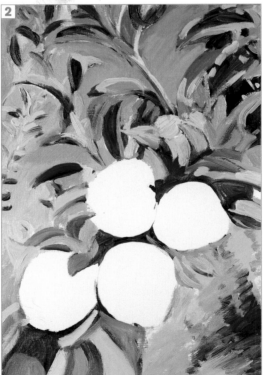

1. We begin by defining the background. To do this, the sky is painted with an uneven mixture of light blue and titanium white, to which we add a touch of green in the lower areas. We leave the spaces for the leaves and the fruit unpainted.

2. With emerald green we define the areas of shade on the leaves, which are painted with a mixture of permanent green and yellow, and a little bit of white.

■ The three colors used to paint the sky are light blue, white, and a touch of permanent green.

HIGH-LIGHTS

The white highlights are left for last, painted using a brush charged with pure white paint. The brushstrokes should be applied without fear of mixing them with the red paint underneath.

■ A medium round brush is the best option for this modeling exercise.

■ Carmine, cadmium red, and titanium white are the three colors used to model the apples.

4. Over the wet base we add pink tones for the most illuminated parts of the apple. The brushstrokes should be circular to give the apples volume.

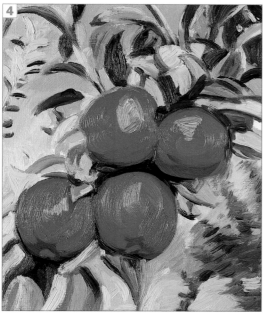

5. We apply some dashes of very light pink on the light areas, always using circular movements. Inside of them we add touches of pure white paint to represent the reflection of the light.

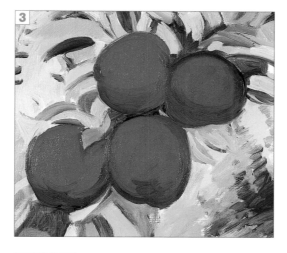

PHASE 2:

MODELING THE APPLES

3. We paint the circles that define the fruit with cadmium red, adding some touches of carmine on the bottom of each apple to define the shadows. These brushstrokes should be applied with a circular motion following the shape of the sphere.

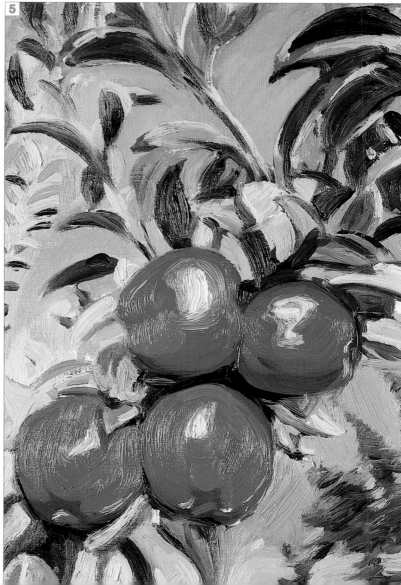

**BRUSHSTROKES
AND MODELING**
THE DIRECTION OF
THE BRUSHSTROKE

PAINTING

206

Creating rhythm

We can represent a subject with a series of small, quick, vigorous brushstrokes that cover the surface completely, as if it were composed of a myriad of squiggly lines. A good way to create tension and rhythm is by filling the painting with repetitive brushstrokes so that, in addition to suggesting the forms, they guide the eye of the viewer throughout the painting, creating an effect of depth, atmosphere, and energy. Let's look at the different ways to achieve rhythm and organize the brushstrokes.

■ A rhythmic effect is established when the brushstrokes are applied in an orderly, repetitive manner throughout the painting.

The brushstrokes direct the eye

Rhythmic brushstrokes are an important tool for creating depth and perspective. If we select an imaginary point on the horizon line to where all of the brushstrokes converge, we visually stimulate the viewer to direct his/her gaze from the foreground to the background.

■ The sky is constructed with diagonal brushstrokes that suggest the rays of sun bathing the landscape.

■ The brushstrokes indicating the sand are somewhat wavy and all converge at a single point on the horizon, giving the painting a feeling of depth.

■ In this landscape, the direction of the brushstrokes changes to express the different surfaces represented.

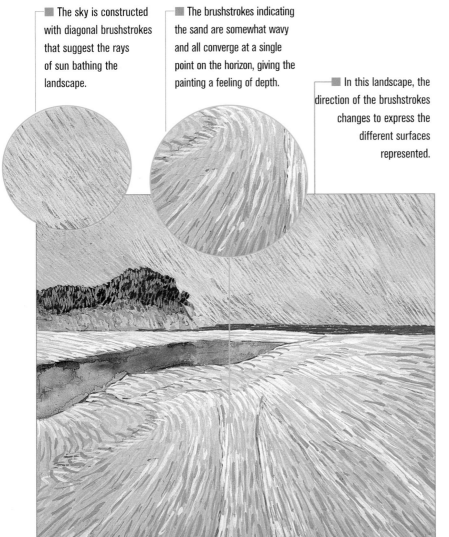

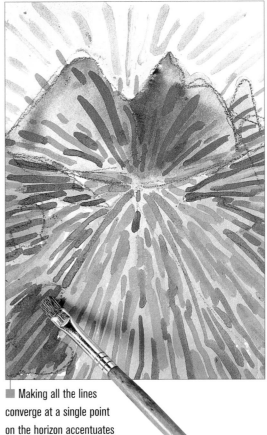

■ Making all the lines converge at a single point on the horizon accentuates the depth of the painting.

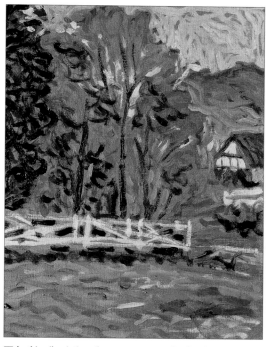

PAINTING

**BRUSHSTROKES
AND MODELING**
THE DIRECTION OF
THE BRUSHSTROKE

207

Nervous brushstrokes

Making nervous, stuttering brushstrokes will be easier if the brush is thin, the smallest available, which will make a line that is clearly noticeable. These brushstrokes look as if they have been done quickly and without much thought, but in reality they are applied in a controlled, thoughtful manner. Many artists consider this squiggly brushstroke approach a less serious technique but one that is very emotive and expressive. This painting method is not exclusive to oil and acrylic paints; it can also be used with watercolors when the washes are completely dry.

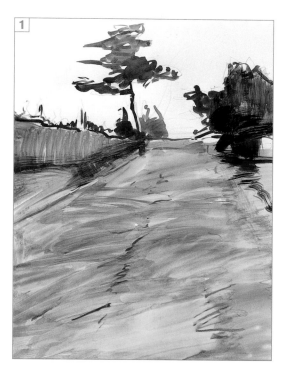

1. Before applying rhythmic, nervous brushstrokes with watercolors, the previous washes should be completely dry.

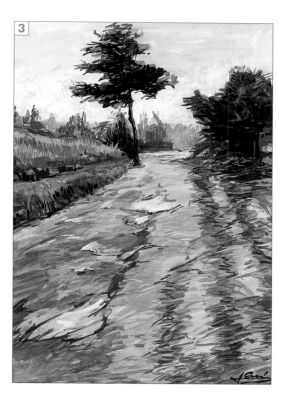

■ In this oil painting, the nervous, stuttering brushstrokes are grouped to form areas of agitated color.

3. Notice the result of the rhythmic brushstrokes on the road and on the vegetation of this landscape done with watercolors.

2. With a thin round brush we paint lines in a zigzag configuration, as if the line were drawn with a trembling hand.

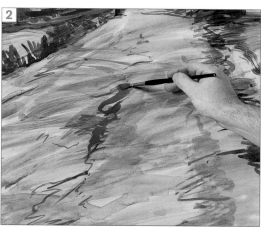

**BRUSHSTROKES
AND MODELING**
THE DIRECTION OF
THE BRUSHSTROKE

PAINTING

208

Still life with splashes of color

Painting with splashes of color is another variation of the rhythmic brushstroke. It consists of constructing the model with short and slightly spaced brushstrokes that add a sense of rhythm and tension to the painting. The brushstrokes give a trembling effect to each of the elements so that the painting has an unfinished and imprecise, but very effective, look. Painting with splashes of color creates an intense and vibrant feeling that cannot be achieved when the paint is applied evenly; work done in this way is bright, energetic, luminous, and fresh. For that reason, this technique should be considered an extension of the previous lesson.

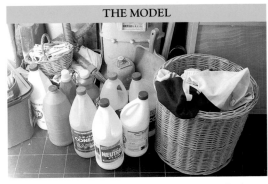

THE MODEL

■ This still life with detergents, plastic bottles, and a basket of laundry is a common household scene.

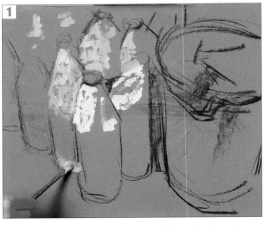

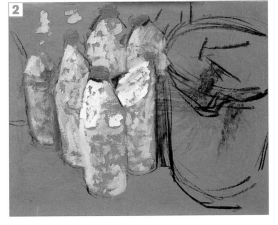

PHASE 1:

**FRAGMENTED
BRUSHSTROKES**

2. We continue working the bottles with the brush, alternating light with dark tones in each case, depending on the angle of the light.

1. On a gray background we draw a still life with charcoal. Almost immediately we apply the first splashes of color, with minimally diluted paint, leaving small voids through which you can see the color of the background.

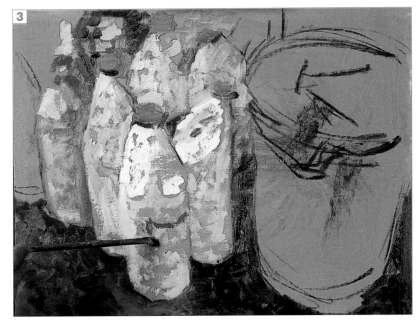

3. As we finish up the bottles, the caps are nothing more than smudges. We suggest the labels with fragmented lines of color. The floor is covered with compact brushstrokes of darker colors.

PAINTING

209

**BRUSHSTROKES
AND MODELING**
THE DIRECTION OF
THE BRUSHSTROKE

When you work with splashes of color, it is important to pay attention to the distance between the brushstrokes so the color of the background can act as a unifying element.

PHASE 2:
A VIBRANT SURFACE

4. The clothes in the basket are painted with longer brushstrokes to suggest the wrinkles and folds. The gray color from the background is slightly visible between the brushstrokes.

5. The freshness of the moment and the vibrant sensation that the bursts of color produce is evident in the finished exercise.

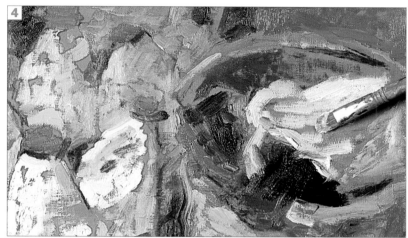

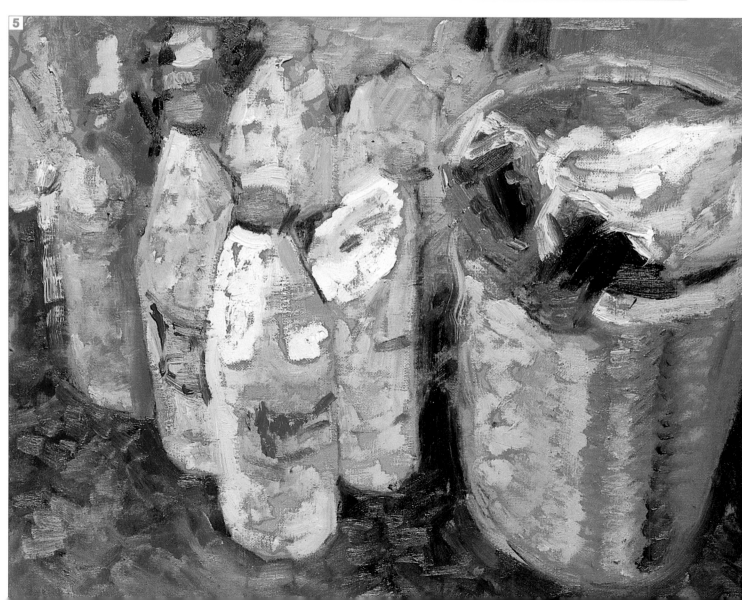

BRUSHSTROKES
AND MODELING
THE DIRECTION OF
THE BRUSHSTROKE

PAINTING

210

Strong brushstrokes

In the next exercise we are going to test the true impact of colors applied thickly and generously. We will reconstruct a simple seascape, using collage to lay out the base of color, which will then be completed with generous brushstrokes charged with a large amount of paint. The surface of the painting will be thick and oily, which will help with the gestural movement of the brush and emphasize the spontaneous marks that it leaves behind. This treatment can be considered on the border between figurative and abstract.

THE MODEL

■ A seaside cliff without features in the foreground, divided into four distinct areas of color: the sky, the rocks, the sea, and the sand.

PHASE 1:

FROM COLLAGE TO PAINT

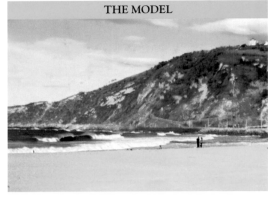

1. We simplify the main areas of the model by cutting out two pieces of paper of different textures and colors. We adhere them to the support with liquid glue.

■ To avoid colors that are overly saturated, each application can be systematically darkened with dirty mineral spirits

2. Over the glued paper we draw the profiles of the cliff and the edges between the water and the sand with colored wax.

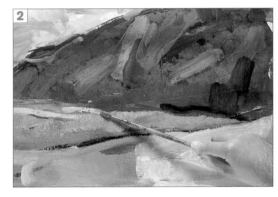

3. With a wide bristle brush we cover the sky with blue and white mixed with mineral spirits. The white has turned muddy because the mineral spirits are a bit dirty.

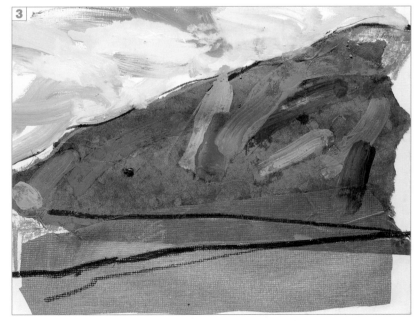

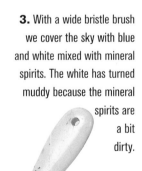

PAINTING

**BRUSHSTROKES
AND MODELING**
THE DIRECTION OF
THE BRUSHSTROKE

211

■ The brushstrokes should be very generous and applied without fear of dripping—in fact, drips add a greater graphic effect and a modern flair.

4. With the same wide brush we add green colors to the center of the painting with vigorous brushstrokes. The sea and the sand are differentiated with blue and ochre mixed with white.

PHASE 2:

FROM FIGURATIVE TO ABSTRACT

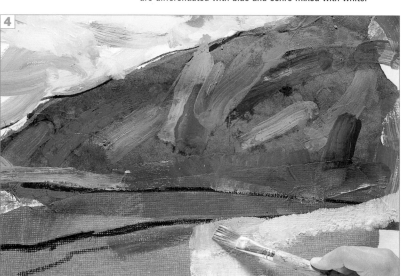

5. We overlay new oily brushstrokes over the previous ones, with some dripping occurring as well. The beach is finished with pink-gray tones that are spread with an industrial-grade spatula.

6. To give the composition a more abstract look, we add a heavy yellow impasto, spreading it in circular motions with a brush. We do the same on the sand with red paint.

BRUSHSTROKES
AND MODELING
THE DIRECTION OF
THE BRUSHSTROKE

PAINTING

212

Seascape with cliffs: rubbing the brush

**PHASE 1:
EXTENDED
AREAS OF
COLOR**

This model is similar to the previous one, although this time the ocean is viewed from a higher altitude. The mode of application is going to change quite a bit as well. The brushstroke will not be thick, but it will be oily enough to be applied with the brush held at a slight angle and to leave a mark when vigorously brushed on the support. This approach combines splashes of color with a rhythmic and consistent brushstroke. The final work has a sketched feeling with no textural details. This painting was done with acrylic paints, although oils could be used as well.

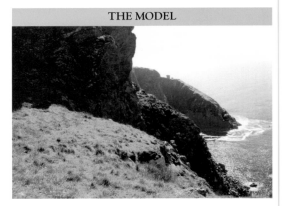

THE MODEL

■ Intense light illuminates the foreground, which contrasts with the dark silhouette of the rocks.

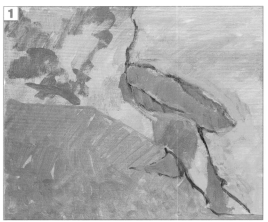

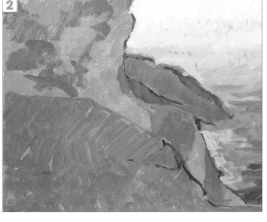

2. Whenever we paint a landscape, we do it from the most distant to the closest planes. Here, we begin by painting the sky and the sea, which are a gradation of blues.

1. We paint the background with diluted orange. Then we draw the contours of the cliffs using a brush charged with blue. The background is painted with oranges and pinks to create an anticerne effect.

3. Now we begin the rubbing effect. We charge the brush with brown and violet-gray paint to cover the somber rock walls with rhythmic and slightly separated brushstrokes. The brush is held at an angle to use up all the paint.

The technique of rubbing with a brush charged with paint requires holding the brush at a slight angle so you can rub with the side of the bristles and not the tip.

PAINTING

**BRUSHSTROKES
AND MODELING**
THE DIRECTION OF
THE BRUSHSTROKE

213

**WEARING
OUT
BRUSHES**

If you are going to use this technique, rubbing the paint on the support instead of brushing it gently, it is a good idea to work with bristle brushes because they are more durable. Despite this, the brushes wear out quickly, especially on highly textured surfaces.

PHASE 2:

RUBBING ADDS TEXTURE

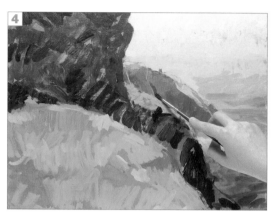

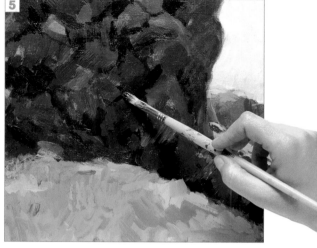

4. With a thin round brush we apply the violet colors on the rocks of the background. The grass is painted with green mixed with a generous amount of yellow. The direction of the brushstrokes should be vertical, in keeping with the direction of the grass blades.

5. We resolve the structure of the rocks by combining black, dark brown, and gray. The direction of the brushstrokes is somewhat spontaneous and unstructured.

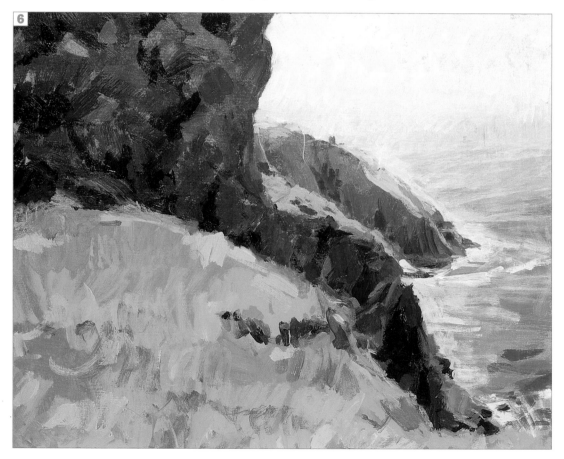

6. We paint the sea foam by rubbing horizontally with diluted white. Each area has been painted with different types of brushstrokes. The closer the plane, the easier it is to see the pink and orange colors of the background.

BRUSHSTROKES
AND MODELING
THE DIRECTION OF
THE BRUSHSTROKE

PAINTING

214

Brushstrokes describe the light: a silhouette

Brushstrokes are necessary when representing rays of light, which normally are not visible but appear in scenes with silhouette effects (when the light source is behind the model). The scene of a riverbank with the sun going down behind a hill has a powerful source of light that darkens the features of the landscape and illuminates the surface of the water. The brushstroke is the key means of representing silhouette effects and the shimmering highlights on the constantly moving water. We only need to know what type of brushstroke technique to use and in what direction to describe the sunrays and the reflected light. The medium used in this case is oils.

THE MODEL

■ This scene depicts the moment in which the sun begins to go down behind a hill, illuminating the landscape with a powerful silhouette effect.

PHASE 1:

A DARK BACKGROUND

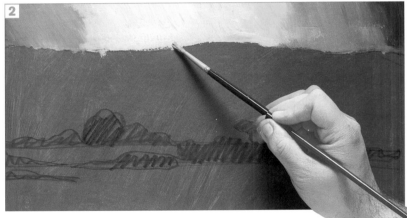

1. We sketch the subject with graphite lead over the dry paint. It is enough to outline the hills and the edge of the river.

2. We apply a gradation on the sky that goes from white, in the area where the sun is going to be located, to blue, as we progress to the sides.

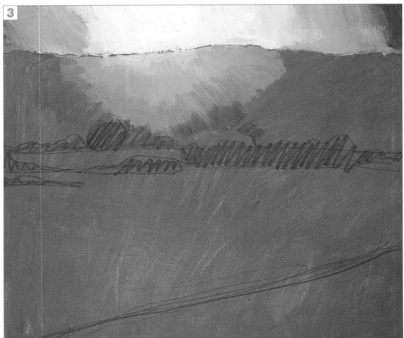

3. Now we prepare to paint the sunrays. We start painting the lighter area of the hill. Next to the white on the sky we add ochre mixed with white, which is darkened as we move farther away, forming an arc.

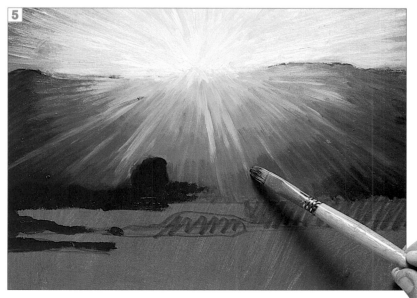

SILHOUETTE EFFECTS

These effects appear when the light source is located behind the object, blinding the viewer, which makes all the features appear darker and clearly outlined. The background lights up and is filled with bright, radiant colors.

▪ The sunrays should begin at a central point and extend in every direction, in a radial configuration.

PHASE 2:
PAINTING LIGHT

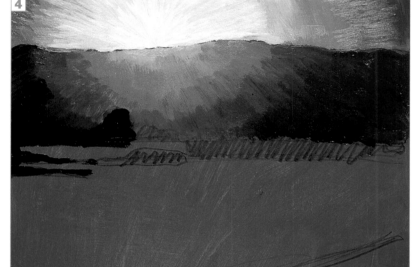

4. The brown of the mountain becomes darker as it gets farther away from the light source. It is burnt umber in the darkest areas.

Light moves in a straight line and a radial configuration. The lightest colors are found near the focal point and get darker the farther away they are from it.

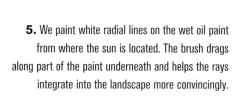

5. We paint white radial lines on the wet oil paint from where the sun is located. The brush drags along part of the paint underneath and helps the rays integrate into the landscape more convincingly.

**BRUSHSTROKES
AND MODELING**
THE DIRECTION OF
THE BRUSHSTROKE

PAINTING

216

PHASE 3:
THE WATER

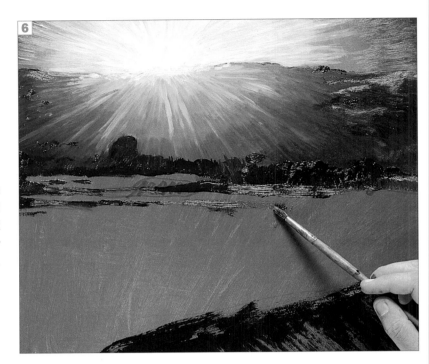

6. The vegetation on the river's edge is silhouetted, which means that we need to paint it dark with a mixture of burnt umber and violet. We paint the lower part of the water with the same color.

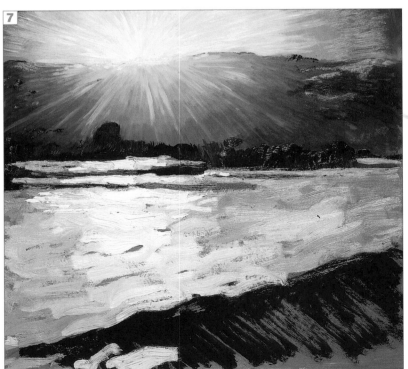

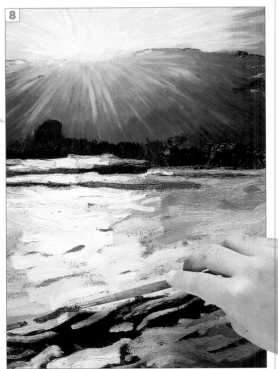

7. We continue to paint the water with various wavy, quick brushstrokes of blue and violet-blue applied diagonally. The path of light will be painted with whiter, vertical brushstrokes.

8. New brushstrokes are added over the blue gradations on the water, this time with dark violet, which represent the waves in the foreground. The color is applied very thickly.

PAINTING

**BRUSHSTROKES
AND MODELING**

THE DIRECTION OF
THE BRUSHSTROKE

217

NOT ALL LIGHT IS PAINTED THE SAME

All effects of light aren't painted the same way. Each type of light requires a different interpretation, according to its source and the type of medium used. You should learn how to change the technique according to the light source.

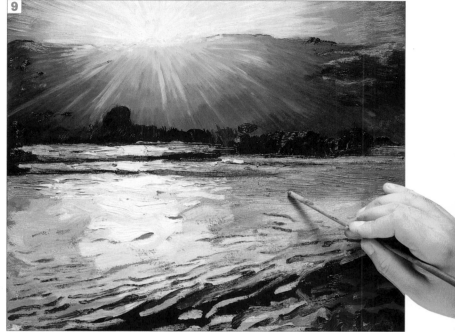

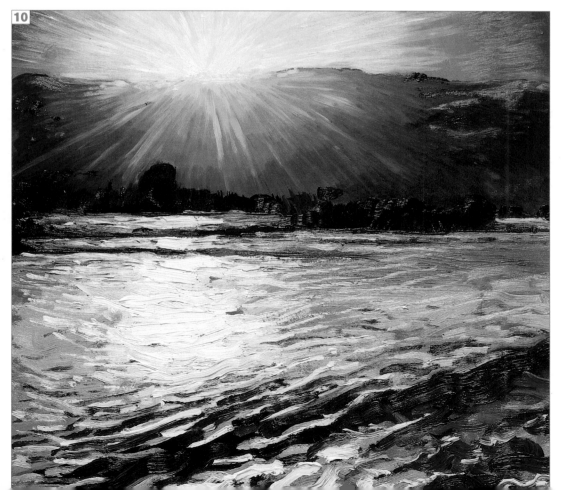

9. The accumulation of brushstrokes becomes increasingly important to describe the surface of the water in the foreground. We apply some sgraffito with the handle near the water's edge.

10. Additional white brushstrokes cover the surface of the water, although this time they are longer and thinner and concentrate around the main area of light reflection.

RELIEF PAINTING

*I*n the second half of the twentieth century, artists explored materials in search of new forms of artistic expression, in which the texture and relief of the work was appreciated. These were modern concepts, very different from the realism and perfect brushstrokes of the past. Since then, artists have mixed paint with different materials to change its composition, viscosity, and tactile quality, and to create greater volume.

■ Emil Nolde (1867–1956), *Bridge on a Marsh.* Oil painting created with generous impasto applied with a spatula and a brush.

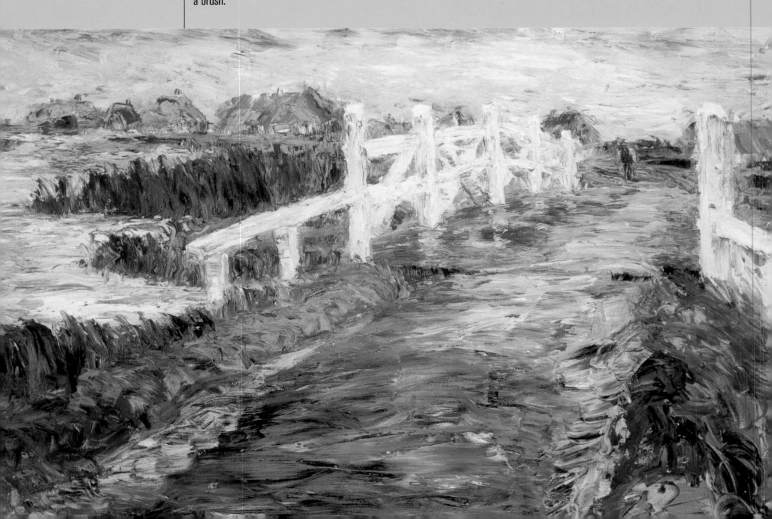

Relief and impasto paintings lose their freshness when the paint is rubbed, mixed, or painted over too much on the canvas or if it is applied carelessly.

■ Sgraffito effects can be created with the rounded tip of the spatula on the surface of thick paint.

Textures with impasto

Impasto is an approach that can be used both with oil or acrylic paints to enhance the look of relief and volume. Impastos can be modeled independently of the color, making their texture an additional resource in the painting process. They can be applied directly, using only thick paint or paint mixed with other materials to create greater volume or a particular textured effect. Regardless of the technique, they are all used for a common purpose, to make the painting more expressive and to remind the viewer that the painting is a flat surface and not a window into a real scene.

■ Gabriel Martín (1970), *Still Life with Pears.* Acrylic paint has been mixed with a bit of sand to make this unique textured surface.

Painting with a spatula

The thick consistency of oils and acrylics allows them to be mixed on the palette with a spatula and then transferred to the canvas, where they can be modeled into a specific texture. The artist creates the forms and the surface of the model that he or she wants to represent with the spatula, in complete control of each color impasto. The outlines of the subject are created with the edge of the spatula, and the large areas of color by dragging the paint with the side of the blade. The paint can be scratched with the tip of the spatula, creating different indentations and textures. It is a good idea to experiment with all of the spatula's possibilities beforehand on a piece of scrap paper.

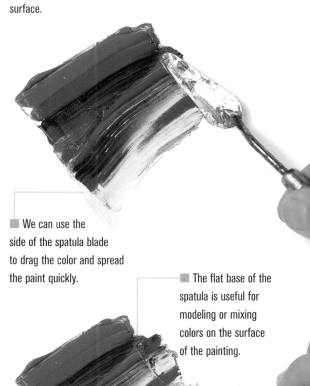

■ We can use the side of the spatula blade to drag the color and spread the paint quickly.

■ The flat base of the spatula is useful for modeling or mixing colors on the surface of the painting.

**BRUSHSTROKES
AND MODELING**
RELIEF
PAINTING

PAINTING

220

Tactile paint

Numerous materials and substances can be mixed with paint to
create textures or, in other words, a relief painting. The relief is
enhanced by adding charges of sand, marble dust, straw, rice, thickening
gel, sawdust, and other materials to the paint, although these can also be
sprinkled onto the support when the layer of paint is still wet.

In this chapter we will give you some suggestions, but we also invite
you to experiment with new materials. As far as the type of paint used,
these techniques require consistency and thickness, so oils and acrylics
are best.

■ These oil paints were applied with a spatula. The
colors are mixed on the support.

■ Texture created with gesso and painted over
with acrylics.

■ Extruded paint—that is, paint applied directly
from the tube.

■ Oils mixed with small pieces of scrap metal.

■ Oils mixed with small lead shot. It is not a good
idea to use too many of them because they are very
heavy.

■ Oils mixed with washed sand, applied in various
thicknesses.

WASHES OVER TEXTURE

Washes can also be useful for highlighting texture. When a layer of thick paint is dry, an oil or acrylic glaze is applied over it. The diluted paint concentrates in the cracks on the surface, highlighting its texture.

■ Rice mixed with gel and brown acrylic paint.

■ Crumpled tissue paper glued with latex and then painted over with acrylics.

■ Gel and green paint mixed with noodles. Then the protruding pieces are painted orange.

■ Gluing various objects to a surface is another way to create relief. They can then be painted over with bright colors.

■ A very volumetric paste that dries very easily is made from a mixture of paint and fine marble dust.

■ This landscape was painted with acrylics mixed with gesso to add volume and character to the spatula marks.

■ A spatula can be used to make channels and ridges on gesso or marble dust mixed with paint.

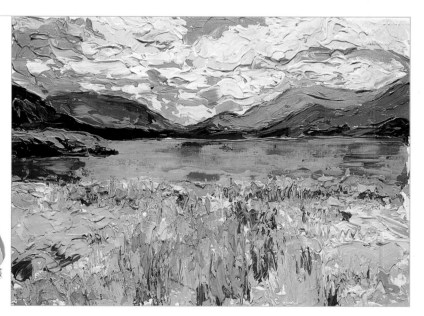

BRUSHSTROKES
AND MODELING
RELIEF
PAINTING

PAINTING

222

Still life with spatula

The spatula, which in this case stands in for the brush, provides a new range of effects to the still life. Painting with a spatula and oil paints enhances the relief and the textures and adds the vibrant character of its marks to the painting. To obtain good results, you should first practice with simple exercises to learn how to handle the spatula. Acquire some mastery of this tool, because it can be as versatile as a brush and you need not pay attention to detail. The process of painting with a spatula is similar to painting with a brush, but the paint should be laid on gently to avoid dragging and mixing the colors underneath.

THE MODEL

■ This still life has a wood background, which adds additional texture to the theme.

PHASE 1:

THE LARGEST AREAS

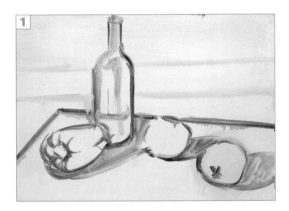

1. We make the layout of the model with a brush, drawing lines with brown paint mixed with mineral spirits. The drawing can be strong and defined because it will be covered with thick layers of paint.

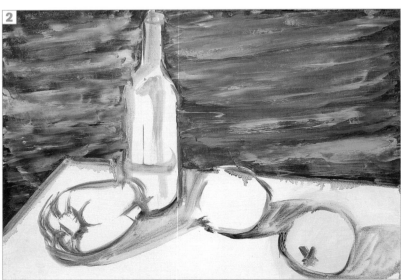

2. We paint the background with ochre, sienna, and burnt umber. These colors are not mixed completely. They are applied with the spatula held horizontally, touching the paper gently with the lower part of the metal blade.

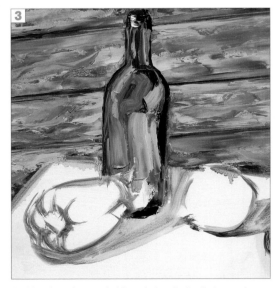

3. After the colors needed for painting the bottle (green, burnt umber, black, and white) are identified, we mix them by moving the spatula up and down.

PHASE 2:
PAINTING THE VEGETABLES

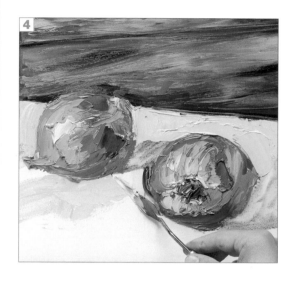

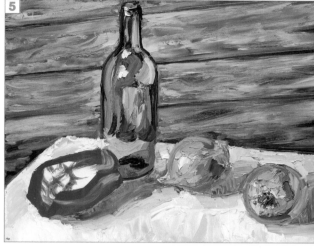

4. We paint the onions, first with an even brown color and then with new dabs of color to differentiate the light from the shadow. The colors should be applied with circular motions following the shape of the vegetables.

5. We paint the table with gray, ochre, and white. The intermediate tones are created by mixing one color with another on the support.

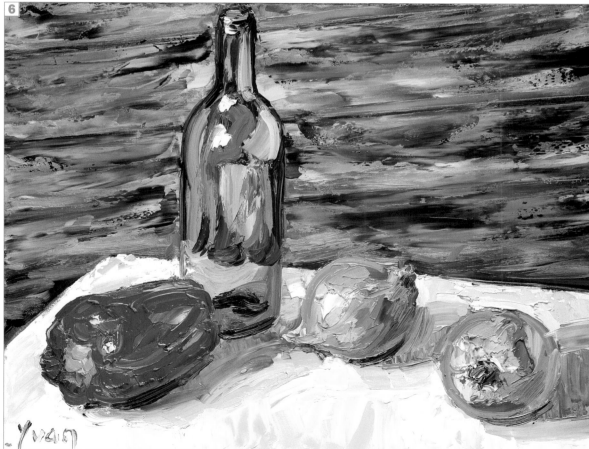

6. To finish the exercise, we resolve the coloring of the pepper, mixing red and carmine and a dash of white for the reflected light. The spatula adds a very expressive mark to the painting.

Landscape with spatula

Generally, landscape themes turn out best if painted with a spatula; this is not only because of the variety of relief and textures that they offer, but also the fact that landscapes are wild and natural, which allows for a freer, more spontaneous color treatment that is easy to carry out with a spatula. Here, we are going to work with a spatula held flat to paint the distant planes and with the tip to highlight the textures of the vegetation.

PHASE 1:

DRAWING AND PAINTING

1. We represent the essential forms with a simple drawing. It is not necessary to develop the drawing in detail because soon it will be completely covered by paint.

2. With abundant yellow and ochre we cover the golden field below. We work with the spatula held flat, using large horizontal movements.

THE MODEL

■ The scene is a little river flowing through fields surrounded by dense forests.

3. The ochre in the foreground has new green and brown smudges. We paint the field in the center of the image with two tones of green, passing the spatula over it gently.

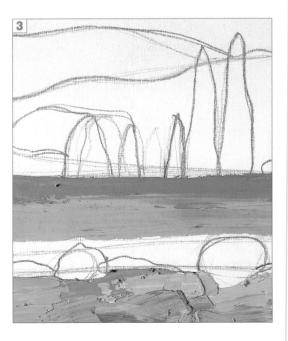

LIGHT COLORS

It is important to apply light or warm impastos over dark ones, so they seem to advance visually.

Doing the opposite creates very odd and sometimes incomprehensible visual results, especially since work done with a spatula is always more abstract and intuitive than work done with a brush.

PHASE 2:

SGRAFFITO IS LIKE DRAWING

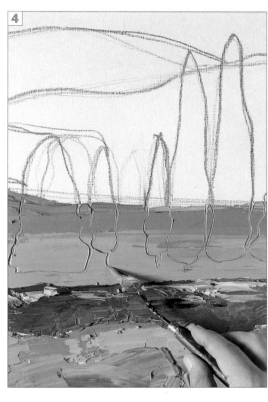

4. When the paint is applied, the initial drawing is covered. We can restore it by drawing with the tip of the spatula on the fresh paint.

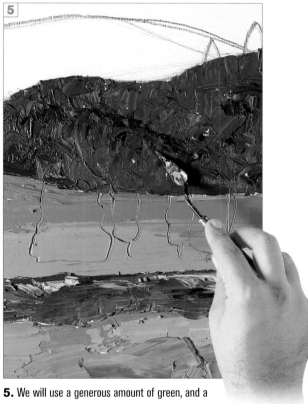

5. We will use a generous amount of green, and a small amount of red and violet, to represent the texture of the vegetation on the mountains. The colors are mixed with nervous movements of the spatula.

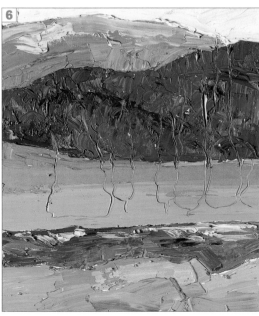

6. The mountains in the distance and the sky are painted with streaks of uniform colors. Once again, we can restore the outlines of the trees by working with the tip of the spatula.

THE TEXTURE OF VEGETATION

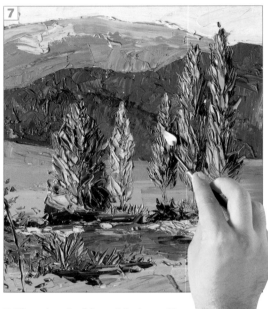

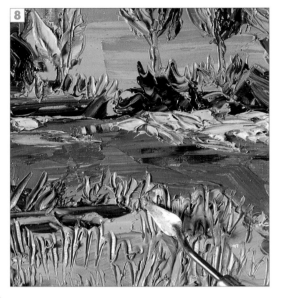

8. We construct the bushes in the foreground with a spatula and permanent green and burnt umber. Then we create the texture of the grass with the sgraffito technique.

7. We work on the foliage of the trees with the tip of the spatula charged with different green tones. The paint should be applied by moving the spatula in the direction of the branches to make the texture more credible.

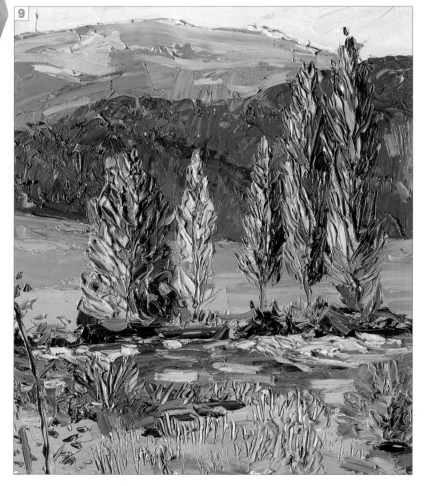

9. We add the last touches by applying a few brushstrokes of white paint on the mountains in the background and a few thicker dabs of paint for the water and the closest bushes.

PAINTING

**BRUSHSTROKES
AND MODELING**
RELIEF
PAINTING

227

The effects created with the spatula can express different textures, and they all basically result from pressure and the lines made on the paint.

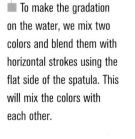

Four types of applications

We are going to study a painting closely to understand how the spatula is handled in each area of the painting. In other words, each surface requires a different color treatment and a specific motion of the spatula. This variety of textures is what makes the painting interesting.

■ The color of the road is a homogenous blend mixed on the palette. We charge the spatula with the paint and spread it gently on the paper.

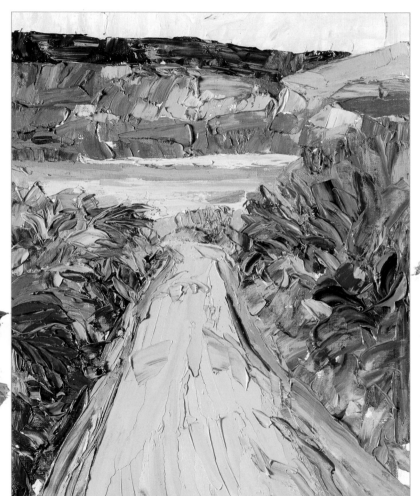

■ To make the gradation on the water, we mix two colors and blend them with horizontal strokes using the flat side of the spatula. This will mix the colors with each other.

■ Holding the spatula at a slight angle, we apply the different colors to recreate the texture of the rocks in the background. The colors should appear juxtaposed, not mixed.

■ To create the vegetation, we apply the paint with the rounded tip of the spatula. Then we texture the fresh paint by tapping it with the tip.

**BRUSHSTROKES
AND MODELING**
RELIEF
PAINTING

PAINTING

228

Painting over texture

Modeling paste and gesso are useful materials for applying texture to a painting. They can be mixed directly into the paint or applied beforehand and then painted over after drying. In this step-by-step exercise we chose the second approach, using acrylic modeling paste and pumice to create the texture. The greatest asset is the rich texture in the finished painting, and its biggest drawback is the deterioration that the brushes endure from painting on such a textured surface. We will use acrylic paints for this exercise.

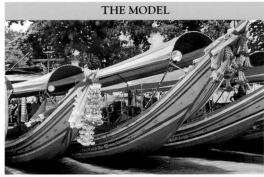

THE MODEL

■ This group of brightly painted boats is richly adorned with vivid decorations.

PHASE 1:
BUILDING UP
THE RELIEF

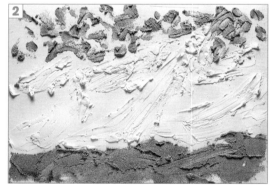

1. Using acrylic modeling paste we roughly draw the shapes of the boats. We spread the material with a metal spatula.

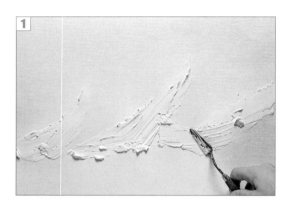

2. We cover the area of the water with the pumice paste, which is gray and stands out from the previous layer, and we begin adding more on the upper part, pressing with the tip of the spatula.

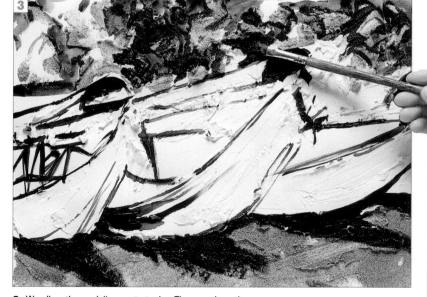

3. We allow the modeling paste to dry. Then we draw the model with a medium flat brush charged with black paint, paying special attention to the outlines of the boats.

Normally, modeling paste is made of sand, marble, or alabaster dust, which are granular products that provide an even texture throughout the paste.

DRY BRUSH-STROKES OVER TEXTURE

We apply an impasto and let it dry. Then we paint over it with a brush charged with a small amount of thick, undiluted paint, so that it will only stick to the areas that stand out.

PHASE 2:
BRIGHT COLORS

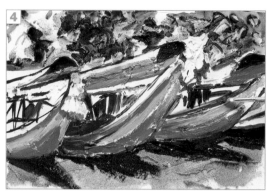

4. We paint each of the stripes on the boats with their respective colors. The texture of the surface makes the color appear uneven and the paint irregular.

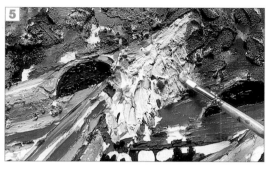

5. We add thicker green and ochre paste to the trees and on the water to prevent the gray of the pumice from coming through to ruin the finish. The adornments on the stern are suggested with dabs of color.

6. Finally, we add the blue stripes on the boats. The treatment is very loose, as the relief paste does not allow the use of small brushes or the addition of details.

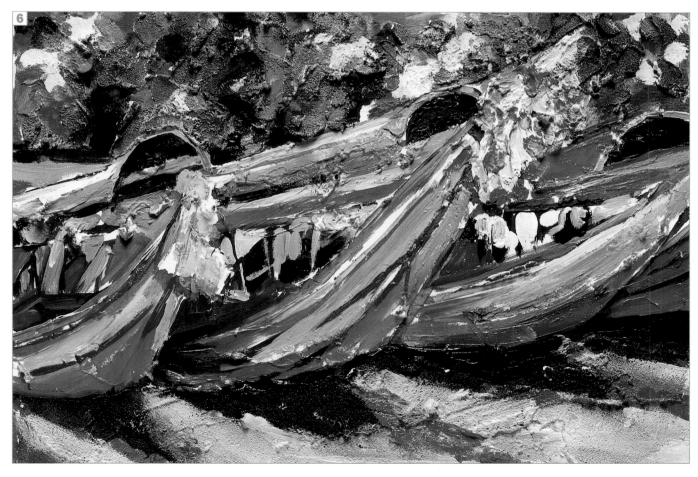

SOME CREATIVE NOTES

*T*o conclude, we will present a few exercises that incorporate some creative techniques for achieving fresher, more modern results. Generally, they rely on dramatic effects, on shocking the viewer with certain finishes or textures, which minimizes the importance of drawing and reaffirms the supremacy of paint and its expressive capability. We will practice some uncommon methods of painting, often used by professional artists, whose results are very gratifying. Our goal is to encourage your creativity and help you achieve original results.

■ Gabriel Martín (1970), *A Couple of Lemons.* Painting with a sponge gives a different and creative look to the still life. The variety of textures and lines helps interpret the theme.

PAINTING

BRUSHSTROKES
AND MODELING
SOME CREATIVE
NOTES

231

"I am not afraid of making changes, of destroying the image, etc., because the paint has a life of its own. And I try to let it manifest itself."
Jackson Pollock

ON THE ROAD TO ABSTRACTION

To begin with a real object and take it apart until you arrive at an abstract representation is a good way to test your creativity and your skill in the use of alternative materials and techniques to achieve surprising effects and textures.

■ The more versions you make of the same model, the better you will understand it. Every interpretation requires creative effort on the part of the artist.

Alternative methods for painting

Normally, paint is applied with a brush or with a spatula; however, progress brings with it greater freedom in painting, in terms of style as well as painting tools. Therefore, when we encourage you to explore alternative painting methods, we refer to any object capable of applying the paint to the support or to leave a mark on it. A curious artist can resort to objects that provide new effects like sponges, rollers, toothbrushes, sandpaper, stencils, collage, and the like.

Experimenting with models

If you are going to experiment with new techniques and new work methods to which you are not accustomed, it is very helpful to work on different paintings at the same time. You can paint the same subject several times to introduce different variations and interpretations and experiment with the composition, the color, or a specific pictorial effect. This approach will help you overcome technical difficulties, develop your creativity, and understand that the same model can offer different options.

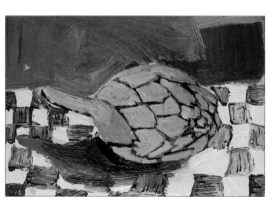

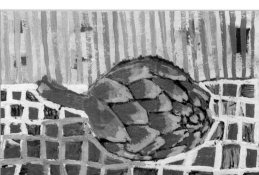

■ Sponges are an alternate method to brushes for painting. If you use different types (roller, spatula, synthetic, natural), the variety of effects will be greater.

**BRUSHSTROKES
AND MODELING**
SOME CREATIVE
NOTES

PAINTING

232

Paint puddles

This technique consists of applying acrylic paint as a wash on a support that is not very absorbent and that does not have a tendency to buckle, like canvas or primed wood, never paper. The lack of absorbency makes the paint form puddles, which upon drying create areas of distorted color that can be applied as glazes.

Interrupting the drying process

If you work with the previous method you can interrupt the drying process before the water evaporates completely to create washes with bare spots—that is, opening irregular shapes on the surface that allow the underlying color to show through. This is because the puddles of acrylic paint do not dry evenly but from outside in, so if you wait some time and then brush them with a wet sponge, you will only remove the central portion of the paint, leaving behind the paint accumulated on the edges, which will already be dry.

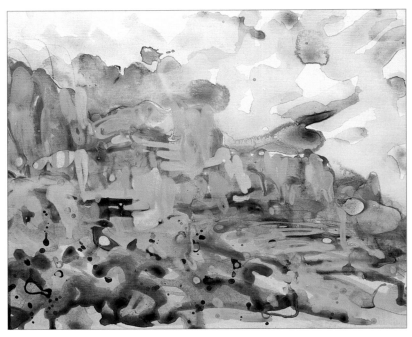

■ The puddles of watery paint have dried over each other. If we tip the support, a few drips may even occur.

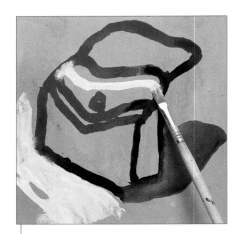

■ Let's see with a simple example how the puddle process can be interrupted. First, draw the object with acrylic paint mixed with water.

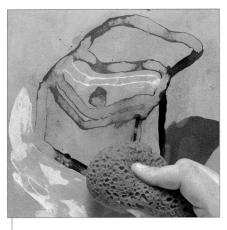

■ Wait a few minutes until the wash is partially dry and then wipe a wet sponge over the surface.

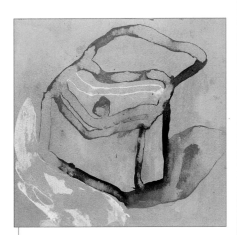

■ The central part of the wash, which was still wet, was removed, leaving the edges of already dry paint.

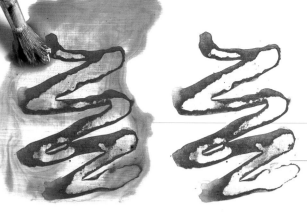

PAINTING

**BRUSHSTROKES
AND MODELING**
SOME CREATIVE
NOTES

233

■ The longer you wait to wash the puddle of paint with water, the thicker the lines on the edges will be. It is better not to wait too long or the drawing will be completely dry and you will not be able to clear the areas.

1. We will practice using puddles of paint with a simple landscape. We prepare a piece of wood with white gesso primer, and then apply the first washes with three colors.

2. We complete the previous washes with larger, more generous washes, taking care not to tip the support to avoid dripping. Now we only need to wait for it to dry a little bit.

3. This is the moment to wipe with a wet sponge to remove part of the wash. We repeat the procedure with other colors until the model is complete.

**BRUSHSTROKES
AND MODELING**
SOME CREATIVE
NOTES

PAINTING

234

Spattered painting

Now we are going to review the spattering technique. It consists of spraying diluted paint on the support, forming a shower of minute droplets that cover the surface of the painting to give it a strong atmospheric effect. To do this, first dip an old toothbrush in a container full of diluted creamy paint and then scratch the brush with your fingernail over the area that you wish to spatter. This technique can be used with any medium, but it produces the best results with watercolors and acrylics.

PHASE 1:

PREPARING THE BACKGROUND
AND THE SKY

THE MODEL

■ An architectural detail including a chimney and a window. It is very easy to draw.

2. To spatter on the sky, first we cover the rest of the painting with a piece of cardboard and masking tape to avoid painting over those areas. We charge the brush with white paint and spatter the sky, concentrating more droplets on the lower area.

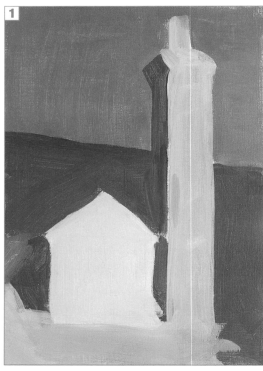

1. We start with a geometric pencil drawing. We paint the sky with ultramarine blue mixed with white, the roof violet, and the chimney and the window ochre. The colors are applied flat, without any texture.

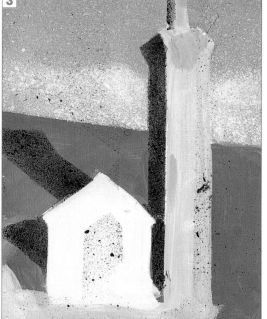

3. We remove the paper from the covered area to appreciate the spattering effect on the sky. With more paper and masking tape we reserve the shadows on the chimney and spatter with violet. When the stencil is removed, the areas are clearly divided.

PAINTING

**BRUSHSTROKES
AND MODELING**
SOME CREATIVE
NOTES

235

*Spattering paint on the support is a very dramatic way
to suggest textures, but you can also use it to enhance
or add interest to an area of flat color.*

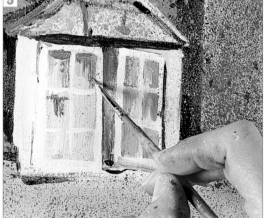

5. We spatter the roof with ochre, in such a way that this color
will also cover part of the sky. To finish we use a thin brush and
brown paint to bring out the shapes of the bricks on the chimney,
the shingles, and the window.

> **6.** Now we add spattered violet paint all over the
> painting, enhancing even more the surface already
> covered with droplets. The spattering effect gives
> the painting a foggy and atmospheric look.

PHASE 2:

ATMOSPHERIC EFFECT

4. Again, with masking tape
and paper we reserve the
areas to be spattered to define
the shape of the chimney and
the window. Then we spatter
with brown paint.

PAPER MASKS

It is common to make paper or cardboard cutouts to
paint with the spattering technique; this way, you can
preserve certain parts of the painting from the
spontaneous splashes of color. Otherwise the droplets
will scatter all over.

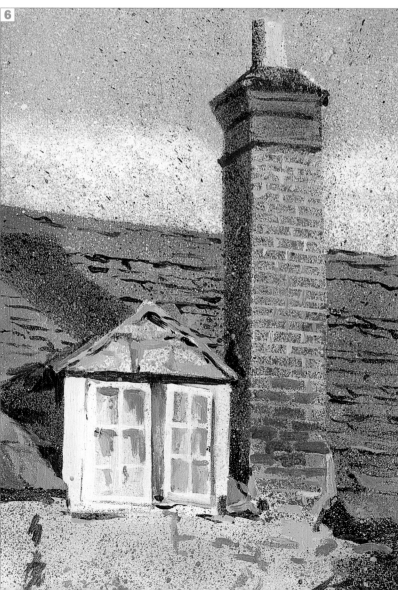

Halfway to abstraction

THE MODEL

■ The inside of a dome whose structure is a series of circles inscribed inside each other.

THE MODEL

Now we are going to attempt a more creative exercise. We begin with a real model, a dome, which has a clear geometric structure, interpreting it with collage using paper cutouts. Then we will paint the surface with colors that have no relationship to the real colors of the model; they are colors that we chose according to our creative mood, and the treatment will not be very realistic. We are venturing into the world of abstraction, where decorative and dramatic looks are favored over realism and replication. For a different take on this, we will make two paintings simultaneously to experiment with different interpretations of the same model. This exercise is done with acrylics, although similar results can be achieved with oil paint.

PHASE 1:
FIRST MODEL WITH DOMINANT CIRCLES

1. We attach several newspaper and colored cutouts inspired by the round shapes of the model on a white background with white glue.

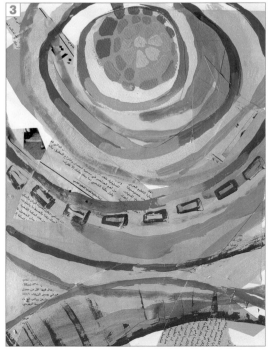

2. When the glue is dry, we paint the bands of color, forming circles around the orange paper. The colored stripes are complemented with red and green concentric circles.

3. We paint the glass cupola with blue geometric shapes while adding new squares and lines with blue brushstrokes. The spiral configuration produces an interesting effect of movement between the colors.

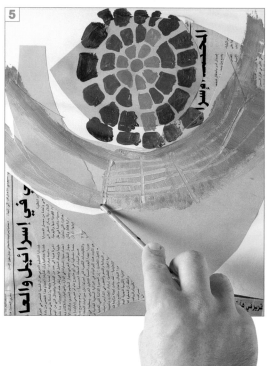

PAINTING

**BRUSHSTROKES
AND MODELING**
SOME CREATIVE
NOTES

237

DIFFERENT PAPERS

If you work with collage, don't limit yourself to one type of paper. There are many varieties available, some of which have unusual textures and wrinkles that you can incorporate in your creations. Such is the case with tissue paper, which crumples easily and creates a very interesting effect.

4. We make another collage, varying the shapes and the disposition of the colors with respect to the previous model.

PHASE 2:

SECOND MODEL WITH DOMINANT SQUARE SHAPES

6. Despite some similarities in the shapes, the development of the color and the forms differ from the previous example. Here, the circles are not as prominent as the squares of the dome's stained glass.

5. In this case the glass panes on the cupola are going to have more relevance. We paint them with darker colors. When the paint is still wet, we create a few sgraffito effects with the handle of the brush.

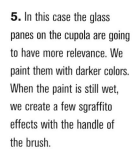

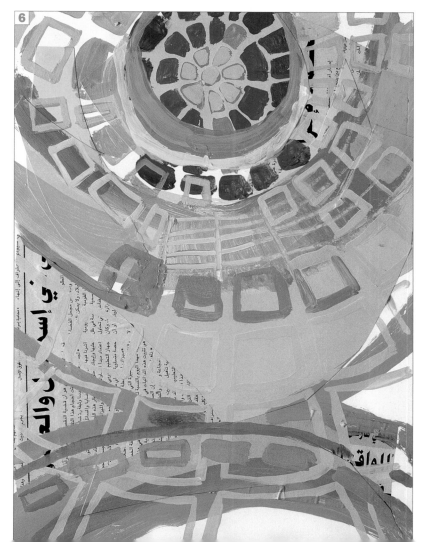

**BRUSHSTROKES
AND MODELING**
SOME CREATIVE
NOTES

PAINTING

238

Total abstraction

Abstract paintings do not begin with a real model, and the canvas is considered an autonomous space where a visual language can be developed by combining colors and balancing shapes, lines, and brushstrokes with a single objective: to move or surprise the viewer. It is considered the zenith of creativity in the world of painting because the artist has no starting reference other than his or her own imagination. To achieve good results, it is important to balance the forms in the design with the variety and dramatic value of the techniques used. We recommend that you select two or three techniques for applying paint that appeal to you the most and try to incorporate them into an abstract project.

PHASE 1:

**WORKING WITH
THE SPATULA**

2. With a wide metal spatula we mix the colors on the palette. Then we pick them up with the edge of the blade and spread them over the paper forming large dispersed squares.

1. With a medium round brush and sienna mixed with a small amount of mineral spirits, we draw several geometric shapes on colored paper. These first lines will help us plan the space.

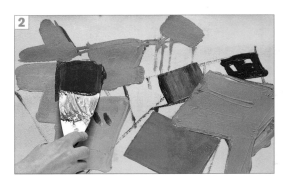

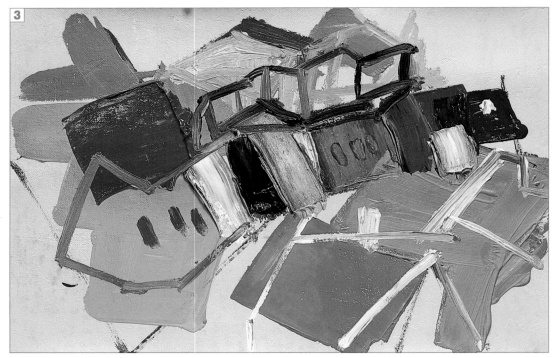

3. We go back to using the medium brush to add lines and brushstrokes. The combination of lines and colors provides greater graphic interest to our composition.

PAINTING

**BRUSHSTROKES
AND MODELING**
SOME CREATIVE
NOTES

239

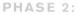 A wide metal spatula is
very useful for larger format
paintings. It requires greater
amounts of paint.

PHASE 2:
SEVERAL VERSIONS

Painting variations

When you make an abstract painting, the color is applied quickly, and the entire process happens very fast. This means that, during the time you would devote to painting a traditional painting, you can make several abstract paintings. It is important to take advantage of this and to work in series—that is, to make different variations by changing the composition and distribution of paint on the support. You do not need to change the colors; if you prefer you can continue working with the same range.

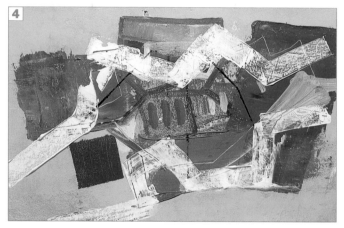

4. The background is covered with new impasto designs in gray, ochre, and sienna. We drag white paint with a thin metal spatula, forming two zigzag lines.

5. Here's another possibility, a background made with impastos and brushstrokes using muddy colors. Above, several linked geometric shapes are painted over with flat colors.

6. Here is a dry impasto background. Over it, we apply paint mixed with mineral spirits, forming a wash and drips. The silhouette of a house is suggested, although very subtly.

7. This is a much more robust painting with very geometric contrasting shapes. The lines are thick and strong. The same color range as in the previous exercises is used.

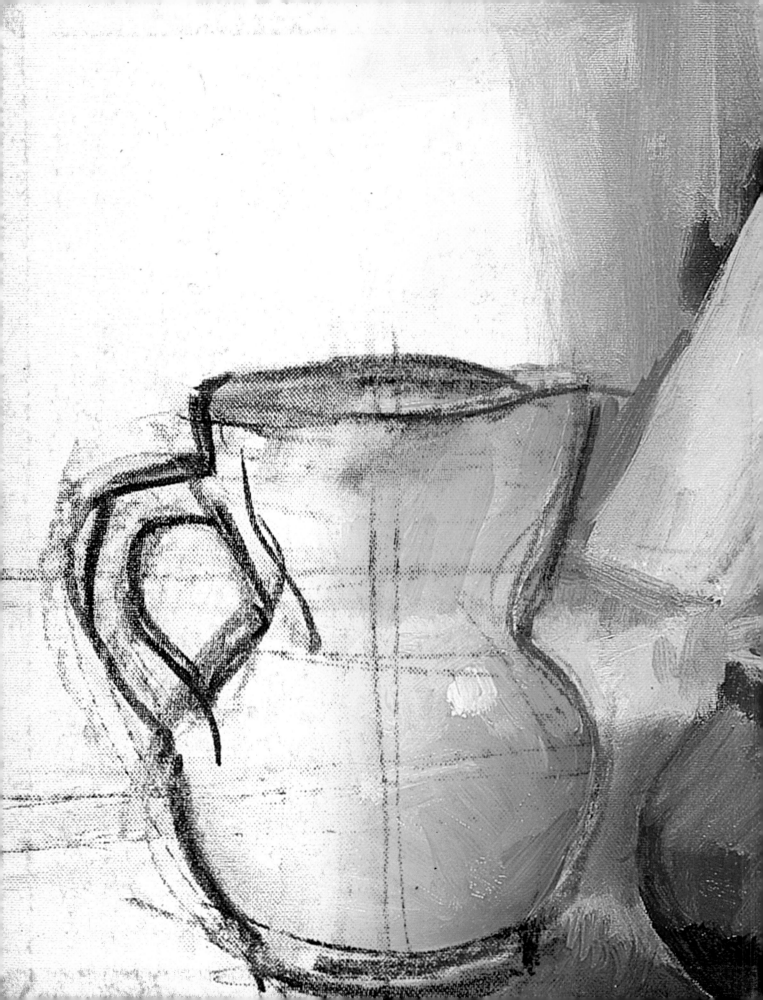